MODERN JAPANESE
PAINTING TECHNIQUES

A Step-by-Step Beginner's Guide

SHINICHI FUKUI

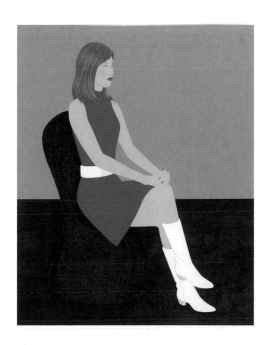

TUTTLE Publishing

Tokyo | Rutland, Vermont | Singapore

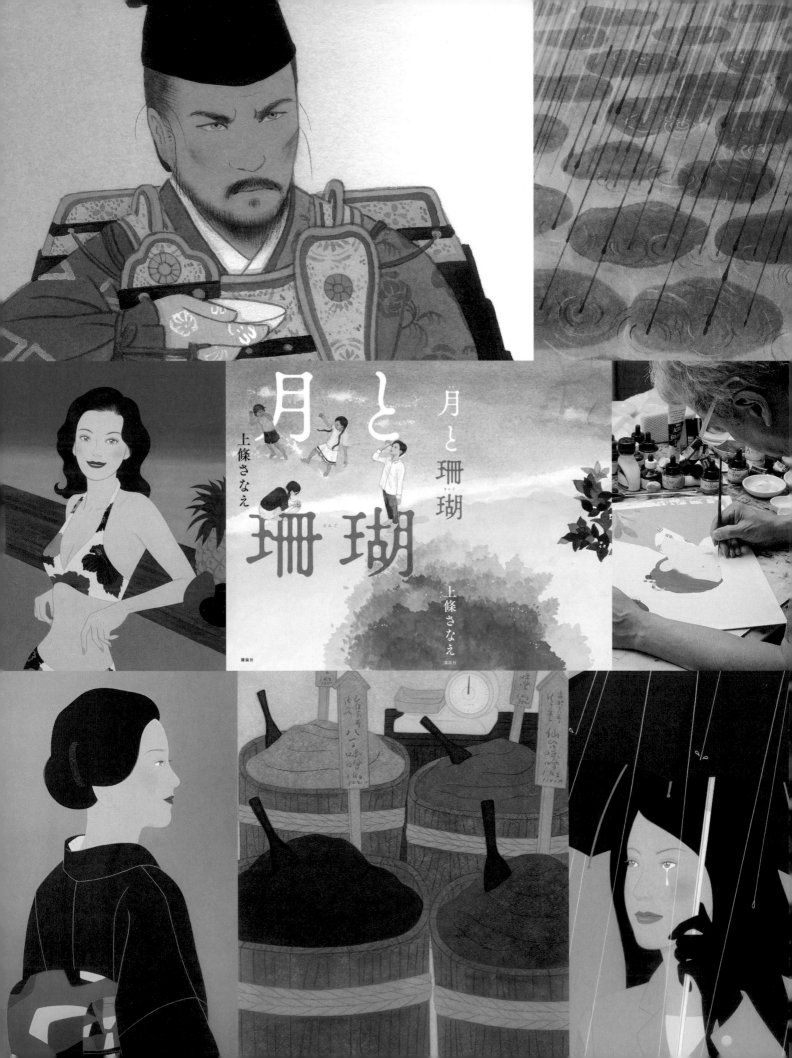

CONTENTS

Why I Wrote This Book

This book introduces techniques for drawing Japanese-style illustrations using acrylic paint. I use the term "Japanese style" because the materials and methods are different from those used for what is officially known as "Japanese painting," but I recommend acrylic paint because it is easy to use and has a variety of applications.

I have been creating art with acrylic paints since even before the start of my career as an illustrator. I did try my hand at genuine Japanese painting methods using *iwa-enogu* mineral pigment paints. However, these paints are expensive and difficult to use, and their grainy texture wasn't suitable for me. So, I used familiar acrylic paint instead and developed an expression of Japanese style that is all my own.

Although there are many subtle elements that comprise Japanese painting, it characteristically portrays imagery that is flat with very little depiction of shadow and depth. Effective use of contour lines and blurring also appear in Japanese painting, and this is also true for my own expressive style. However, even if these conditions are not met, there are many types of expression that can give the impression of being Japanese. This characteristic can also be conveyed through the shape or expression of a face, as well as the use of color and texture.

There are a great many illustrators who use different methods from mine to express Japanese painting styles and Japanese tastes and I introduce seven of them in this book.

My style of artwork is what is known in Japanese as *bijin-ga*, which depicts women in portrait-style illustrations wearing a range of fashions from traditional kimono to modern fashion. Pop art began to develop in the West during the time of the ukiyo-e movement in Japan, whereas illustration is very much a modern popular art that reflects contemporary and social circumstances. So, illustrations need to be able to capture the attention of even those who aren't necessarily interested in paintings by including certain elements like charming faces, attractive hairstyles and current fashion.

For this book, I have created more than twenty new works that include fashion and hairstyles from various eras. The paintings and associated instructions can be used as a reference for how to form faces and bodies, combine colors and create artistic effects in your own paintings and illustrations.

I have included explanations of the techniques used and the creation processes for all these works. Now you can see how these paintings were created and try Japanese-style painting for yourself!

—Shinichi Fukui

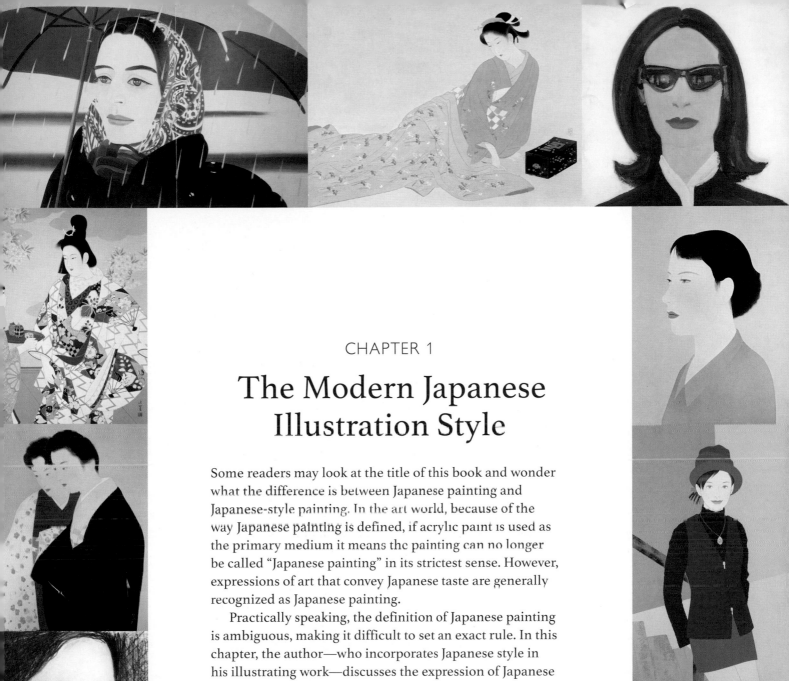

CHAPTER 1

The Modern Japanese Illustration Style

Some readers may look at the title of this book and wonder what the difference is between Japanese painting and Japanese-style painting. In the art world, because of the way Japanese painting is defined, if acrylic paint is used as the primary medium it means the painting can no longer be called "Japanese painting" in its strictest sense. However, expressions of art that convey Japanese taste are generally recognized as Japanese painting.

Practically speaking, the definition of Japanese painting is ambiguous, making it difficult to set an exact rule. In this chapter, the author—who incorporates Japanese style in his illustrating work—discusses the expression of Japanese painting and how it applies to illustration.

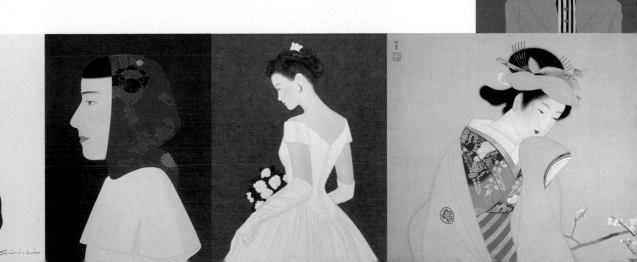

How Do We Define Japanese Painting?

This book explains the techniques for creating Japanese-style art using acrylic paint. I use the word "style" because it differs slightly from original Japanese painting, with the largest difference being the type of materials used. Japanese paintings can be officially referred to as such if they have been created using *iwa-enogu*[1] mineral pigment and other Japanese painting materials. However, the definition for the other elements of this type of expression are vague. To begin with, what should be depicted to make artwork recognized as a Japanese painting? I think it is helpful to have some knowledge of Japanese painting, so I'll provide a simple explanation along with some historical background information.

What kind of art do you think of when you hear the phrase "Japanese painting?" Some people have an image of pictographic scrolls and brush painting, while others think of *fusuma* sliding screen paintings or pictures on room partitions in castles and temples. More still probably imagine ukiyo-e and *nishiki-e* woodblock prints that became popular during the Edo Period. But these are not strictly Japanese paintings. These are just classical traditional paintings from Japan, whereas the art term definition for Japanese painting is much more specific.

During the Meiji Period, when Japan reopened to the world and modernization entered, there was a huge influx of Western technology and culture. Art was no exception and works using oil paint were introduced from Europe (strictly speaking, this had already been happening during the Edo Period) and work of this nature became known as *yōga* or Western painting.

[1] **Iwa-enogu**
A pigment made from powdered minerals. Depending on the fineness of the particles, the same mineral can have different color tones. As the pigment has no natural binder, it is mixed with *nikawa* glue solution before application. New hybrid pigments made by firing glass and metal oxides can also be used, in addition to natural pigments, as can synthetic mineral pigments made of powdered quartz and calcite that have been colored with dye.

[2] **Kanō school**
A group of artists active from the middle of the Muromachi Period to the end of the Edo Period (late fifteenth century through to 1868) who played a very central role in Japanese painting. This school was established by Kanō Masanobu (1434–1530) and his son Kanō Motonobu (1476–1559), and Kanō Eitoku (1543–1590) painted a great number of wall panels in the Azuchi–Momoyama Period. At the start of the Edo Period, Kanō Tan'yū (1602–1674) was appointed to be the shogunate's official painter in Edo (Tokyo), further strengthening the school's position and leading to many offshoots being created. Kanō Sanraku (1559–1635), who remained in Kyoto, established the Kyō-ganō offshoot.

The term *Nihonga* (Japanese painting) was coined to differentiate between the art in Japan and art from overseas. The genre of *Nihonga* Japanese painting is a relatively recent development in the Japanese art world.

Prior to the influx of Western painting, the distinctions had been between schools or styles of art (for example the Kanō school,[2] the Maruyama school[3] and *Yamato-e* classical painting). A characteristic of these artworks is that they all use common materials (ink, *iwa-enogu*, *gofun* white pigment, *nikawa* glue).

The characteristic expressions of Japanese painting that differ from Western paintings were laid out as follows by the American art historian Ernest Fenollosa[4] when he introduced traditional Japanese art under the name "Japanese Painting" in a lecture he gave in 1882.

1. Does not emphasize realism
2. No use of shading
3. A *kouroku* technique is used to outline objects
4. Light color tones
5. Simple expression

Does this list agree with your impression of the characteristics of Japanese painting? Incidentally, the phrase *Nihonga* is said to originate from the translation of the phrase "Japanese Painting" that Fenollosa used in his lecture. At that time, Fenollosa's assistant and interpreter was Okakura Tenshin,[5] who contributed greatly toward establishing modern Japanese art.

[3] **Maruyama school**
A Japanese painting school founded by Maruyama Ōkyo (1733–1795), who studied under the Kanō school and developed a personal style that incorporated Western painting perspectives and Chinese sketching. It was combined with the Shijō school, founded by Matsumura Goshun (1752–1811) who studied Southern Chinese literati painting and was later influenced by Ōkyo, so is often referred to as the Maruyama-Shijō school.

[4] **Ernest Fenollosa** Asian art historian and philosopher (1853–1908) Fenollosa came to Japan in 1878 to work as a foreign faculty member at Tokyo University. He had a deep interest in Japanese art, including Buddhist statues and ukiyo-e. He collected antique works, and visited old temples to conserve the Buddhist statues and paintings stored there. Together with Okakura Tenshin and a number of others, he helped establish the Tokyo Fine Arts School (now Tokyo University of the Arts).

[5] **Okakura Tenshin** Art administrator and scholar (1863–1913) Tenshin acted as Fenollosa's interpreter and assistant, in addition to studying Japanese art and collecting and conserving antique works. In 1890, he was appointed the first head of the Tokyo Fine Arts School. Then, in 1898, he founded Nihon Bijutsuin (Japan Art Institute) and promoted innovation in Japanese painting. He also organized and cataloged Asian art in the Chinese and Japanese art departments at the Museum of Fine Arts in Boston.

Japanese Painting and Traditional Painting

Okakura Tenshin went on to work toward the opening of the Tokyo Fine Arts School (now Tokyo University of the Arts) and became its first dean. While encouraging innovation in Japanese painting, he also proposed new styles of Japanese painting that kept original traditional techniques of expression, but also incorporated the strengths of Western painting, for instance the portrayal of realistic perspective, to create expressions that could compete with the sophistication of Western art. This was a step forward from the Japanese painting expression that Fenollosa had described. However, it received strong opposition from those wanting to preserve traditional modes of expression. This rejection finally led Okakura to resign as head of the Tokyo Fine Arts School. He went on to help establish Nihon Bijutsuin (Japan Art Institute).

At the Nihon Bijutsuin, artists such as Hashimoto Gahō,[1] Yokoyama Taikan[2] and Hishida Shunsō[3] left an indelible mark on Japanese painting expression, and the art exhibitions held by the institute influenced the subsequent development of Japanese art. However, many others rejected Okakura's proposal and chose to preserve the traditional styles of expression and methods that had been practiced up to that point.

The perspective of these objectors was that art that continued in the same vein as that prior to the Meiji Period (1868) was not Japanese painting, but rather constituted new developments in traditional painting that occurred through natural exchanges between the different schools.

In the art world, it is common for work created from the Meiji Period onward to be called *Nihonga* (Japanese painting) and these paintings are clearly distinguishable from traditional Japanese painting created before then. However, in reality, there are probably many who consider art prior to that period to also be Japanese painting. Regardless of the painting material or method, it can be said that in a sense, it is natural to interpret anything that has been rendered using a Japanese style or motif as a "Japanese painting." In contrast, modern Japanese painting has moved away from using such motifs and has become more abstract, so the general public may no longer consider them to be Japanese painting.

Viewed this way, Japanese painting can be defined as imagery rendered with Japanese painting materials, but it's difficult to distinguish between what is a Japanese painting and what isn't based on differences of expression and style.

There is no set rule defining whether the art world's definition of Japanese painting or the general public's perception of it is correct. However, the art world's definition is not applicable to illustration, which is prepared as commercial art for a wide public audience. Leaning more toward the general perception of Japanese painting, Japanese-style illustrations can be defined as an expression that incorporates Japanese styles, motifs and tastes along with traditional Japanese elements, regardless of the materials or methods used.

[1] **Hashimoto Gahō** Japanese painter (1835–1908)
Gahō studied under the Kanō school and, together with Kanō Hōgai from the same school, explored new methods for Japanese painting. Along with Okakura Tenshin and a number of others, he helped establish the Tokyo Fine Arts School and as the chief painting instructor at that school, he taught Yokoyama Taikan and other artists. When Okakura was forced to give up his position, Hashimoto also resigned and helped to found the Nihon Bijutsuin.

[2] **Yokoyama Taikan** Japanese painter (1868–1958)
As a first-year student at the Tokyo Fine Arts School, Taikan received guidance from Okakura Tenshin and Hashimoto Gahō, and researched new expressions of Japanese painting. He presented work that used what is known as *morotai*, a style of painting that emphasizes the use of subtle changes in tone to define shapes instead of relying on strong outlines. It received high praise from overseas and was well regarded in Japan too. He also contributed to the revival of the Nihon Bijutsuin. He became the recipient of the first Order of Culture Award.

[3] **Hishida Shunsō** Japanese painter (1874–1911)
Under the guidance of Okakura Tenshin and others at Tokyo Fine Arts School, Shunsō helped innovate Japanese painting along with his students Yokoyama Taikan and Shimomura Kanzan, but he died at the young age of 37.

What are the Elements of Japanese-style Paintings?

The five characteristics Fenollosa described are factors that make it easy to decide whether a piece of art is Japanese painting or not. The main themes and motifs of traditional Japanese art are: birds-and-flowers, landscapes, Chinese and Buddhist narrative depictions, and genre painting. Among these, genre painting was developed as popular art spread during the Edo Period and its mass production as ukiyo-e led to its popularity. The ukiyo-e pictures included *bijin-ga* portraits of women, *yakusha-e* prints of Kabuki actors and *ōkubi-e* portrait paintings, all of which played a similar role to the glamor and celebrity photography of more recent times.

Bijin-ga was popular from the seventeenth to nineteenth century and although it's not included in the genre of Japanese painting today, it holds an important place in the general perception of Japanese painting. For modern illustrations too, the female form is an extremely popular subject and more than 90% of the figures I paint are women. I mainly depict women from the torso up rather than showing the entire body, but *bijin-ga* has also been primarily portraiture since the Meiji Period, in keeping with Western portrait painting.

The perception is that what people generally regard as elements of Japanese art actually include a lot of the expressions used in ukiyo-e. The slight distortion of faces, bodies and poses is the same, as it is with Hiroshige's famous paintings, which express perspective in a compositional way providing an exaggerated sense of depth despite the flat scene.

Book cover (1992)

The Significance of Japanese-style Illustrations

The painters who continued the tradition of classical painting and ukiyo-e deviated from the mainstream art world during the Meiji Period and onward, but their work on genre paintings and *sashi-e* illustrations meant they were able to acquire a new position. The Westernization movement led to city lifestyles and buildings rapidly becoming modernized and more people began wearing Western-style clothing. Younger generations, known as *mobo* (modern boys) and *moga* (modern girls), could be seen strolling around town dressed in modern fashion. Many genre paintings using Japanese painting methods reflect those societal changes. I, too, often draw figures wearing fashion that reflects contemporary society and to do that I refer to both modern and classic genre paintings that were drawn during the Meiji and Taisho Periods.

Sashi-e illustration artists, who followed in the tradition of Japanese painting (including classical painting), and ukiyo-e painters were active from the Meiji Period (1870s) through to the mid-Showa Period (1940s). Painting materials have also changed, so now more artists use pen and ink, along with brushes and ink, and watercolor paint is used for coloring. However, following World War II, there was a rise in graphic design that had a strong American influence, and, in the 1960s, professional painters appeared who referred to themselves as "illustrators."

Advertisements, magazine covers and illustrations had a modern art look with abstract characteristics and the old-style *sashi-e* illustrators lost influence, becoming relegated to working on book covers and book illustrations.

The late 1970s into the 1980s saw a boom in photorealism, a form of realistic expression created using an airbrush[1] in a variety of applications. This was followed in the early 1980s by a rise in popularity of *heta-uma*,[2] a movement where art was intentionally rendered with an unpolished look.

During this time, there were also painters who followed other traditions, incorporating elements of Japanese painting to create modern expressions in different ways. Ichiro Tsuruta[3] is representative of this kind of work. His graphical expressions with flat color surfaces and airbrushing used to add blurring give the impression of Japanese painting. His depiction of wide, narrow eyes is an element found in *bijin-ga* as well.

From around this time, there was a so-called "retro boom" where the culture and design from what was regarded as "the good old days" enjoyed a renaissance and illustrations reflecting Taisho to mid-Showa Period (1920s–1940s) tastes and styles became popular again.

The works of Suehiro Maruo[4] and the manga artist

[1] **Airbrush**
A painting tool that sprays paint as a fine mist through the use of compressed air or gas. The paint can be applied smoothly and evenly, something that is difficult to do with a traditional brush, and with such a tool it is possible for the artist to express smooth gradients and soft shading.

[2] *Heta-uma*
A style of expression advocated by Teruhiko Yumura (1942-) that at first glance looks *heta* (bad), but is actually *umai* (good, as in skillfully executed). There are four types—*uma-uma*, *heta-uma*, *uma-heta* and *heta-heta*, with *heta-uma* being the most appealing.

[3] **Ichiro Tsuruta** Artist and illustrator (1954–)
Tsuruta began using the airbrush method in his work. He established his own unique *bijin-ga* style incorporating photorealism, which was popular at the time, together with the style of the Rimpa school. He gained popularity in Japan 1987 when his art was used to advertise Noevir cosmetics.

Kazuichi Hanawa,[5] who were active at this time, can be said to convey the aesthetic of Japanese painting, and the influence of Kashō Takabatake (a popular Taisho Period artist) is evident in them. Regarding this retro aesthetic, it is important for the motifs to reflect Japanese style and evoke the good old days in Japan and, while it doesn't always have the same characteristics as Japanese-style painting, it can now be seen in a wide range of genres, including advertising posters.

I made my debut as a professional illustrator in the 1980s. From that time up to now, I have focused on depicting young women's portraits, but I do pay attention to clothing and hairstyles, trying to incorporate the fashions and tastes of each era I portray. Even with the flat appearance of Japanese-style painting, ultimately I am depicting modern women. In recent years, there have been more opportunities to depict women in kimono, but as there is now also more freedom in how kimono are worn, I pay attention to the differences in Japanese dress throughout the periods.

In regard to design overall, Japanese tastes are being re-evaluated and becoming more widely appreciated. Illustrations that incorporate expressions using Japanese tastes and methods are being seen in more and more places.

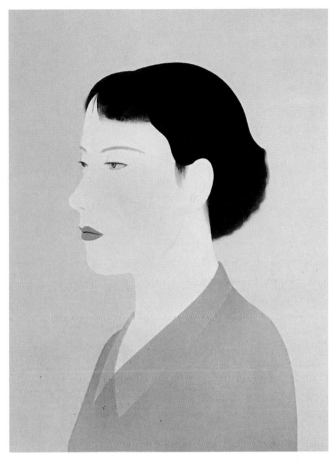

Editorial (1988)

4 **Suehiro Maruo** Manga artist and illustrator (1956–)
Maruo draws his own fantasy world using a retro aesthetic style influenced by Kashō Takabatake. His representative work is *Shōjo Tsubaki* (*The Camellia Girl*—1984). In recent years, he has created many works based on literary classics by writers like Edogawa Ranpo and Yumeno Kyūsaku.

5 **Kazuichi Hanawa** Manga artist and illustrator (1947–)
In the early stages, Hanawa drew bizarre works based on childhood traumas, and more recently he has been drawing a fantasy world set in medieval Japan. His rich painting style is influenced by Taisho modernism, represented by artists like Hikozō Itō.

Painters Who Have Influenced Me

The artists who I am interested in and have been influenced by in Japanese painting are: Shinsui Itō,[1] Shimei Terashima,[2] Kiyokata Kaburaki[3] and Settai Komura.[4] The first artist who I became aware of as being a Japanese painter was Shinsui Itō. I'm not sure where I saw his work, maybe in a department store. It was definitely in Kyoto. Shinsui Itō was a pupil of Kiyokata Kaburaki, and even though Kiyokata was a *sashi-e* illustrator, he followed in the steps of ukiyo-e, and remarkably he lived until 1972, the same year that Shinsui passed away. There was a significant age gap between them (Shinsui was born in 1898, while Kiyotaka was born in 1878).

Settai Komura was strongly influenced by the ukiyo-e artist Suzuki Harunobu,[5] so that led me to look at Suzuki too. And then there is Katsushika Hokusai.[6] I use *Hokusai Manga* as a reference.

My tastes have changed steadily over time, so right now I am most interested in looking at work by Shimei Terashima. I have always liked Shinsui Itō as well, but at the moment I am finding myself drawn to the blurring effect Shimei uses in his work.

Shimei and Shinsui were active at around the same time and I was surprised to learn that Shimei was also a pupil of Kiyotaka.

Nevertheless, I think I generally prefer Shinsui Itō's work more. I have looked at work by Uemura Shōen[7] and others, but not as deeply as I have Shinsui's. I find the work of the relatively minor artist Nakamura Daizaburō[8] has a somewhat modern look to it. There is also Kitano Tsunetomi,[9] by whom I may have been indirectly influenced. He is another artist with a

[1] **Shinsui Itō** Ukiyo-e artist and Japanese painter (1898–1972) Itō studied under Nakayama Shuko and Kiyokata Kaburaki, who were both from the Utagawa school of ukiyo-e. His work was selected for the Tatsumi Gakai (Southeast Painting Society), the Nihon Bijutsuin, and the Bunten Ministry of Education art exhibitions, and while he was part of the shin-hanga art movement, he also did *sashi-e* illustrations for newspapers. He is described, along with his teacher Kiyotaka and others, as a master *bijin-ga* artist.

[2] **Shimei Terashima** Japanese painter (1892–1975) Terashima became a pupil of Kiyokata Kaburaki at the age of 21 and his work was selected for many events, including the Teiten Imperial art exhibition and *Bunten* Ministry of Education art exhibition. He gained popularity for his *bijin-ga* and he was part of a famed trio with Shinsui Itō and Yamakawa Shūhō (1898–1944) that studied under Kiyotaka.

[3] **Kiyokata Kaburaki** Painter and ukiyo-e artist (1878–1972) Kaburaki was engaged in *sashi-e* illustrations from early on through the newspaper his father ran and he worked on book illustrations for writers such as Izumi Kyōka. Known as a *bijin-ga* master, he also created many genre paintings depicting scenes from Edo (old Tokyo).

[4] **Settai Komura** Painter (1887–1940) While studying at Tokyo University of the Arts, Komura met Izumi Kyōka and, beginning with Kyoka's novel *Nihonbashi* (1914), he worked on a large number of *sashi-e* illustrations. He also worked for a time (1918–1923) in Shiseido's design department and was involved in stage art too.

[5] **Suzuki Harunobu** Ukiyo-e artist (1725–1770) One of a number of ukiyo-e artists active during the mid-Edo Period, Harunobu contributed to the establishment of *nishiki-e* multi-colored woodblock printing. He produced many *mitate-e*, a style of painting that applied contemporary customs and real-life people to classical art and he was particularly well-known for his *bijin-ga* work.

[6] **Katsushika Hokusai** Ukiyo-e artist (1760–1849) Hokusai's representative work includes *Thirty-six Views of Mount Fuji* and *Hokusai Manga*. As well as ukiyo-e, he incorporated painting methods from the Kanō school, the Tosa school, and Western painting, and was influenced by Impressionist painters too. He worked on many *sashi-e* illustrations for *kibyōshi* picture books and *kokkeibon* novels, and in later years created a great number of *nikuhitsu-ga* brush paintings.

slightly modern look to his work.

These are practically all of the Japanese painters that I have been interested in. I was never really drawn to Yokoyama Taikan or Hishida Shunsō.

Sentarō Iwata[10] and other *sashi-e* illustrators are also interesting, but I haven't looked deeply into their work. I feel I'm more influenced by the people who were the source for these *sashi-e* illustrators, rather than those artists themselves. Another artist I have taken an interest in from time to time is Shigeo Miyata,[11] although he was a Western-style painter. His primary occupation was as a doctor. Even though he did Western painting, I feel his drawings of people are influenced by Shinsui Itō and I think this is what attracted me to his work.

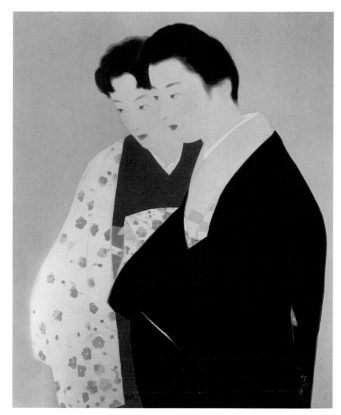

Shimei Terashima (*Two Women*)—
Ozeki Corporation Collection

[7] **Uemura Shōen** Japanese painter (1875–1949)
Shōen studied under Suzuki Shōnen and Takeuchi Seihō, and she was active from the Meiji Period into the Showa Period. Using her female perspective and feminine sensibilities, she was known for her elegant *bijin-ga*, and she was the first female painter to receive the Order of Culture Award.

[8] **Nakamura Daizaburō** Japanese painter (1898–1947)
Daizaburō studied under the painter Nishiyama Suishō. After graduating from Kyoto Prefectural School of Painting (now Kyoto City University of Arts), he participated in government-sponsored exhibitions, including being specially selected twice for the *Teiten* Imperial Exhibition. He taught younger generations of painters at his alma mater and along with specializing in *bijin-ga*, he also created many genre paintings.

[9] **Kitano Tsunetomi** Ukiyo-e artist, painter and printmaker (1880–1947)
After working as a newspaper block engraver, Tsunetomi became a *sashi-e* illustrator and while doing that learned Western painting techniques. He went on to become a painter and his *bijin-ga* work was popular. In his early work, he had a flamboyant, alluring quality, which later evolved into a more serene style. He played a leading role in the art world in Osaka.

[10] **Sentarō Iwata** *Sashi-e* illustrator (1901–1974)
Iwata studied under Kikuchi Keigetsu and Shinsui Itō and began *sashi-e* illustration work from the Taisho Period (1910s) onward. Renowned as a *bijin-ga* master, he also worked on many magazine covers. He served as first board director of the Japan Publication Artist League and contributed to improving the status and rights of *sashi-e* illustrators.

[11] **Shigeo Miyata** Western painter (1900–1971)
Miyata was a doctor who exhibited oil paintings while also serving as the director of a hospital. He was active in a number of other fields too, including *sashi-e* illustration, writing haiku and essays, and making radio appearances. He was responsible for the illustrations in Yōjirō Ishizaka's *Conduct Report on Professor Ishinaka* and when it was turned into a movie, Miyata was given the leading role.

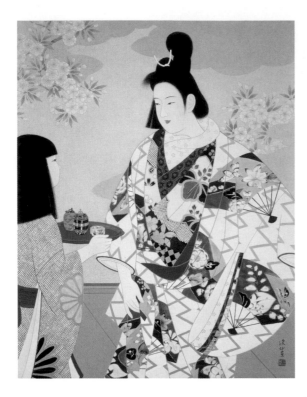

Shinsui Itō (*The Courtesan Yoshino Tayū*—1966)
Yamatane Museum of Art collection

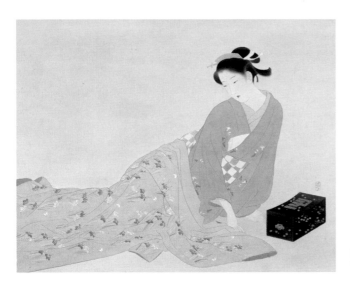

Kiyokata Kaburaki (*Agalloch Pillow*—1936)
Yamatane Museum of Art collection

Settai Komura (*Oden Jigoku*)
From the Yomiuri Shimbun serialized novel *Oden Jigoku*
(*A Legend from Hell*) by Kunieda Kanji 1934–1935
Reprinted from *Gendai Nihon Bijin-ga Zenshu IV Meisakusen*
(*Modern Japanese Bijin-ga Collection Vol. 4 Masterpiece Selection*)
(Shueisha, 1979)

Uemura Shōen (*Fragrance of Spring*)
(1940)—Yamatane Museum of Art collection

Special Exhibition Commemorating a Decade since the Yamatane Museum of Art Opened in Hiroo: Uemura Shōen and World of Bijinga, Paintings of Beautiful Women
Includes Uemura Shōen's *Fragrance of Spring*, Shinsui Itō's *The Courtesan Yoshino Tayū*, and Kiyokata Kaburaki's *Agalloch Pillow*.
Yamatane Museum of Art 3-12-36 Hiroo, Shibuya, Tokyo

Among the *sashi-e* illustrators, I was particularly drawn to Kan Kazama.[12] Kazama's method was different from Japanese painting in that his work is not planar, but rather has a certain amount of depth from shading. Even so, his drawings of people have a lyrical quality that speaks to the Japanese soul and I think this is what inspired me to lean toward Japanese tastes.

Seiichi Hayashi[13] also has a lyrical, Japanese style of painting, which influenced me as well. Hayashi drew for *Garo*[14] manga magazine, as did Mizumaru Anzai, and although the people who contributed to *Garo* at the time were minor, many went on to become major artists. I have met and talked with Hayashi and I remember him saying, "There are minor and major illustrators and I am definitely minor." His illustration of a girl for the Koume-chan plum candy commercial is very well known in Japan, so I consider him "major," but as he followed a career path from animation to manga and then illustration, it meant few others were really following in his footsteps, so maybe that is why he doesn't regard himself as a mainstream artist.

Kan Kazama (*Irotoku*)
From the novel *Irotoku* by Jakucho Setouchi, serialized in the weekly magazine *Shukan Shincho* in 1972–1973
Reprinted from *Gendai Nihon Bijin-ga Zenshu IV Meisakusen* (*Modern Japanese Bijin-ga Collection Vol. 4 Masterpiece Selection*) (Shueisha, 1979)

[12] **Kan Kazama** *Sashi-e* illustrator and printmaker (1919–2003)
In 1953, Kazama illustrated the serialized story *Koi Ayame* by Kanji Kunieda in *The Asahi Shimbun*, which broke new ground both for newspapers and *sashi-e* illustration. He was known for his lyrical scenes and *bijin-ga*. He went to Paris, France twice to study copperplate engraving and exhibited many prints.

[13] **Seiichi Hayashi** Manga artist and illustrator (1945–)
While working as an animator, Hayashi released manga in the manga anthology magazine *Garo*. He became popular with his 1970 work *Red Colored Elegy*. He directed and created the character design for Lotte's Koume-chan plum candy commercial and his lyrical, beautiful girl character was popular.

[14] *Garo*
A manga magazine that was launched in 1964 by the first editor Katsuichi Nagai (1921–1996) in order to serialize *Kamui Den*, the representative work of Sanpei Shirato. Other editors included Shinbō Minami and Kazuhiro Watanabe, and many talented manga artists were discovered, such as Yoshiharu Tsuge, Kazuichi Hanawa, Yu Takita, Yoshikazu Ebisu, Shungicu Uchida, Hinako Sugiura and Takashi Nemoto.

Combining Western and Japanese Techniques to Achieve My Own Style

In my case, I use a combination of Japanese and Western painting techniques, so I am also influenced by overseas painters. The strongest influences have been David Hockney[1] and Alex Katz.[2] I'd say my painting techniques and methods are like a mix of Japanese painting + Hockney + Katz. But I can't leave out Seymour Chwast.[3] Chwast is a graphic designer and illustrator and I especially like his early ideas and color schemes.

Alex Katz's paintings are very planar for Western art and are not expansive three-dimensional pieces at all. He doesn't include such strong shading and there is a soft blurring effect, so they give me a real impression of a Japanese painting. That made his work accessible for me, I think. Also, I'm not sure if he is adding distortion or just drawing as he sees things, but his take on the shape of faces is fascinating. It gives a real sense of the subject and it made me think that Katz has an interesting approach to depicting shapes.

Alex Katz uses matte color too. His sketches are also like Japanese painting and don't really give the sense of Western design. He may well have seen Japanese paintings somewhere. He's a modern creator, so there is plenty of information available. There are paintings where the figures stand out from black backgrounds and this technique of using dark to accentuate the figure in the foreground has been around since the time of Caravaggio, but I was influenced by Katz to create this type of painting using the same effect (page 100).

My work on page 92 has a light blue background, but I made the clothing a maroon-like purplish-red. While the pose is one that fashion models often make, I also look at photos for reference in drawing. The person's face is based on the image of the actress Jane Birkin, but there is a lot of reference material all jumbled together. Jane Birkin's face has deep features, but instead of portraying them with verisimilitude, I

[1] **David Hockney** Painter (1937–)
Hockney was born in the UK. In his early period, he created pop art pieces, but when he relocated to Los Angeles, his style changed drastically. As well as paintings and prints, he is active in a variety of fields including photo collages, digital works, costumes, and stage design.

[2] **Alex Katz** Artist (1927–)
Katz as born in New York. He is engaged in creating paintings, prints, sculptures, and the performing arts. He worked on representational art when the art world was focusing more on abstract expressions and he took part in the pop art movement. His expression of people through the use of simple lines and color surfaces was a major influence on illustrators too.

[3] **Seymour Chwast** Graphic designer (1931–)
Chwast was involved in establishing the world-renowned design studio Push Pin Studios. For many years, he has been engaged in designs for advertising, record jackets, and packaging, as well as in illustration.

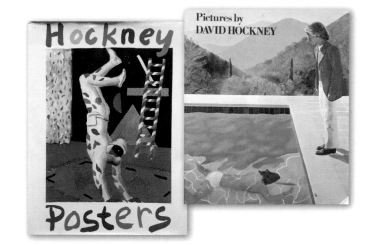

The author's collection of art books about David Hockney (right) and Alex Katz (below).

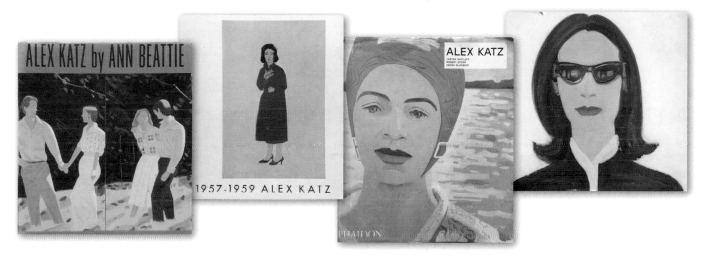

kept them shallow and as I worked, the face gradually taking on the appearance of a Japanese person's face.

I left her eyes large though, so it may make a slightly different impression than that of a Japanese person's face. Many Western people have a quite angular skeletal structure and the contours are often not as rounded as those of the Japanese.

Hockney's paintings and methods gradually changed with the times, but I prefer and am most influenced by his early works, especially those in the late 1960s through early 1970s. It was a period when he often painted swimming pools and palm trees. When I look at images from that period, I feel his depictions are tight and quite planar, so they have a Japanese style to them. When you see the original, masking has clearly been used, but that was a time when airbrushing was popular, so everyone used masks (frisket). Look at Hockney's pool paintings and you can see the unique depiction of ripples in the water. I was impressed by that and tried painting that way as well.

My Methods are Not "Pure" Japanese Painting

My paintings are in the Japanese style, but that doesn't mean I am fully following Japanese painting forms and methods. Take the depiction of rain, for example. Many people draw pictures of rain, but in ukiyo-e it is expressed by lines. Alex Katz's method for rain is to draw water droplets, very different from Japanese painting. Hockney draws rain too, but he uses black lines. My way of drawing rain is somewhere in-between as I draw lines and water droplets.

Settai Komura used only fine lines. If you look at Settai's *sashi-e* illustrations, the lines of rain are parallel. Whereas in ukiyo-e paintings like that of Utagawa Hiroshige, the lines intersect here and there rather than running parallel to each other.

Settai emphasized the impression of a rainy scene through the incorporation of umbrellas. Several other artists also use the umbrella motif, and Shinsui Itō created many images of people holding umbrellas too.

I've synthesized a range of these techniques. If an illustration is created referencing only one specific picture, it essentially becomes a copy and risks copyright infringement. So I have made it a habit to use multiple references all the time. To begin with, I look at various things and mix them up, and I think that might be where my own unique aesthetic comes from.

I Buck Neo-impressionism

In the early 1980s when I began thinking about becoming an illustrator, the Nippon Graphic Exhibition[1] and other open-call art exhibitions were really popular and the phrase "New Painting"[2] was trending.

There was Jean-Michel Basquiat,[3] Julian Schnabel,[4] Keith Haring,[5] and a lot of other artists too. Paint was slathered, things were stuck on, like Schnabel who glued plates to canvas, and the influence from that expression of New Painting was really strong, plus a lot of those works were on display at the Graphic Exhibition.

I was influenced too and I tried to do the same, but it never really clicked with me. I submitted work in that style to the Graphic Exhibition once or twice, but was only selected as a semi-finalist.

It made me think about what exactly it was that I wanted to do. I realized I didn't want to fool myself and that I should try drawing what was true to me. That's why, contrary to what was trending at the time, I tried going in almost the opposite direction to New Painting. And that's how I moved toward Japanese-style painting.

New Painting works are created with a lot of spontaneity, but that cannot be done in Japanese painting. There are clear stages of first creating a draft, copying it, and then carefully painting it, so the method is completely different. I thought that was the direction I was heading in. It was while I was thinking that, that I came across Shinsui Itō's paintings and began studying those techniques.

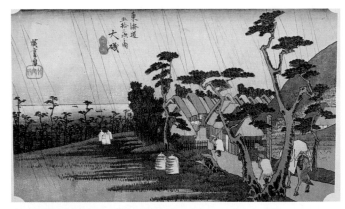

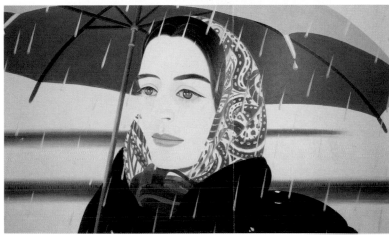

(Top left) Settai Komura (*Osen Rain*), a *sashi-e* illustration (Umbrellas) from *Settai Komura Sakuhin-shu*, a Settai Komura art collection book (Abe Publishing)
(Top right) Utagawa Hiroshige (*Fifty-three Stations on the Tokaido Oiso—Tora-ga-ame* [*Tora's Rain*]) The Museum of Fine Arts in Boston collection
(Bottom left) David Hockney *Japanese Rain on Canvas* from the art collection book *Hockney's Pictures*
(Bottom right) Alex Katz *Blue Umbrella No.2* from the art collection book *Alex Katz*

1 **Nippon Graphic Exhibition**
An open-call graphic art exhibition organized by Parco department store chain. This exhibition started in 1980, producing a number of famous artists including Katsuhiko Hibino, and created a boom in open-call art exhibitions during the 1980s. In 1984, the Nippon Object Exhibition focusing on three-dimensional pieces was derived and later was reintegrated to become URBANART in 1992 and held until 1999.

2 **New Painting**
A trend in painting that occurred from the late 1970s through the 1980s and was characterized by rough brushwork and the bold use of mainly primary colors. This is now more commonly known as neo-expressionism.

3 **Jean-Michel Basquiat** Artist (1960–1988)
Basquiat started as a graffiti artist in the late 1970s and eventually succeeded in the art scene too. He collaborated with Andy Warhol, but died of a drug overdose at the young age of 27.

4 **Julian Schnabel** Painter and filmmaker (1951–)
Schnabel is a representative painter of 1980s neo-expressionism. His works using broken ceramic plates that he glued onto canvas are well known. He is also active as a filmmaker and director. He associated with Basquiat as a painter and he is known for directing the biographical film *Basquiat* (1996).

5 **Keith Haring** Artist (1958–1990)
Haring was a pioneer of graffiti art. His art became popular due to its simple lines and bright color surfaces that had a pop feel and he conducted exhibitions, workshops and merchandise sales. He created a number of murals in different countries too. He died at 31 due to AIDS-related complications.

Why I Started Using Acrylic Paints

It's said that works made using Japanese painting materials are Japanese paintings, but the definition of "Japanese painting" is actually ambiguous, as I've explained. While I was exploring Japanese-style expressions, I tried genuine Japanese painting techniques. But the *iwa-enogu* medium was really tedious to use! The pigment is dissolved into *nikawa* glue, which is annoying to handle and it takes a long time to dry, so applying it to the canvas is difficult. I wanted to be an illustrator, and even though *iwa-enogu* wasn't without its merits, I quickly determined that it wasn't suitable for my illustration work. In this field, the deadlines are typically aggressive, so if the work doesn't dry quickly enough it can't be used. That's ultimately the reason why I made the choice to use acrylic paint.

Even those who submitted works for the Nippon Graphic Exhibition using New Painting techniques were using acrylic paint rather than oil paint. So, that convinced me that acrylic paint can be used for anything—plus, the illustrators active at the time were all using acrylic paint. These factors meant that, while I was influenced by the expression of Japanese painting, I used acrylic paint and color ink for my work.

The Japanese Aesthetic Sense

This may seem like a tangent, but a unique trait for Japanese people is that they actually feel cooler when they hear the sound of a wind chime. It is like they have been imprinted with the idea that summer and wind chimes are connected and it's been said that their body temperature actually drops when they hear that sound. This generally isn't the case for people from overseas who hear a wind chime and just think it's a beautiful sound, but they don't feel cooler and their body temperature remains unchanged.

There is probably a unique Japanese aesthetic in paintings too and I think I may have that DNA as well. If I look at an oil painting that has three-dimensionality similar to a plaster-cast drawing I think, "Wow, I don't want to draw that kind of thing!" Instead, when I plan my own illustrations, I prefer to create a planar painting. That's easier for me. It gives me the most satisfaction. It might be the environment I was born and grew up in that causes that feeling to come naturally.

My father was an oil painter, so that led me to create oil paintings too, and I also did prints and various other types of expression. That in itself was gratifying, but I was always wondering how I could find my own expression. If you become an illustrator, you have to draw in one style for years. If I wanted to continue for a long time, I needed to do it in the easiest way for me, and I realized it wouldn't be wise to force myself to work in a different style than the one that came to me naturally. So, this Japanese-style painting was truly my style. I think other artists using Japanese-style painting methods have this same mindset.

I didn't study Japanese painting in a systematic way. I looked at the work of painters I liked and just painted in the same style. I imitated completely—Hockney used Liquitex (an acrylic paint brand), so I copied by using acrylic paint too.

Up until just before the Graphic Exhibition created a boom, photorealism was at its peak, and the first one or two times the exhibition was held, there were quite a few award-winning photorealistic pieces. I was influenced by that too and even considered using an airbrush. I like drawing people, so I tried imitating the style of Pater Sato, who was popular at the time.

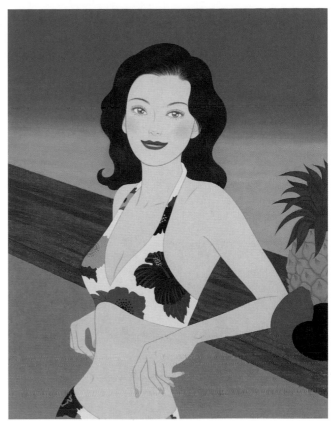

Tropical—Calendar (Year unknown)

Flat Paintings Allow More Freedom with Color

Manga and animation, for example the Disney movies *Snow White*, *Sleeping Beauty* and *Alice in Wonderland*, have planar depictions of cute girls and beautiful women, and I think my work has been somewhat influenced by media like that.

Among the works I created for this book, the picture of a moonlit night with a waterfall in the background is like something from a traditional Disney animated movie and reflects Western tastes. In the West, cel animation is planar too, and that kind of look is expected.

When composing an oil painting, you generally render the imagery as you see it—if you are depicting a red flower, you paint it red, right? However, like in Seymour Chwast's flat paintings, his desire to use a certain color is paramount and this provides a lot of freedom regarding color. The floor of the room can

be green and the walls pink, and while that room doesn't actually exist, he can do it because he wants to use those colors for that composition. It's not because the motif is that way, it's because those are the colors he *wants* to use. Chwast is interesting that way and it's easier to use that strategy in planar paintings. Seymour Chwast is both an illustrator and a designer, and when he composes an illustration, his color choices make it seem more like a graphic design than a painting.

I Keep Gradation to a Minimum

Another important factor in Japanese painting expression is *bokashi*, a kind of color blending or gradation. Just by incorporating gradation into a planar image, it takes on the appearance of a Japanese painting. I used to use an airbrush to do this during the period when photorealism was at its peak, but airbrushing is more an expression of gradation. Gradation can give figures a three-dimensional effect, but I don't want to use it like that. I like the way the sky is blended in ukiyo-e, but I only use gradation on certain key points like women's cheeks and hairlines. Airborne particles from airbrushes are not good for your health, so now I use color ink to create gradients.

Realism and photorealism grew in popularity from the 1960s onward and Japanese artists imitated that, but because people were aware these works were probably created using an airbrush, photorealism gradually began to mean that those pictures looked airbrushed—regardless of the medium used.

However, the styles of Harumi Yamaguchi[1] and Pater Sato,[2] said to represent this kind of expression, are not actually photorealism. Harumi and Pater are

[1] **Harumi Yamaguchi** Illustrator (1941–)
Yamaguchi has been working as an advertising illustrator since the Parco department store opened in 1969. From around 1972, she started using photorealism achieved with airbrushing to mainly paint women and those works, known as "Harumi gals," dominated the scene.

[2] **Pater Sato** Illustrator (1945–1994)
In the early stages, Sato used an airbrush to create illustrations of futuristic images and received high praise both within Japan and overseas. From around 1980, he began creating portraits using pastels, which gained him popularity. He died suddenly in 1994 at the age of 49 due to pneumonia.

Conveying Form with Lines

As with ukiyo-e and Settai Komura's paintings, painting with lines differs from typical oil and watercolor paintings in that first the motif gets conceptualized and reformulated before being output to the canvas. In short, it's descriptive, or rather, conceptual. Even when Japanese artists make sketches, they draw lines and then, as if they are putting it through their own filter, suddenly distortions appear and instead of drawing what they see, they have created their own form. The beautiful stylistic form of ukiyo-e is easier to do with lines. In oil paintings, the subjects and situations are rendered as they are seen and it's difficult to make it more interesting by injecting your own style. If you work relying heavily on lines, it naturally becomes your form.

I previously touched on the method of expressing rain with simple lines. Just through inscribed lines, the viewer can recognize that the artist is portraying rain. Japanese painting, especially ukiyo-e, employs this kind of simplification in various ways, so for example in a night-time scene, even though the sky is dark, skin tones remain the usual value. That is not a problem in ukiyo-e, but it cannot be pulled off when creating a Western oil painting. When the surroundings are dark, the figure's skin tone alone doesn't generally remain brightly lit.

In Japanese painting, there is a sort of effortlessness in the appearance of the lines, so it is easier to convey meaning through them. Faces, leaves and practically anything can be depicted with lines. When I portray landscapes, I express them with lines. Drawing two-dimensionally makes it easier to perpetuate themes and to put concepts forth with clarity.

artists known for having produced airbrushed works where their own style shone through, so you can tell who created it at a glance. In photorealism, there is a preoccupation with mimicking photography, while these two tried to express something that was more than reproducing a photo, even depicting things that can't be captured with photography. It is realism of a sort, but what they were aiming for was different. They borrowed the airbrushing aspect from photorealism and made it serve their own form of expression. I think that in itself is interesting.

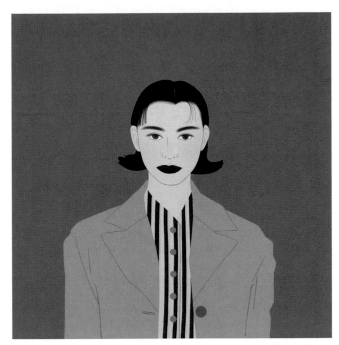

Striped Shirt—Laser disc jacket (1990)

I Draw Various Types of Women

Many of the requests I get are "Please draw a Japanese-style woman" or if it's flowers, "Please draw a unique Japanese flower." For work assignments, I'm often asked to portray female office workers, as well as high school girls. I don't paint many foreigners, although I can. I'm able to draw various types of women. I'd say that the majority of requests I get are for Western clothes, while the subject age range and era vary—I get asked to draw women in their 70s too.

When I draw women in their 40s and 50s, which is the age range when "laugh lines" start to show, I'm often asked not to draw those in. The men get wrinkles, but the women don't! It's a bit of a struggle, but I still try to subtly give a sense of age. I slightly lower the outer corners of the eyes and position the facial features further down, so even if I don't draw lines in the curves of the eyes, the sense of maturity isn't lost. I think it's more difficult to draw an older person attractively when creating a three-dimensional effect. If you draw realistically like in Western painting, the effects of aging become conspicuous.

To make it Japanese style, the trick is to not depict the features with too much realism.

Make the face smooth or don't make the eyes too detailed. It might not be common practice these days, but I make the eyes appear to have uncreased eyelids as well. Don't create wide eyes with double eyelids. The hair is basically black. When brown hair was really popular, I painted brown hair too, but I found that it looked rather boring. Japanese-style expression isn't realistic though, so even if the hair is brown, it doesn't give a tasteless impression. In my case, most clients are wanting a classy image, not a tacky one. I think that's different to the comic-like illustrations that are popular these days. Ukiyo-e was originally really vulgar, but *bijin-ga*, that made up a part of that, had a high-class image.

Sometimes I get requests like "Paint this specific person." If it was a realistic portrait, it would be fine to accentuate that person's unique features, but that would become a different style of art, so I don't engage in that. It would be as if I'm capturing the features of the face, while trying to make it resemble the person but without adding too much detail. Operating this way, one could tell who the model is, but it doesn't make them look very human—so it's not for me.

The Definition of Illustration

I'm an illustrator, so when I compose imagery, I create illustrations. Looking at the difference between illustration and fine art, we see that the definition is vague.

The illustrator Jun Tsuzuki[1] gives a very clear answer though. He says that illustration is a state in which the image is "functioning" in a medium. In other words, deciding if it is an illustration or not isn't based on the style or type of image; imagery that serves a function within the medium are all illustrations.

[1] **Jun Tsuzuki** Illustrator (1962–)
Tsuzuki has been active as an illustrator since the 1980s and also holds discussions about illustration, abstract art, and graphic design. In recent years he has blurred the borders between those genres and continues to promote thought about paintings. He is an associate professor at Kyoto University of the Arts.

My Reason for Using Bold Color in Illustration

In my case, women are the main subject of the paintings I do for work assignments. I compose pieces with the intention that when women look at them, they will think they are attractive or stylish and generally appealing. They're not necessarily interested in the painting—it's the figure depicted that is attractive in their point of view.

I realized when I started doing work assignments that illustrations have to be understandable to people who have absolutely no interest in art. Fine art paintings are pieces that you intentionally go to museums and art galleries to see. Whereas illustrations are experienced more casually and people can be intrigued by them, even if they're not interested in art, because they appear in posters and on book covers, etc. In short, the images need to attract the viewer. So the pictures need to be entertaining and easy to understand.

That said, it's not good to attract them too much! It has to be entertaining without being lurid. It's a bit challenging to strike a good balance between fulfilling the requirements of the work assignment and making it your own painting. Be it a book cover or poster—it has to exhibit individuality. I intentionally use vivid colors. I've always liked using bright colors, and recently I've been trending even more in this direction, but it may be that subdued tones would make for a calmer, more conservative "Japanese painting." Even so, I mainly use saturated colors to make them stronger and to add bold contrast. Fine artists may not think that way, but having been an illustrator for many years, it's natural for me to employ vivid colors in order to make them stand out.

Make It Feel New

One more point is that illustration has to have a freshness to it. That said, there is nothing entirely original in the world anymore. So in this case I'm referring to something that looks new. In a sense, I'm deceiving the viewer—even though something isn't technically new, it *looks* new. It's Japanese painting, but I'm always thinking about how to make it look new.

The key to making my work look new is to depict something in a way that's rarely seen, in other words, taking the road less traveled. What's trending right now is actually already "old," so my work needs to be something that's not yet that popular or something that goes against the trend. That approach has the power to produce work that looks new.

Each era has its own novel things, so this is easier said than done, and I don't want to sound like a know-it-all, but some things that have gone out of style come back into fashion and become new again. Now that I think about it, in the 1980s, when the Nippon Graphic Exhibition was at its peak and I moved in the direction of Japanese-style painting, it may have been because of its novelty. At the time I wasn't really aware of it, but I did want my work to be fresh.

A young illustrator using Japanese painting methods to draw contemporary-style girls filled an interesting niche. I've continued doing that for a long time and most of the women I have painted up to now have been modern. I also draw motifs that don't usually appear in Japanese painting, for example palm trees or a psychedelic[1] style.

Psychedelic style was popular in the 1960s, but I thought it might make for a fresh approach if I did it in the Japanese painting style. I stand by what I said before about the use of vivid colors. Traditional Japanese paintings don't use colors as vivid as these, so that makes it look new. It may not look like Japanese painting anymore, but I am not overly concerned about keeping with tradition.

One artist I like, Alex Katz, despite being a Western painter, creates two-dimensional work with predominant calm, neutral colors, much like Japanese painting. That strikes a chord with Japanese people too, and I think it was probably seen as fresh overseas. I use Japanese painting methods, but with strong, vivid colors—the Yin to Katz's Yang.

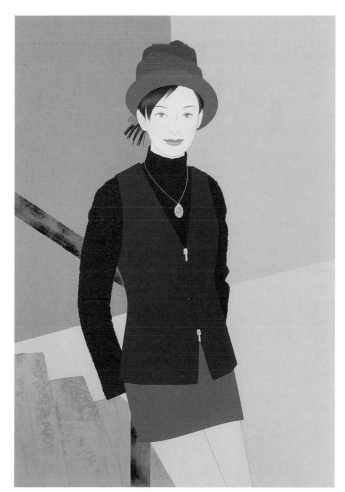

Aki—Poster (Year unknown)

[1] **Psychedelic**
A cultural movement, including music and design, that celebrates the experience of altered mental states such as hallucinations and trances brought on through the use of hallucinogens. It is often visually expressed with richly colored geometric patterns and abstract forms.

Being Released from the Curse of Individuality

This can be a difficult conversation depending on the person, but let's discuss the word "individuality." It's said that if an illustrator doesn't have a lot of individuality, they can't survive, but is that really the case?

I think that individuality is exhibited when an artist depicts something and the piece is recognized as being unmistakably their work. But Settai Komura, for example, said that there was no individuality in the figures he portrayed. Andrew Wyeth said that when he painted he wanted to work himself out of existence. In short, they're saying there is no need for individuality. But even if they say they don't have individual style, anyone who looks at a Settai Komura painting can tell it's his, and when they look at Wyeth's work they know it as Wyeth's. That is without a doubt individuality, but the artists were not consciously attempting to exhibit their individuality. I'd say that's my way of thinking too. I don't intentionally exhibit my individuality. Instead, I think it's better to conceal it.

Individuality is different from an artist's working style, but in some ways the two are inseparable.

When Mizumaru Anzai[1] created line drawings with fountain pens, he said that once he had become used to the nib of the pen and it was easier to use, he would change it. The easier it got to use, the more his own style would emerge. He said he didn't want this to happen, so he preferred unfamiliar pen nibs that weren't so easy to use. Even though his illustrations exhibit his individuality, he was consciously attempting to suppress it.

The lines drawn by Ben Shahn[2] were extremely individual and I feel he wanted that individuality to come out. That in itself is interesting, but my feeling is that it's better to suppress individuality when creating a piece and I get the impression there are many others who think the same way. The message I have for younger artists is that there is talk about having a lot of individuality or having none, but it's fine not to force showing your individuality because you can still create wonderful work.

Ben Shahn influenced a huge number of people, including most of the first generation of Japanese illustrators in the 1960s. One such illustrator, Makoto Wada,[3] who was strongly influenced, is said to have met Ben Shahn and when he showed him his illustrations, Shahn said his drawings "had no individuality." (Ha, ha!) By setting out to imitate someone, it ultimately results in finding one's own individuality, even if you

[1] **Mizumaru Anzai** Illustrator (1942–2014)
Anzai worked with Dentsu and Heibonsha before going freelance. He made his debut in Garo. He was engaged in illustration and design using simple line drawing and color surface expression and is particularly well known for his work with Haruki Murakami. He died suddenly at the age of 71, but his work still remains popular. He also wrote essays and novels.

[2] **Ben Shahn** Artist (1898–1969)
Shahn was born in Lithuania and active in the United States. Many of his works dealt with social themes.
Along with paintings, he was also engaged in creating posters and illustrations. His drawings, which used unique lines, were especially influential to many illustrators.

[3] **Makoto Wada** Illustrator and graphic designer (1936–2019)
Wada worked in a wide range of fields including magazine cover design, illustration, book design and picture book illustration. He is also known for being a film director. From 1977, he was responsible for the cover of the weekly news magazine *Shūkan Bunshun*, and in 2017 he reached the milestone of completing his 2,000th cover.

did not set out to establish your individual style. Before being an illustrator became widely known as a career choice, everyone was a "designer." I also design posters and I sketch all of the original drawing to be used myself, so I think the first generation of illustrators had the spirit of true artisans.

At the time Osamu Harada[4] made his debut, he imitated the styles of the illustrators he'd seen in the United States and been influenced by, so he apparently had many sources of inspiration. A more realistic example is Seiichi Horiuchi.[5] Horiuchi looked at a lot of picture books from around the world and worked in those styles. He was obviously very skilled, so he could paint that way. He had the ability to assimilate a lot of information too, so he was very skilled at absorbing and then reconstituting various elements.

Seiichi Hayashi is one of the illustrators who influenced me and around thirty years ago I met him on several occasions. At the time, I was drawing mostly non-Japanese, classic actresses like Marilyn Monroe and Marlene Dietrich, and Hayashi said, "Fukui-kun, why are you painting only foreigners? Try painting Japanese," and I felt he made a good point. (Ha, ha!)

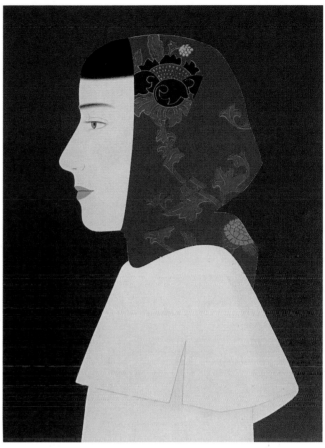

Red Scarf with Floral Pattern—Editorial (1989)

[4] **Osamu Harada** Illustrator (1946–2016)
Harada made his debut in *An An* magazine, which was first published in 1970 and became popular with his original "Osamu Goods" characters. He formed Palette Club with Mizumaru Anzai, Pater Sato and the art director Masahiro Shintani, and conducted illustration lessons. This has now become the main Palette Club School.

[5] **Seiichi Horiuchi** Art director and picture book illustrator (1932–1987)
Horiuchi was responsible for magazine art direction at Heibonsha (now Magazine House) and designed the logos for that company's magazines, including *An An*, *Popeye* and *Brutus*. His books *Kurouma Blanky* and *Groompa's Kindergarten*, which he created as a picture book illustrator, have become perennial bestsellers.

The Dawn of Illustration in Japan

When I did the feature *History of Japanese Illustration*[1] with Jun Tsuzuki in *Bijutsu Techo* magazine, we talked about where to divide the content and where to begin. In fact, there was a book called *Illustration in Japan Yearbook* published by Kodansha and we even decided to include the people who were listed in that book. Without those individuals, there'd be no basis to discuss the topic. At any rate, they all began as commercial designers.

In the 1960s, the work of Makoto Wada, Tadanori Yokoo,[2] Aquirax Uno[3] and Tadahito Nadamoto[4] began to be recognized as what was being referred to as "illustration" in the United States and it was from then on that the words "illustration" and "illustrator" began being used in Japan.

We decided to start from that point, so the Kodansha book became the standard. I think a number of uncomplimentary things have been said about this by critics, but oh well. (Ha, ha!)

There were book illustrators with backgrounds in Japanese painting; however, I wasn't particularly drawn to them. Shinsui Itō drew illustrations for *Fujin Gahō* magazine too and while I like looking at *sashi-e* illustrations, I didn't get a sense of these being *sashi-e*. I use color when I paint and so I prefer the illustrations where Shinsui Itō also used color—I will always be attracted by that. Regarding *sashi-e* illustrations, I also like Sōhachi Kimura[5] and would love to be able to draw those same unmistakable lines, but I can't.

It's skillfully done, but I can't draw in that rough way. Mizumaru's work has a similar element. He depicted some tofu on a plate and apparently it won first place in a contest. But at the time photorealism was at its peak and the piece that came in second was very realistically drawn and he ended up feeling self-conscious about his entry. But maybe from the perspective of the judges, Mizumaru's illustration was really fresh!

[1] *History of Japanese Illustration*
This article was a special feature in the January 2010 issue of *Bijutsu Techo* magazine. Under joint supervision by Jun Tsuzuki and Shinichi Fukui, illustrators who had been active between the 1950s and the 2000s and were key to that era were interviewed and a study of illustration after World War II was included. It was published as a book in the same year.

[2] **Tadanori Yokoo** Artist (1936–)
As a designer and illustrator in the 1970s, Yokoo worked in a wide range of fields including magazine art direction, book design, illustration, and poster creation. Since the 1980s, he has mainly centered his work around art.

[3] **Aquirax Uno** Illustrator (1934–)
Uno is known for a body of work that is particularly rich with fantasy and romanticism, and his motifs of girls are particularly popular. In addition to illustration and picture books, he is engaged in fashion brand direction and curating performing arts and exhibitions.

[4] **Tadahito Nadamoto** Illustrator (1926–2016)
Nadamoto used carefree lines and highly realistic touches and was involved in many fields, including illustration and book cover design, combining Japanese and Western painting styles. He was also known for his boldly distorted and unique *bijin-ga*.

[5] **Sōhachi Kimura** Japanese painter and *sashi-e* illustrator (1893–1958)
While he exhibited many works as a Western painter, he also worked on a large number of *sashi-e* illustrations for novels, including Kafū Nagai's novel *A Strange Tale from East of the River*. He had a considerable and lasting influence on stage settings and historical research into customs in Tokyo after the Westernization movement.

Paintings That Are Open, Not Claustrophobic

Some painting are described as being "airy" or "open." On the other hand, there are paintings that are well done, but have a claustrophobic atmosphere about them. I don't know why this is—maybe it's an expression of the artist's personality. Painting smoothly using the minimum number of lines like Mizumaru could promote a look of openness, although even if something is simply rendered, it doesn't automatically mean that it will have an airy quality, just that has a better chance of not giving off an oppressive feeling. There are paintings that have lots of detail and color, but that still give a relaxed impression.

Speaking of color, it's trickier to use high-saturation colors than the subtler low-saturation ones. But it feels really great when you can use the colors well to create a well-formed image. Illustration, especially poster art, needs to give a more satisfying impression than that exuded by a cramped composition.

When colors are used well, it brings great enjoyment to the act of painting. When the palette is really working well, you'll want to remember that combination of colors. I don't really want to keep repeating the same things in my personal work, but that is not how it goes with work assignments and I do get requests asking me to "please use the same colors as those in this other painting."

As with motifs, composition, textures—anything, really—it's more gratifying to regularly try something new rather than repeating the same things over and over. Even if something works well, don't repeat it too often. If you keep drawing the same patterns and motifs, you'll broaden your portfolio, but the freshness and variety of your work will suffer. I think it's the same with music in that you should always be exploring new avenues.

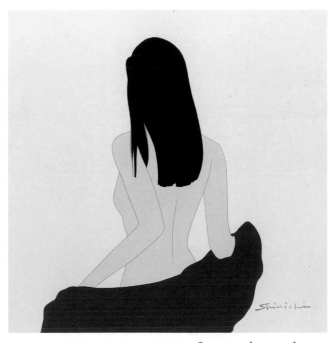

Source and year unknown

A Japanese Way of Expressing Perspective

I love Settai Komura, but the way he draws people's faces is borrowed from ukiyo-e artist Suzuki Harunobu. As I mentioned before regarding the depiction of rain, Utagawa Hiroshige and other ukiyo-e artists use lines going in various directions to express this; however, Settai only expresses it with parallel lines, so that way of using lines is unique. Viewed objectively, anyone who sees it knows it's Settai Komura's work, so the whole image, including the composition, has individuality.

The composition, trimming and cutting are unique and this may have some connection with the way that Settai was engaged in the performing arts. The performing arts take place in a three-dimensional space, but there is only shallow depth to stage, which brings with it major restrictions. When you see ukiyo-e, it does not exhibit Western perspective, where the top of the image shows things that are farther away and the bottom shows things that are in the foreground.

Additionally, there are no shadows depicted at all, so there is no illusion of depth or a three-dimensional effect. However, when you look at ukiyo-e landscapes, there are trees in the distance and further away is Mount Fuji, so even though there is no Western expression of perspective, there is a sense of perspective. It doesn't provide a systematic view of objects in space that diminish toward a vanishing point, but rather the distance between objects is expressed in terms of size, so it still exhibits a form of perspective. It's a very left-brained approach.

Line drawings are basically like that. Because, of course, there aren't actually lines defining edges in real life. In drawings, edges are expressed by lines, allowing the viewer to understand the images in a left-brained way. Western paintings use lines in preliminary sketches, but finished Japanese paintings almost always use lines for expression, and I think that must have been a curious thing to people overseas. Everything is drawn with lines, although ink paintings and the gradient backgrounds in ukiyo-e may have been expressing atmospheric perspective.[1]

There was no so-called "linear perspective"[2] in Japan. Suzuki Harunobu's paintings are completely flat and include no perspective, but later in Settai Komura's time, Western perspective was already being used, and so Settai used linear perspective. He may have been subconsciously influenced by examples of Western perspective without actively deciding to incorporate it in his work.

[1] **Atmospheric Perspective**
An expression of perspective that takes advantage of the way objects appear sharp and with saturated colors the closer they are to the viewer, and more hazy and muted when farther away. During the Renaissance, Leonardo da Vinci enthusiastically studied perspective, taking perspective drawing (linear perspective) and combining it with atmospheric perspective.

[2] **Linear Perspective**
An expression of perspective that uses the way nearby objects look larger, and more distant objects look smaller. It is also referred to simply as "perspective." If you depict receding parallel lines, they will converge to a certain point. This is called the "vanishing point" and while the one-point perspective method sets only one vanishing point, a number of vanishing points can be set depending on the composition and motifs.

When the Materials Change, the Painting Changes

My basic expressive style hasn't changed, but I have been gradually trying new things over time as new materials become available. So, while at first glance my paintings may not seem to have changed, they've actually evolved quite a bit. For instance, people's faces are slightly different in recent paintings to those drawn before. The face depicted is not the model's face as I see it, but one slightly adapted to suit the demands of the project, and this way of creating the face is different from what it was before.

The biggest change has been with color. I think the colors I am using now are bolder than before. In some cases, I have consciously started using strong colors and the change in painting materials has had a huge influence. I cover this in the section titled, "Painting Materials" (page 52), but I mainly use

Liquitex Prime and it's had a considerable impact on my work. Liquitex Prime features single pigment formulations, so it exhibits an array of rich colors. In particular, the reds are vivid and moreover, there is an extensive number of shades available.

I think that when you change the painting materials, the painting will also change to a surprising extent. When I'm seeking change, I change the materials I use and try new things, but there are also a lot of times when the materials I've been using are discontinued. When that happens, I have to use something else instead. Color ink is like that right now and I'm trying out Talens' products. The color characteristics are quite different from Dr. Ph. Martin's and Holbein inks, which I had been using up to this point.

Japanese DNA in Painting Expression

I think this goes for music as well as painting, but Japanese people tend to focus on enjoying individual elements of things as much or more than appreciating something as a whole. Western food is served in courses with an appetizer, main dish, and dessert. Classical music has four movements and the overall harmony can be enjoyed. Japanese music is based on tone, so rather than focusing on enjoying the impression of an overall piece, there are passages designed to be enjoyed individually.

So it could be that the Japanese didn't really require the use of perspective in a painting. There is near and far, with a tree in the foreground and a mountain in the background, but the whole is not viewed as a realistic space, which in that sense makes it two-dimensional.

People are also depicted with lines rather than captured three-dimensionally—the eyes are shaped

like this, the nose and mouth like that, the outline of the face looks beautiful this way, and so on. I use that method too and it's because I was born and raised Japanese that I have that DNA. My father was a Western painter and even though he called his paintings "Western paintings," he didn't create many three-dimensional ones. Those who have studied oil painting know there is a process to working with the medium, and he did as he pleased in that framework.

Sometimes students taking entrance exams to art school would come to my father's studio to do plaster cast drawings and there were a lot of those drawings around the house.

Plaster cast drawings are just something that get you into art school. Anyone who puts in a few months of practice can become good at them, so I was perplexed about what was interesting about them. Once the entrance exams are over, no-one does that

kind of boring work. My father said the same—they have to be done for the entrance exam, but it's best not to spend too much time on plaster cast drawings.

If plaster cast drawings come into vogue, painting will become boring. That's how many painters feel.

I feel that Japanese artists are better off not creating plaster cast drawings. That type of strictly three-dimensional drawing isn't suitable for them. When Japanese artists try mimicking the realistic expression of Western painting, I can't help but feel that a level of freedom is lost.

I feel that even most Western paintings don't express the freedom of works by artists such as Cezanne.[1] When you consider photorealism, you can see something akin to Japanese dexterity. Drawing with dexterity is paramount. Pursuing the development of your own drawing ability and the ability to render details skillfully should come before worrying about coming up with an interesting composition.

Back when photorealism was at the height of its popularity in the United States and other places, those paintings were physically enormous.

It seemed to me that they were large in order to facilitate packing in so much detail. However, Japanese artists pride themselves in being able to work in minute detail on a small scale. Haruo Takino,[2] for example, is able to do detailed work on a small canvas.

In Japan and elsewhere, airbrushes are used to make photorealistic art and I didn't like the way that they can be bad for your respiratory health. That factor reinforced my lack of interest in painting with an airbrush. Spraying paint from a nozzle doesn't provide the tactile experience that I crave in my work. If I'm not holding a brush in my hand to paint, I don't feel like I'm making art.

Masking is essential for airbrush expression and all of the bits of frisket film need to be carefully prepared.

I do masking on my own painting too, but it's not really enjoyable work. Illustrators have deadlines, so to a certain extent, they have to be able to work quickly. For that, masking is a useful and effective means to paint quickly and move onto the next step in the process. Masking allows one to apply paint without having to fuss with defining edges freehand. Artistic effects can be added with masks as well.

Some of the works in this book are ones I've previously created, but nearly all are from after the year 2000. When I look at my paintings from before that time, I feel they're not very good. In some ways, I've changed my style of rendering people and objects, but I've not included older works because I'm not satisfied with the sophistication of the techniques on display.

One thing that needs to be said is that for work assignments, I edit as I work. Looking at the original sketch, the arms are a little long or the obi belt is too wide, but I draw those pictures on the premise that I'll be adjusting them, so I'm actually tailoring the image as I paint.

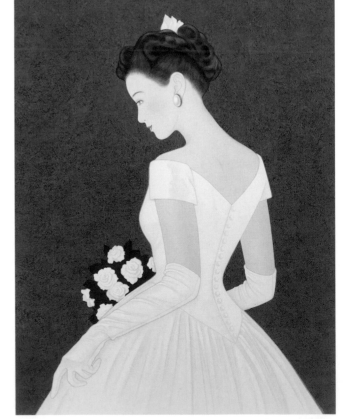

Wedding—Poster (Year unknown)

[1] **Paul Cezanne** Artist (1839–1906)
Cezanne was an Impressionist who went on to pursue his own painting style. Although he was repeatedly rejected by the Paris Salon, he received a great deal of support from young painters of his generation. He greatly influenced twentieth century painting, including cubism, and is known as the father of modern art.

[2] **Haruo Takino** Illustrator (1944–)
Takino was a leader in the photorealism and illustration boom that occurred during the 1970s and '80s. He won an award from the Japan Advertising Artists Club. His representative work includes the poster for the movie *Apocalypse Now*.

CHAPTER 2

A Look at Seven Japanese Illustrators

There are a variety of illustration expressions that convey *wa*, or Japanese tastes. These include not just easily identifiable Japanese painting flourishes, but also those that exhibit unusual use of color and expressions of space. The works of seven illustrators, chosen by Shinichi Fukui, are introduced here to show this wide range of Japanese painting expression and style.

Kazuo Kawakami
Chiaki Takasugi
Miho Tanaka
Ryohei Nishiyama
Jose Franky
Ryouhei Murata
Keiji Yano

川上和生

KAZUO KAWAKAMI

As you view these paintings, you can almost smell the country air. Kawakami hails from relatively wild Hokkaidō, so that may be one reason for this. Evocative paintings are challenging to create, and these exude a sense of peace. The perspective is reminiscent of Settai Komura's work.

Kawakami's style has evolved and recently he's begun using lines. Even so, his paintings look reasonably three-dimensional and the surface has texture, which differs from Japanese-style painting. It is maybe a more modern Japanese expression. There is a nostalgic feeling expressed as well, but rather than being stale, it feels fresh.

Illustrations for *Tsubasa yo tsubasa* (a novel by Jirō Asada serialized in JAL inflight magazine *Skyward* [all four works])

高杉千明
CHIAKI TAKASUGI

Illustration for *Waraga Shōjo A*
(a novel by Kaoru Takamura
serialized in *Mainichi Shimbun*)

Original (above and the two works to the left)

Takasugi's figures are attractive. She's observed and drawn them well. Skillful composition is evident in the expression of the neckline, the eyes slightly visible and the angled views. I think she expertly portrays difficult angles and she creates realistic forms.

The skin tone is flat. Only the cheeks have slight tonal gradation—a style similar to my own—but the expression of the hair is flat too, which unifies the image. The way I depict hair is the same as Shinsui Itō's method where the face is essentially flat, but the hair appears semi-three-dimensional, giving it an interesting effect. But Takasugi renders everything flatly and even the texture of the hair is depicted with lines to give the piece a unified feeling. The colors are beautiful too.

Original

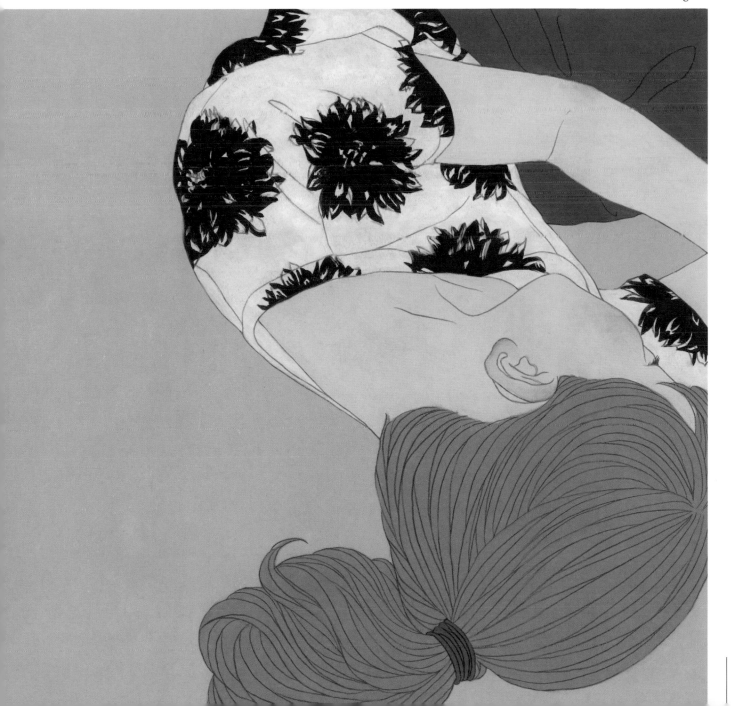

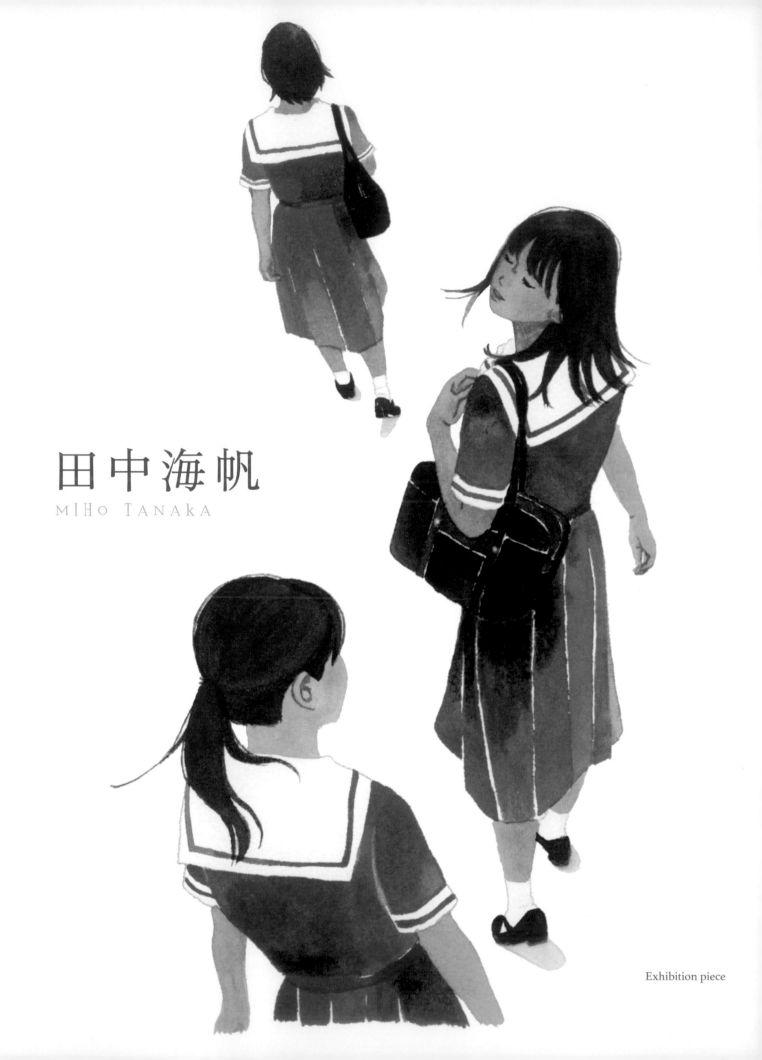

田中海帆
MIHO TANAKA

Exhibition piece

Tanaka was one of my students. Just by looking at the pieces on this page, it's evident that she can drawn men well. She's always had the reputation of being someone who mainly draws high school girls, but her range of expression has developed and she's become good at drawing men too. This hasn't been a sudden change, but rather she has been slowly and steadily widening her repertoire and improving her ability, and I think that's her strength.

She can draw landscapes and scenes too, but I'm most impressed with her depiction of people.

She draws modern young people and their look is contemporary. That's also appealing.

Book cover design for *Hito* (a novel by Fuminori Onodera published by Shodensha)

Book Design: *Kazue Tanaka (Fieldwork)*

Way Back—Original

February Sound—Original

Overhead Bridge—Original

西山竜平
R Y O H E I N I S H I Y A M A

This artist's work is almost too good to be believed! It's amazing how clear the air looks in these scenes. The expression of the sunset and the contrast between the light and dark areas in the image above are excellent. The color surfaces are not exactly flat and while I felt this picture expresses Japanese style, I'm not quite sure which part. It is however undoubtedly a modern Japanese scene and I think it's this gratifying atmosphere that appeals to me.

ホセ・フランキー

JoSE FRanky

着たくなってしまう
ユニフォーム

Meeting—Illustration for *Design no Hikidashi 14* (Graphic-sha)

Book cover design for *Chō Kōsoku! Sankinkōtai Returns* (*Samurai Hustle Returns*—a novel by Akihiro Dobashi published by Kodansha)

Book cover design for *Kiyosu Kaigi* (*The Kiyosu Conference*— a novel by Kōki Mitani published by Gentosha)

Jose Franky is incredibly interesting and very skilled. His girls are cute and he draws men like that too. It's actually difficult to draw men and women the same way. His animals are good too, as are his backgrounds—I think he's the kind of artist that can paint anything!

Although technically adept, he doesn't flaunt his skills; he has a sense of humor, the ability to set scenes and poses, and I like that the subject matter is really interesting.

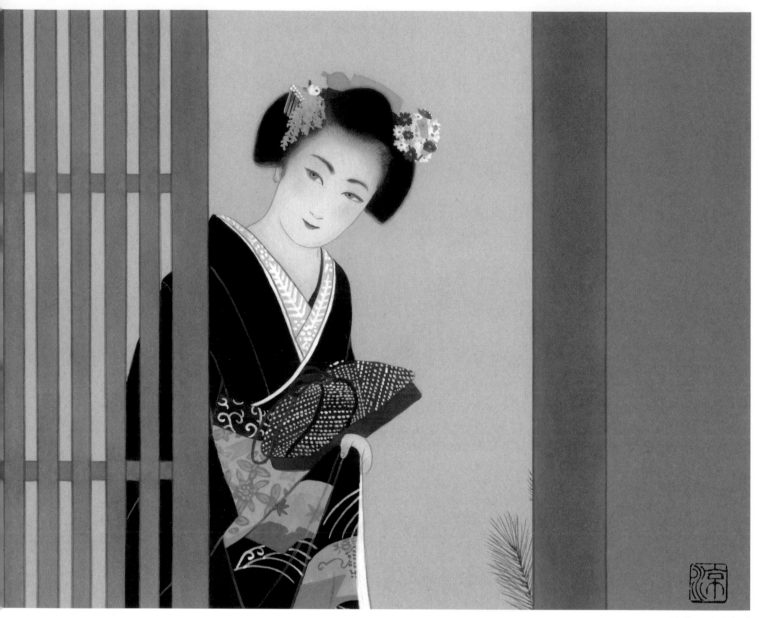

Maiko—Original

村田涼平

RYOUHEI MURATA

Daughter—Original

Book cover design for *Kanpon Mitsumei Makino Nijū Senkoku Setchū Gyō* (a novel by Yasuhide Saeki published by Shodensha)

Ryouhei Murata is absolutely brilliant. This artist creates historical pieces and paints striking figures—the men are cool and the women are cute. His bird-and-flower paintings are good too. He can portray birds really well.

Despite the orthodox-looking style, his works have a modern feel and not passé at all. It's just the right feeling. I hope he continues like this, constantly raising the bar for quality in Japanese illustration.

Illustration for *Rakka* (a novel by Tōko Sawada serialized in *Yomiuri Shimbun*)

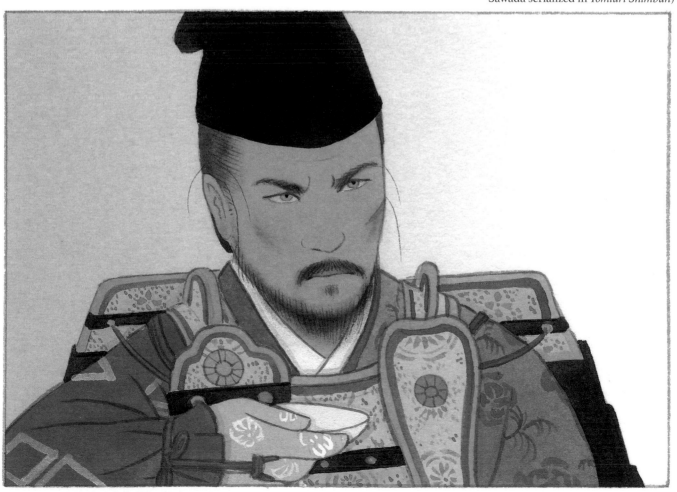

Prayer for Victory—Original

Well-being of One's Family—Original

Makeup—Original

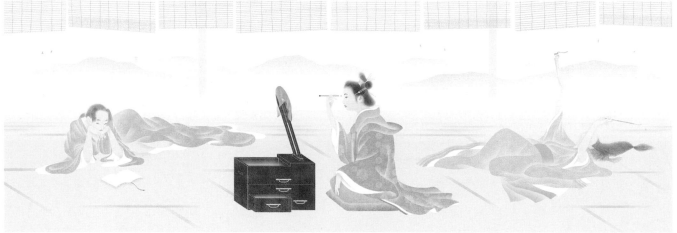

Banquet—Original

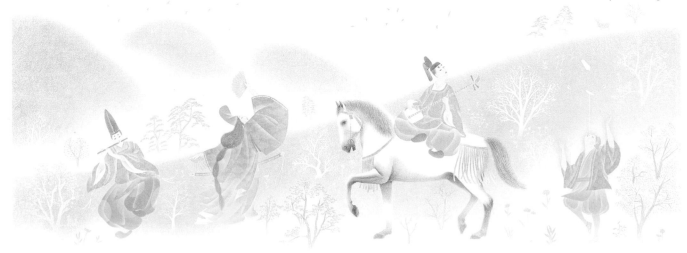

矢野恵司
KEIJI YANO

These are all great pieces, but I found the illustration of the whale really interesting. I like the way it is distorted. There's a weight to the way the shape is formed and it's excellent. The expression of gradation is unique too.

The colors are also beautiful and he uses bold colors as well as light tones skillfully. Uncommon in Japanese painting, some of his works use a single tone, such as a shade of red, and that's interesting too.

Landscape Illustration—Smi:re Stay Oshiage Hotel / Entrance mural

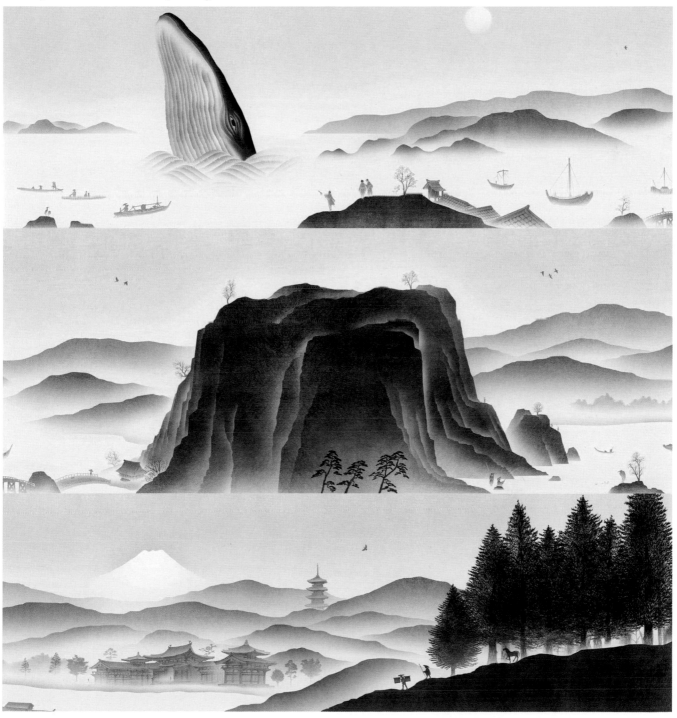

Profiles

Kazuo Kawakami

Born in Hokkaido in 1959. Graduated from Sapporo Designer Gakuin. He went freelance in 1986 after working at a design company. He holds many individual and group exhibitions. His main work assignments are for magazines, corporate PR magazines and book designs, and he is a member of the Tokyo Illustrators Society (TIS).
kazuokawakami.com

1. *Which materials do you use?*
 I paint with acrylic gouache on Watson paper.

2. *What are your favorite themes and motifs to paint?*
 People, scenery, objects, anything. Nostalgic things.

3. *What are you aware of that expresses a Japanese aesthetic in your work?*
 Color. Soft colors like those of mineral pigments.

4. *What inspiration and techniques do you draw from Japanese painting, ukiyo-e and traditional Japanese paintings?*
 There are probably some.

5. *Who are some of the painters, artists and illustrators that influence you?*
 Saul Leiter (photographer). I only learned about him recently, but I thought his bold cropping was similar to my own style.
 Seiichi Motohashi (photographer) His works *Alexei and the Spring* and *Nadya's Village* are about village life in the exclusion zone after the Chernobyl disaster, but I used photo compositions from each as references for my own exhibitions.
 Settai Komura (including his scene compositions).

Chiaki Takasugi

She mainly creates book cover designs and illustrations. She creates paintings that give the impression of day-to-day life and snapshots of single moments sometime, somewhere. She was runner-up for the Takahashi Kintaro Award in the Pater's Gallery Competition, she won the Nisshinbo Paper Products Award in the 3rd Tokyo Book Jacket Illustration Competition, was selected for the 4th Tokyo Book Jacket Illustration Competition Award, and was the Grand Prize winner in the 35th The Choice Annual Award.
giggle.hacca.jp

1. *Which materials do you use?*
 Acrylic paint, watercolor pencils, white Watson paper.

2. *What are your favorite themes and motifs to paint?*
 People.

3. *What are you aware of that expresses a Japanese aesthetic in your work?*
 It's not something I'm particularly conscious of, but maybe my expression of drawing lines without shadows?

4. *What inspiration and techniques do you draw from Japanese painting, ukiyo-e and traditional Japanese paintings?*
 I store images of works that I feel are beautiful on my mobile phone and I'm always thinking about whether I can reflect that in my own expression or not.

5. *Who are some of the painters, artists and illustrators that influence you?*
 Andrew Wyeth, Egon Schiele, Uemura Shōen and Yuki Ogura.

Miho Tanaka

Born in Hyogo Prefecture. Graduated from F-SCHOOL OF ILLUSTRATION. She was runner-up for the 2013 Shirane Yutanpo Award in the Pater's Gallery Competition and won the 2014 The Choice annual award.
She is mainly engaged in work assignments for book cover design and literary magazine illustrations.
mihota.com

1. *Which materials do you use?*
 Transparent watercolors and colored pencils.

2. *What are your favorite themes and motifs to paint?*
 People. In particular, I draw high school students a lot.

3. *What are you aware of that expresses a Japanese aesthetic in your work?*
 When I depict people (and the details have not been specified by the client), I tend to draw mainly with Japanese body forms in mind.

4. *What inspiration and techniques do you draw from Japanese painting, ukiyo-e and traditional Japanese paintings?*
 I use them as references for composition and other points. In particular, I keep art books on Uemura Shōen and Shinsui Itō close by and look at them from time to time.

5. *Who are some of the painters, artists and illustrators that influence you?*
 In junior high and high school, I read a lot about the manga artists Mitsuru Adachi, Yumiko Kawahara and Fumiko Tanikawa, which I think influenced me. Others include Lisbeth Zwerger, Chihiro Iwasaki, Seiichi Hayashi and Hisashi Eguchi. I use the basic principles that my teacher Shinichi Fukui taught me in his classes, which I attended for ten years.

Ryohei Nishiyama

Born 1988 in Fukuoka Prefecture. Graduated from the Department of Design, Aichi University of the Arts. He completed a master's program at the same university. He's responsible for illustrations in books, magazines and picture books, and on packaging.
ryoheinishiyama.jimdo.com

1. *Which materials do you use?*
 Liquitex, ink, pencils, Arches watercolor paper and SaundersWaterford watercolor paper.

2. *What are your favorite themes and motifs to paint?*
 I like to draw places near where I live and scenery of places that I've experienced, for example places I've visited.

3. *What are you aware of that expresses a Japanese aesthetic in your work?*
 I don't intentionally include Japanese tastes in my work, but when I paint, rather than include something, I try to omit it in order to create an expression that emphasizes the missing element.

4. *What inspiration and techniques do you draw from Japanese painting, ukiyo-e and traditional Japanese paintings?*
 I touched on this a little in No. 3, but I've been influenced by the idea of holding something back rather than adding it to express the essence of the object I'm depicting. I also came to know that the margins are not just a frame, but that there's a beauty in imagining space, light, fog and snow, and I learned that by not drawing something, it can sometimes be seen.

5. *Who are some of the painters, artists and illustrators that influence you?*
 Hasegawa Tōhaku, Muqi, Ogata Kōrin, Maruyama Ōkyo, Heihachirō Fukuda, Yōson Ikeda, J. M. W. Turner, Claude Monet, Andrew Wyeth, Yoshitaro Isaka, Goro Sasaki, Shinta Chō, Mitsumasa Anno and Yōzō Hamaguchi.

Jose Franky

Born in Hokkaido in 1971. Graduated from the oil painting department at Musashino Art University. He primarily produces work for magazines, books, advertising and online content, with styles from the classics to the contemporary. He creates illustrations and paintings. He won the 23rd The Choice Annual Award and Award of Excellence.
josefranky.com

1. *Which materials do you use?*
 Mainly watercolors on BB Kent paper. I use *iwa-enogu* on the rare occasion that I use silk canvases. When I create pen drawings, I use a drawing pen for the lines and then add the color scheme with Photoshop.

2. *What are your favorite themes and motifs to paint?*
 I often depict what I experience in everyday life. Mainly people. Followed by animals and plants that I use as motifs.

3. *What are you aware of that expresses a Japanese aesthetic in your work?*
 Using flat color surface compositions and drawing light, clear lines. The spaces between people.

4. *What inspiration and techniques do you draw from Japanese painting, ukiyo-e and traditional Japanese paintings?*
 None.

5. *Who are some of the painters, artists and illustrators that influence you?*
 Uemura Shōen, Hishida Shunsō and Tsuchida Bakusen.

Ryouhei Murata

Born in 1977. Studied under Kazuo Hozumi. He has worked as a freelancer since 2006. He won the Illustration Prize in the 47th Kodansha Publishing Culture Awards in 2016 and is a member of the Tokyo Illustrators Society.
behance.net/ryouheimurata

1. *Which materials do you use?*
 Mainly acrylic gouache and ink on watercolor paper, supplemented by soft pastels and *gansai* (traditional Japanese watercolors).

2. *What are your favorite themes and motifs to paint?*
 I rarely paint for myself, so I'll paint anything a client asks me to produce.

3. *What are you aware of that expresses a Japanese aesthetic in your work?*
 I try to be aware of the basics rather than Japanese taste, so I focus on the balance between drawing and painting, as well as keeping the saturation low.

4. *What inspiration and techniques do you draw from Japanese painting, ukiyo-e and traditional Japanese paintings?*
 There are a lot of points I reference, such as composition and abstraction.

5. *Who are some of the painters, artists and illustrators that influence you?*
 Tsuruzo Ishii and Settai Komura.

Keiji Yano

Born in Kochi Prefecture in 1988. Graduated from the Sculpture Department at Tokyo University of the Arts. He completed the Art Anatomy Studio graduate course at the same university. After working as a designer for Nintendo, he started working as an illustrator from 2017. His major awards have been the 2018 HB File Competition Hiroaki Nagai Award and the TIS Open Call Award.
yano-keiji.com

1. *Which materials do you use?*
 Pencils, copy paper and Photoshop.

2. *What are your favorite themes and motifs to paint?*
 People. I depict them with the goal of making them anonymous with ambiguous race, gender and nature.

3. *What are you aware of that expresses a Japanese aesthetic in your work?*
 Apart from work assignments to emulate art from certain eras, I'm not particularly aware of Japanese tastes, but as a result of referring to techniques, I find a lot of the time that my pieces are spontaneously coming close to having a Japanese feel.

4. *What inspiration and techniques do you draw from Japanese painting, ukiyo-e and traditional Japanese paintings?*
 A lot. An outstanding versatile expression of gradation that conveys perspective, humidity and quality of the air. Unique bold and free scene compositions that differ from perspective and other methods used in classical Western painting. The beauty of gentle organic curves shown in figures and kimono. The impact of free expression that has been released from the demands of realism—a very effective technique in the world of product advertising and packaging. It's clear how Van Gogh imitated the colors of ukiyo-e and how Toulouse-Lautrec used scene composition as a reference.

5. *Who are some of the painters, artists and illustrators that influence you?*
 Picasso, Rousseau, Cezanne (creator of cubism), Uemura Shōen, Settai Komura, Hokusai, Nagasawa Rosetsu, Yokoyama Taikan.

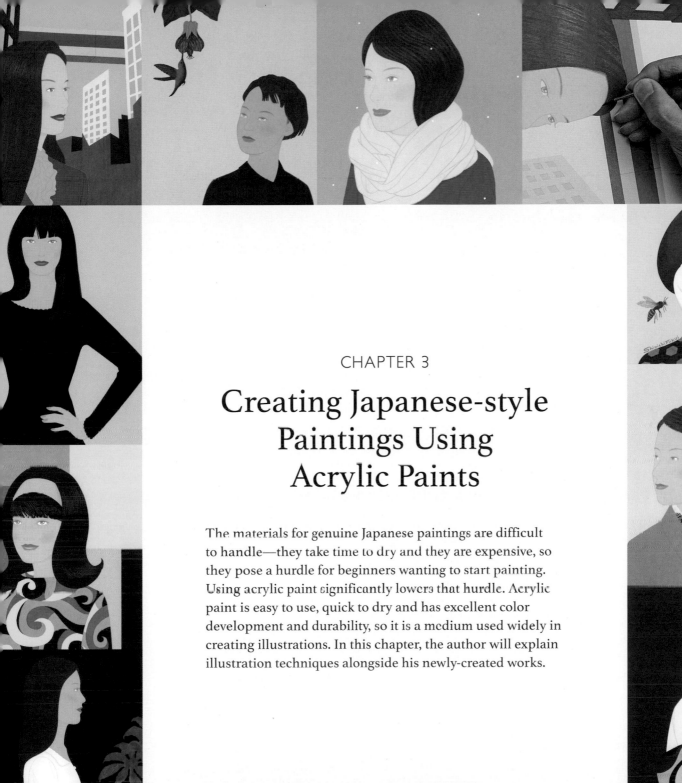

CHAPTER 3

Creating Japanese-style Paintings Using Acrylic Paints

The materials for genuine Japanese paintings are difficult to handle—they take time to dry and they are expensive, so they pose a hurdle for beginners wanting to start painting. Using acrylic paint significantly lowers that hurdle. Acrylic paint is easy to use, quick to dry and has excellent color development and durability, so it is a medium used widely in creating illustrations. In this chapter, the author will explain illustration techniques alongside his newly-created works.

Photography: Toshihiko Sakagami

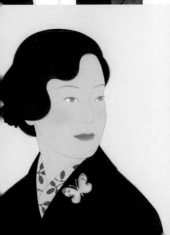

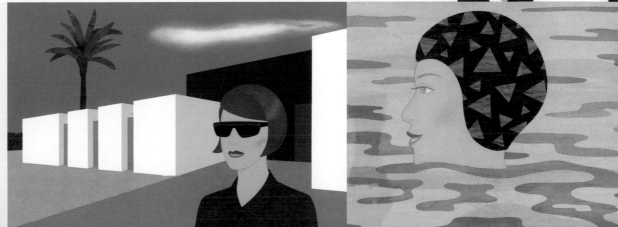

Painting Materials

Acrylic Paint

The main material I use is acrylic paint. It uses acrylic resin as a medium[1] and, like watercolor paint, is thinned with water for use. Its greatest feature though is that it dries quickly and becomes water-resistant. There are many colors available and it has a superior vibrancy, so it is used widely in illustration.

For a long time, I have been using Liquitex, products of a major brand said to be synonymous with acrylic paint, and in recent years I particularly favor the Liquitex Prime series. Prime paints feature single pigment[2] colors, so they have excellent color development and I also like that even after the paint has dried, the color doesn't fade or darken, so I recommend it to the students I teach as well.

One characteristic of acrylic paint is th at a huge range of expression can be achieved. It can be laid on thick like oil paint or diluted to give a thin watercolor-like expression. The usual diluting ratio of paint to water is 3:2, but so that I can achieve a look similar to a Japanese painting, I dilute it to be relatively thin (1:1 to 2:3) and then carefully apply it. It's fine to dilute it with water to around that viscosity, but if it becomes too thin and runny, add a small amount of painting medium and that way it doesn't lose its ability to adhere to the surface. There is also something called glazing medium that is used to allow the paint to be spread very thin. It provides quite a special effect as it increases transparency to give an interesting look, although if you add a lot of medium, the paint will dry to a glossy finish. I don't really like the sheen, so I only use it occasionally when I want to create a watercolor-like impression.

Acrylic paint is mainly transparent (with some opaque colors too), although there is also opaque acrylic gouache. It has a higher proportion of pigment than that of regular acrylic paint and its main feature is that it has high opacity (it can cover up the underlying color). I use it when needed and I find white acrylic gouache to be particularly useful.

[1] **Medium**
These include primers, solvents and protective agents, which improve the flow of the paint. When the painting medium is used to thin the paint, its ability to adhere to the surface isn't reduced. Some mediums make the paint sticky so it's easier to load up the brush and other mediums speed up or slow down the drying process. The paint is produced by mixing pigment with a medium. Paint mediums include drying oils (oil paint), gum arabic (watercolor paint), *nikawa* glue (Japanese painting *iwa-enogu*) and acrylic resin (acrylic paint).

[2] **Single Pigment Color**
A color that is created using only one type of pigment. It is also called "pure" color. The color remains bright and even when colors are mixed, so muddiness is less likely to occur.

Acrylic Paint
Liquitex Prime
liquitex.jp/products/prime

Color Ink

Color ink is a material where a dye has been dissolved in a solvent. As it is a liquid, it can be applied as-is using a brush and because it spreads easily, it has vivid color development. It has come to be widely used in illustration, but because it is a dye, the color fades quickly, so it is not suitable for application where the longevity of the original work is a concern. It should really only be used for printed documents. It makes the expression of blurring—an important element of Japanese painting—easy, so I mix it with acrylic paint and use it to soften hairlines and make-up.

For many years, I have enjoyed using Holbein and Nouvel (Talens), although Holbein is no longer sold. I occasionally used Dr. Ph. Martin's, but recently I've been exclusively using Talens. Although color ink with pigment added to it has excellent durability, it feels heavier to paint with than just using straight ink. And while color ink itself is water-based, by adding a small amount of painting medium, it becomes water-resistant once it has dried.

When I use color ink, I mix it with acrylic paint, but when I'm using it for blurring and gradients, I will dilute it and apply it in a number of layers. In these instances, I always mix in a painting medium so the underlying layers won't dissolve and become uneven, although you need to be careful because if you mix in too much, it starts to become shiny when it dries. Measuring it correctly is a little tricky.

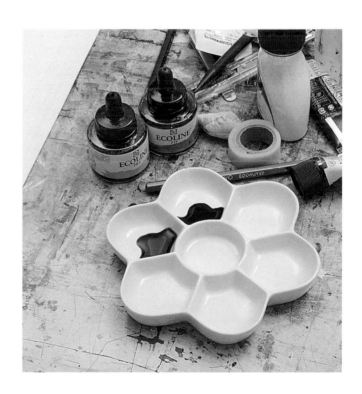

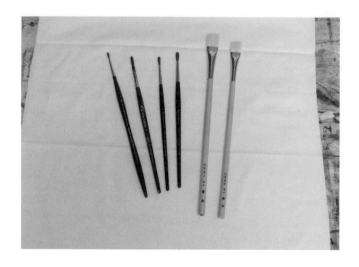

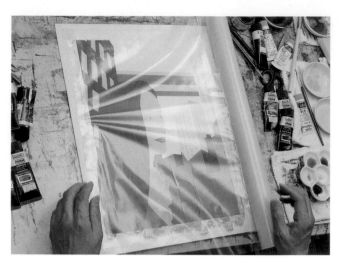

Brushes

Acrylic paint is alkaline so brushes quickly become damaged. Normally, nylon brushes would be used the most as they don't get damaged as easily by alkalinity, but I am more concerned with the ease of painting and so I use more damage-prone animal hair brushes.

The ones I love best are the Winsor and Newton Series 7 brushes, made with high-quality kolinsky sable hair. They are very easy to use as they are moderately firm with neatly aligned tips. I use sizes 0 through 5, and work most often with sizes 2 and 3, followed by size 1. I also frequently use their Sceptre Gold II brushes, which are a mix of kolinsky sable and nylon. These are more reasonably priced.

I use a flat tip brush when painting wide areas like backgrounds and clothes. I also use a flat brush for hair, but the type of brush I use doesn't really matter as I use blotting paper to absorb the paint as soon as I've applied it. I don't have any particular preference for these, but I do use Namura and Seishindo products.

If acrylic paint is allowed to dry on a brush, that brush is no longer usable. So make sure to wash them diligently. It's important to think of brushes as expendable items and replace them frequently.

Masking Film

Masking film, or "frisket," is very effective for defining flat color surfaces like those in Japanese painting. It takes time to apply paint little by little while minding the edges, so it's much faster to mask the areas you don't want to paint and then apply paint quickly to the exposed areas. The precise edges are usually flawless too.

Masking film is indispensable in my illustration work and my choice is the one made by Bumpodo. It has a strong degree of adhesion, which improves the chances that the paint won't leak through any gaps. Another feature is that the film is easy to remove and it's resistant to peeling paint off along with it. I use a pen-style craft cutter knife with a sharp blade to cut the masking film. There are two blade angles to choose from—30° and 45°—and I use a sharp blade with a 30° angle. If not, it just won't cut properly for me.

Paper

Selecting the paper is also an important factor in creating a painting. When I create large pieces, I use cotton paper-based illustration board known as Crescent Board. It comes in a range of types, including grades of surface texture, and I use the smooth types No. 215 and No. 205. Its attractive feature is that it has a smooth surface that doesn't pill easily. I mainly use No. 215 and this is slightly thinner board. No 205 is thicker and for that reason it is a little more expensive. When I want to create a large painting like B2 size (20.24 in × 28.66 in / 514 mm × 728 mm) and I need strength, I use No. 205, and for sizes up to B3 (14.33 in × 20.24 in / 364 mm × 514 mm) I use No. 215.

For a medium thickness, I recommend No. 310 and No. 300. The difference between the two is that the former is bright white and the latter is slightly more natural. There is also No. 99, which is a little cheaper and this is what I recommend in my illustration classes. No. 99 is good for students, but once you start to focus on colors, I think No. 310 or No. 300 is better.

Illustration boards are used for small pictures too, but occasionally I use "PM Pad" paper for rough sketches. It's strong and heavy, so I can paint on it too.

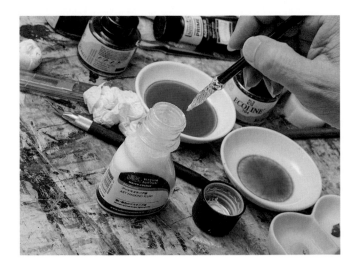
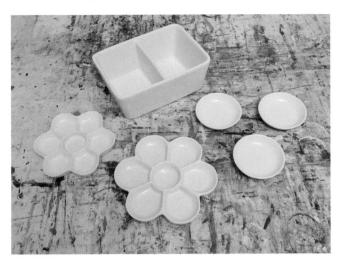

Masking Fluid

Masking fluid is used to mask small detailed sections, such as patterns. I use products from several manufacturers, but the one by Winsor and Newton creates a thin film and performs well. Holbein's products, made in Japan, are reasonable with a good balance of being easy to apply and remove, as well as having good coating ability.

Other Materials

Many people may have an image of a traditional artist's palette on which paint is diluted and mixed, but in my case, I use a kind of palette known as a "plum" or "flower-shape" palette with petal-shaped sections. I chose a slightly larger size as it's easier to use. I use a smaller palette as well for special applications.

With the palette, I can prepare a lot of different colors and they don't mingle easily. When I paint a large work, I need to make enough color for the background. If I run out halfway through, it's difficult to mix more paint and get the same tone. Transparent watercolors are forgiving as, even if they dry on the palette, they can be dissolved with water. But acrylic paint dries quickly and once it does, it's insoluble. With plastic palettes, they will become increasingly stained by the colors and the dried-on material is difficult to peel off. In the case of ceramic though, it can be soaked in water and the dried acrylic paint film easily peels off. So I think ceramic is better for acrylic paint.

In addition, I use a slightly bigger *hissen* (brush washing pot) than usual. This is a Japanese painting utensil for artists who use *iwa-enogu*, but actually Hockney uses this type too and it is very practical.

Sketching Materials

I normally use 3B to 5B pencils for sketches and rough drafts. For finer details, I use a 2B and occasionally a B. I prefer soft lead. With a hard lead, it's difficult to erase marks with a kneaded eraser, so I don't use anything harder than HB. Each pencil gives a different drawing experience, depending on the manufacturer, so it's really a matter of taste. Uni has a nice smooth glide. Those who prefer to have a certain amount of friction use Staedtler and Faber Castell. I love using Caran d'Ache, which is about halfway between Uni and Staedtler. I think I prefer those pencils because they're the best match with PM Pad paper.

So the sketch paper I recommend is PM Pad. It's highly versatile paper that is used for copy paper and memo pads. It's easy to use and because the paper is strong, it's possible to add color to the sketch with paint to finish it, although I don't usually do that. The kneaded eraser I use is by Bumpodo. I chose this one because it doesn't leave any eraser crumbs. You may think that because kneaded erasers are pressed down to erase lines they don't produce eraser crumbs, but surprisingly they do.

When I trace sketches to transfer them from the PM Pad to the actual illustration board, I roughly apply pencil to the back of the paper and for that I use 9B and 10B from Uni. Only Uni makes pencils with such soft leads. Staedtler only goes to 8B.

Model Photography, Drafting Sketches and Tracing

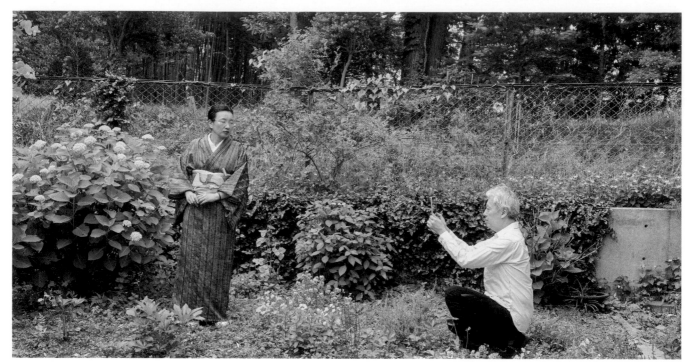

Photographing a woman in kimono in the garden. I don't often depict the backgrounds as they appear in my photos, but shooting in natural light means the colors will appear natural too. It was slightly cloudy on the day, which was just right for photography. I mostly use an iPad to take photos nowadays. It has a large LCD screen with enough resolution to allow me to immediately review of the appearance of the details.

Model Photography

In my work as an illustrator, I use a lot of photos and other materials for reference, but it's difficult to find the exact materials that you want. If you draw using a live model, you can freely decide the pose and angle and it greatly broadens the range of expression. However, there aren't many opportunities to line up a model and there is a limit to the number of sketches that can be done while the model holds a pose.

So I recommend taking photos of the model posing, and then use the photos as references while sketching. This way, the model doesn't have to hold a pose for a long period of time and you can get reference materials with a lot of variation all at one time.

I requested Japanese dress for this session. I asked the model to pose in various ways outside and indoors and took photos, changing the distance and the angle as the session progressed.

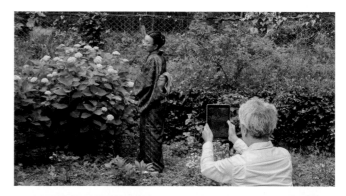

The model is a student from the illustration school. She's able to dress herself in a kimono, so I let her do the styling. Another student also helped with the photography session, including adjusting the kimono when it became loose.

Moving inside, I took close-ups. It's important to take a lot of photos of the pose from different angles. I give the model detailed instructions on how to turn and tilt her head.

Here are the photos I took. I'll create my sketch while referencing a number of these photos.

Model: Kiyoko Ando

Here, I use a chair to capture seated poses. The image below is the photo I took. The body shape is less visible in a kimono, and depending on the pose, the shape of the kimono, particularly the collar and sleeves, changes significantly, so I wanted to focus on how the silhouette changes.

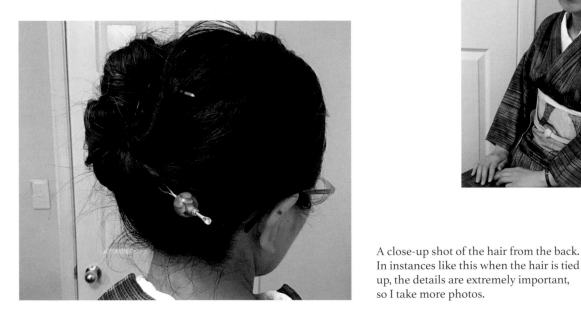

A close-up shot of the hair from the back. In instances like this when the hair is tied up, the details are extremely important, so I take more photos.

I take photos of the accessories like hair clips and pins separately. When the model is wearing them, often the detail can't be seen very well, but even though you can tolerate a little ambiguity while drawing, it does make a big difference if you know the details.

Model Sketching

I don't usually sketch the model exactly as she appears, but instead I draw to record the general impression created by the model. The details are already in the photos, so instead of worrying too much about getting an exact replica down on paper, I draw to capture the overall form and posture.

In this instance, I made a sketch at a diagonal angle from behind. This back view with the distinctive shape of the collar is something unique to kimono wearers.

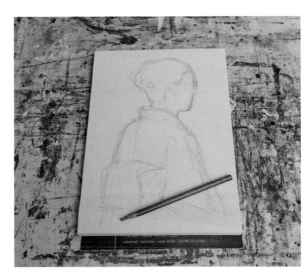

Drawing a Sketch

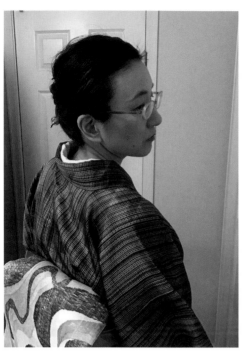

The main photo I used. I actually referred to multiple images.

I capture the overall form. You can see in the initial stage that I am emphasising the shape of the collar. I'm using a 2B pencil.

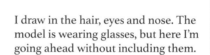

I draw in the hair, eyes and nose. The model is wearing glasses, but here I'm going ahead without including them.

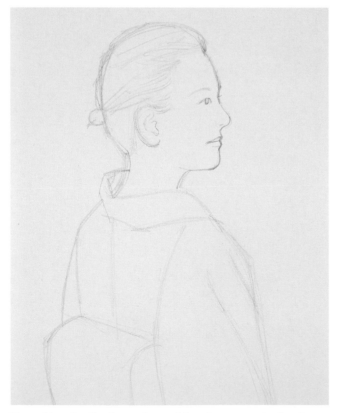

Up to this point, I've drawn the model as she appears in the photo and the face has her character. This isn't a caricature or portrait drawing, so I'm not really focusing on capturing her likeness.

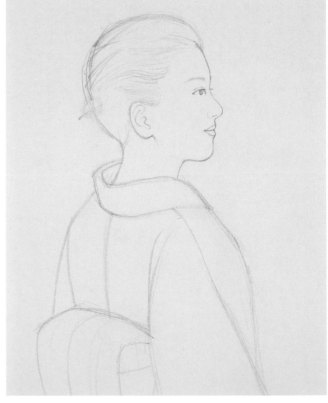

I use a kneaded eraser to rub out the original lines and adjust the form. The face is gradually beginning to look original.

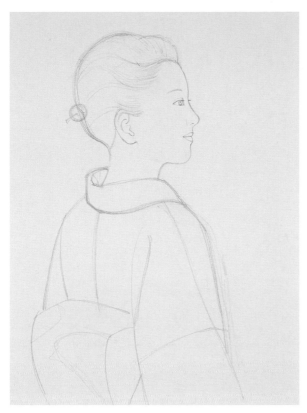

Once the face is completed, I work on adding the details. I don't limit myself to drawing things as they appear in the photo and instead compose the sketch as I feel appropriate.

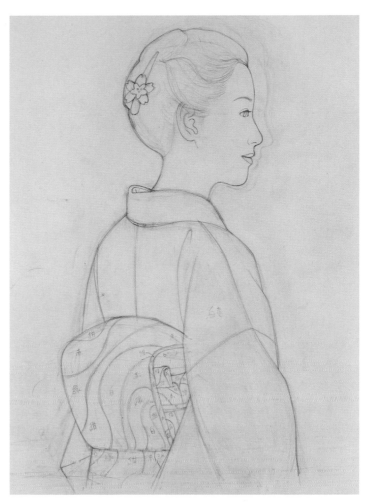

The completed sketch with a different hairstyle. This was used to create the work on page 122. I have changed the angle of the face a little and made the head slightly narrower (you can see where the original lines have been erased).

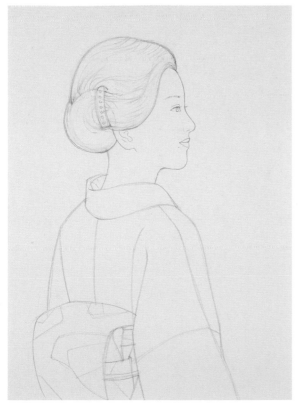

A completed sketch of the altered hairstyle, which I created referring to other materials on hairstyles. I used this sketch to create the work on page 124.

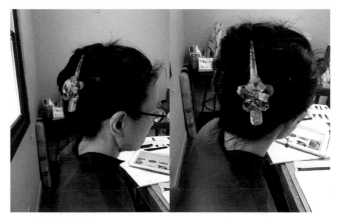

Photos that I took on a different day (the model is the same person). I decided to change the hairstyle based on these reference materials.

Tracing the Sketch

Here, I transfer the sketch from the previous page onto tracing paper. I then turn it over and rub the back side with a soft core 9B–10B pencil.

After rubbing the whole sketch. The coverage is rough and uneven.

I use a tissue to spread out the graphite powder evenly. This acts as carbon paper.

I affix masking tape to all four edges of the illustration board. This is to prevent smudging and determines the rectangle of the picture. I then place the traced sketch on top and fix it in place with more masking tape.

I don't trace it straight down on to the illustration board, however. Instead, here I use my own technique and apply masking film and trace onto that film.

I use a B–2B pencil to trace the outline. The bottom image shows the finished traced outline. I will paint each section while cutting and peeling away the film, so I've kept the lines light. (The procedure for this piece appears on page 125.)

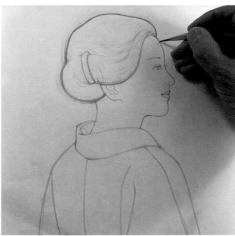

Making Picture Variations

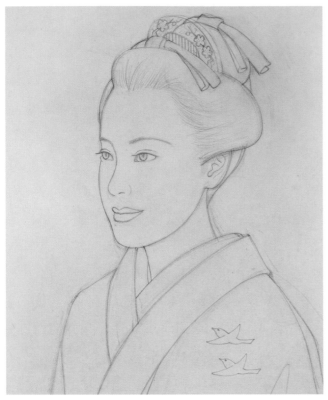

The sketch for the work on page 120. This is a woman with a Japanese hairstyle, but I've drawn her face without referencing any particular photos. I will add my own arrangements to this and develop it into a picture of a woman wearing Western clothes and with her hair worn down.

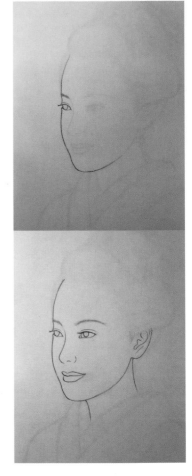

I place tracing paper over the original rough sketch and trace the parts of the woman's face. You can faintly see the Japanese hairstyle and kimono.

I traced the lines of the neck and shoulders, but the silhouette changes a lot depending on whether the clothes are Japanese or Western, so I used a bit of ingenuity and developed it into a woman wearing a scarf. As it covers the collar section, it minimizes the need to make huge changes to the silhouette. You can see at this stage I am figuring out how to develop the hairstyle.

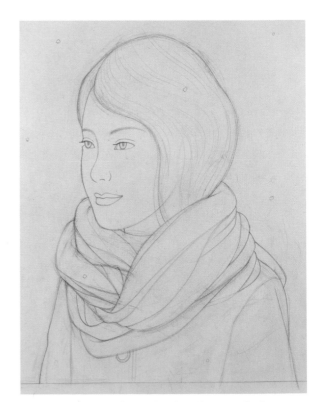

The completed sketch. I've developed two works from one sketch (the completed color work is on page 104).

More Ways to Create Variation

I began by arranging this as a sketch of one woman by herself and then expanded it sideways to include another person (and a dog).

I drew a variation of the sketch on page 44 that includes glasses. It is a much closer approximation of the actual model's appearance. Combining glasses with a kimono creates a contemporary image and I plan to develop this into a painting on another occasion.

How to Paint

In this example I will create an image of an '80s "Bubble Era" woman using Japanese-style painting expression. I want to feature a slightly grainy flat matte texture, as if *gofun* white pigment has will be used. The interesting texture created by pressing tissue to the paint and removing it, along with the expression of organic color surfaces, with edges created by masking film and then brush-softened, bring this closer to a Japanese-style painting.

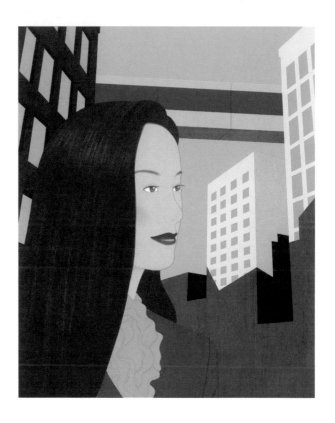

'80s "One-length" Hair

THEME

An expression of '80s hairstyle and fashion.

EXPLANATION

In the early 1980s, I went to a disco, but I got overwhelmed by the din and strange energy, and quickly departed. There were young women with uniform-length long hair dancing, but it was more a relaxed movement than energetic. It was like a strange dance unique to the Japanese and I got the impression it was to release stress on the way home from work.

Materials I Use
▶ Illustration board (Crescent No. 215)
▶ Masking film (Bunbodo)
▶ Liquitex Prime (Graphite Gray / Light Portrait Pink / Titanium White / Cerulean Blue Chromium / Cobalt Turquoise Light)
▶ Turner Acryl Gouache (Titanium White)
▶ Talens Ecoline (706 / 717)
▶ Liquitex Painting Medium, Seishindo (flat brushes)
▶ Winsor & Newton (Sceptre Gold II, No. 2–No. 5)
▶ Winsor & Newton (Series 7, No. 1)
▶ Uni (10B), kneaded eraser (Bunbodo)

1. Create a Draft

I decided on the composition by combining a background envisioned using the reference material (top left) with an original sketch of a woman to create an original work.

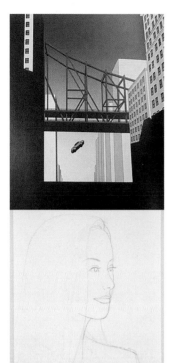

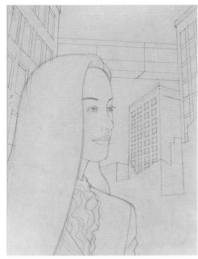

2. Paint the Buildings (1)

I transferred the draft to a board (Crescent No. 215), and then I masked around the shadows of the buildings and applied paint. For the brown building, I used a very wrinkled-up tissue to give an aged effect, and for the shadow of the blue building, I used a tissue with gentle vertical wrinkles to add to the impression of a rising structure.

Tip

Spread pencil (Uni 10B) out with a tissue on the back of the sketch to make it like carbon paper. Even the fine lines come out neatly.

3. Paint the Clothing

The suit is shocking pink and is kept flat. The scarf is yellow-green to give an impression of glamour.

4. Paint the Buildings (2)

1 Overlay the sketch again and transfer the lines of the buildings.

2 Paint the building on the right. Paint the walls and shadows separately using masking film to divide the sections.

3 Then, paint the windows too.

5. Color the Hair

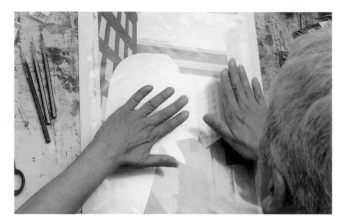

1 Cover the whole surface with masking film.

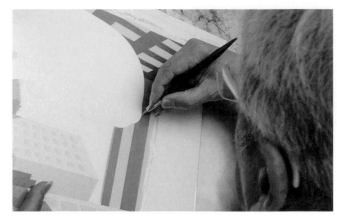

2 Cut out the masking film over the hair section. Use a pen-style craft knife (30° angle blade) to cut the curved lines while turning the board.

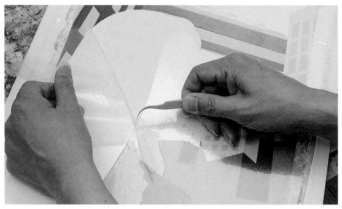

3 Peel off the masking film. Use tweezers for small parts.

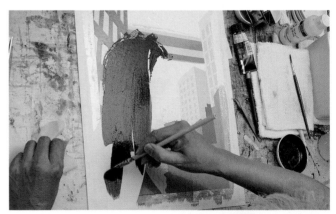

4 To keep paint from seeping in, place a tissue on top and burnish the edges of the film so they adhere firmly.

TIP

The best ratio of paint to water is 3:2, but less water means it will adhere well. If it is diluted, it's better to add a medium. I generally don't use pure black, but when I want to darken colors, I use Mars Black and Paynes Gray, checking the balance of the tones in the clothes and background as I mix.

5 Working quickly with a flat brush, apply thinned-down Graphite Gray to the hair, paying attention to the way the hair flows. The paint is mixed with a small amount of medium to increase its ability to adhere.

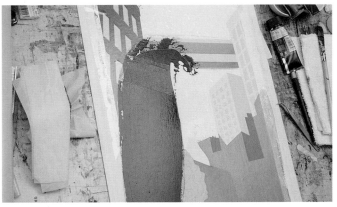

6 To add a highlight section, press a tissue, folded to an appropriate width, press to the side of the head near the top and then immediately peel it away.

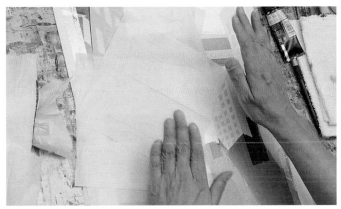
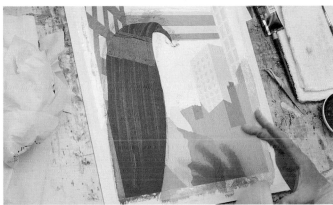

7 Press tissue down all over, and then peel it off.

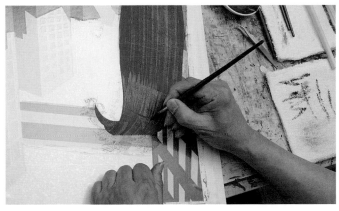
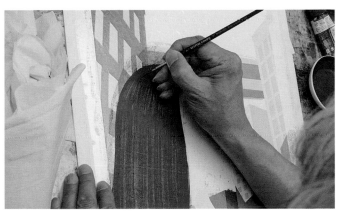

8 Use thinned Graphite Gray to paint the flow of the hair and—while gradually darkening the hair—blend in the borders of the highlight section. Don't rush this.

TIP

To create soft lines, gradually increase the pressure of the brush, and then gradually release it. Be mindful of the fading in and fading out.

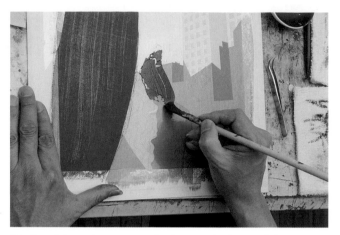

9 Roughly apply paint to the hair at the base of the neck with a flat brush.

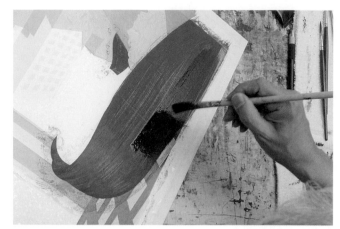

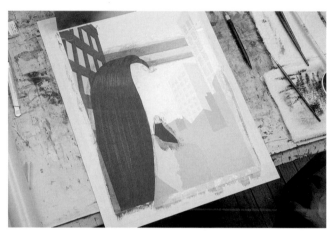

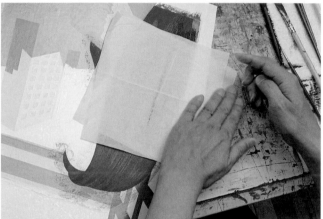

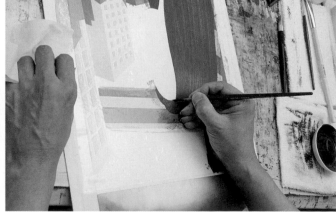

11 It has a more natural atmosphere now.

10 Layer in Graphite Gray from below the highlight section to the tips of the hair, and then press tissue down and immediately peel it away. Use texture to indicate the flow of the hair, adjusting the appearance with a fine brush. Even if you make a mistake, it's fine—keep at it until it looks the way you want it to.

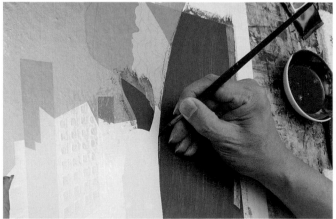

12 Use a fine brush to blur the edges of the hairline and sides of the hair to add a softened look.

6. Paint the Face

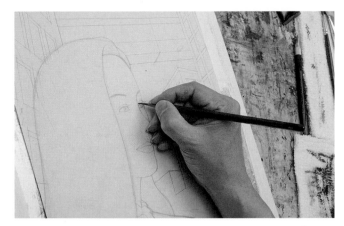

1 Put the traced sketch back down and trace the eyebrow, eye, nose and lip lines with a hard pencil. If you do this before applying color, there will be no leftover graphite dust. This is an '80s-style theme, so the eyebrows are bold.

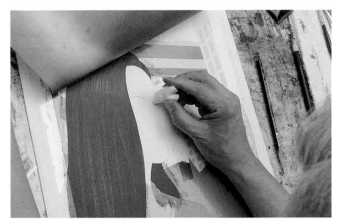

2 If the lines from the sketch transfer too strongly, use a kneaded eraser to lighten them.

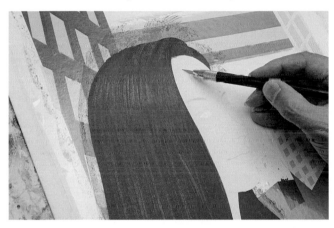

3 Use a craft knife to scrape and correct any soiled areas. Be careful not to scrape too much as the board will pill.

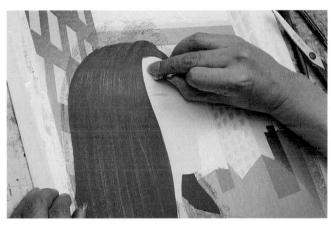

4 Starting with coarse sandpaper and progressing toward fine-grained (4000, 6000, 8000), sand the area until it feels smooth again when you touch it with your finger.

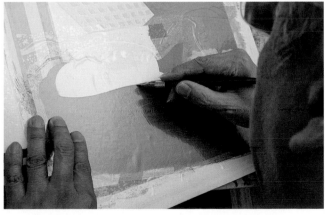

5 Apply masking film that is slightly bigger than the area being prepared and cut just inside the hair area adjacent to the edge of the skin, and then peel off the face section. The face line has already been masked, so this doesn't have to be exact. The skin is the most critical part, so don't rush it.

6 Just the eyes will remain masked.

TIP

If you apply a lighter color onto a darker color, it the darker color will show through, so be sure to always cut the masking film where the edges meet.

71

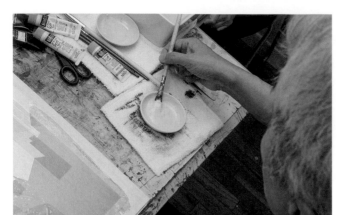

7 Add yellow, white and painting medium to Light Portrait Pink, and then thoroughly mix to blend. Apply the paint to the face area all in one go.

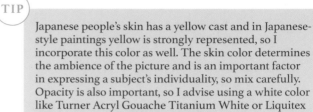

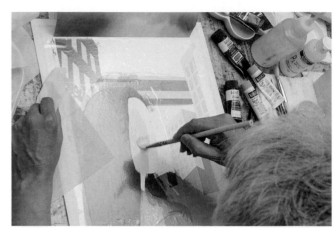

8 Use tissue to seal the edges of the film.

9 Roughly apply the skin color with a flat brush. Press down tissue and then peel it off immediately to create a matte finish.

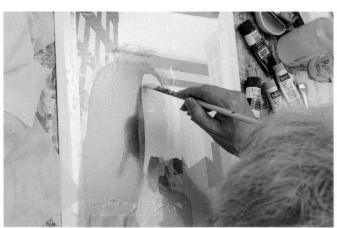

10 Repeat 2–3 times so the texture becomes finer.

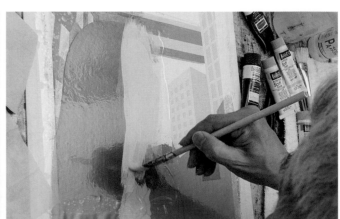

7. Paint the Eyes

TIP

It is often the case that the eyes are painted first, and then covered by masking film until the end. However, each work can have a different order for its creation process—use your judgment and work in the order that seems best to you.

1 Peel off the masking film for the eyes.

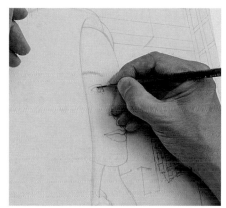

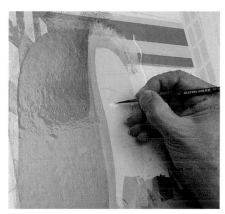

2 Trace the dark iris and pupil onto the white part of the eye.

3 Mix two gray color inks (Talens Ecoline 706 and 717) with a painting medium that decreases solubility.

4 Using a fine brush to carefully apply paint, fill in the pupils little by little.

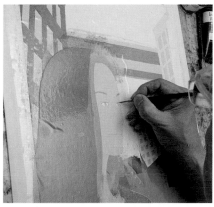
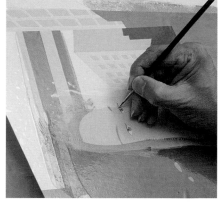

5 Use the same gray as for the hair to underpaint the irises.

6 Dark eyes can be grouped into gray or brown colors, depending on the individual, and here I went with brown color ink (Holbein 353).

7 Gradually layer in the pupil color, while preserving the white highlights.

TIP

When I am working exclusively with color ink, I use a Winsor & Newton kolinsky sable brush.

8. Paint the Facial Features

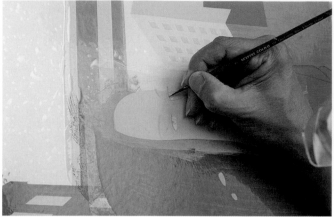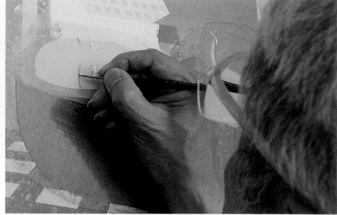

1 With a fine brush, draw in the mouth, eyes, nose and eyebrows using the traced sketch.

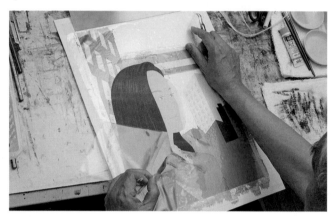

2 Peel off the masking film for the hair.

3 Peel off the rest of the masking film.

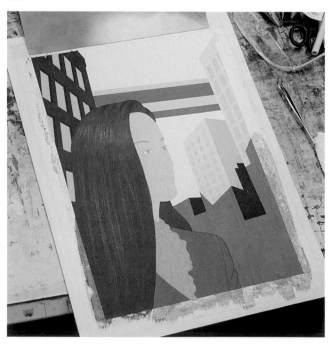

4 Almost all the parts except the background have been painted.

9. Make Corrections

Fix any damage to the color surfaces or unpainted areas and soften the hairline on the forehead.

10. Add Makeup

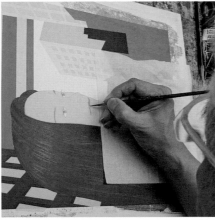

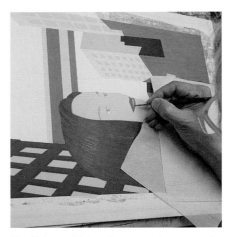

1 Paint what will be the base lipstick. Mix the face skin color with Pyrrole Red Light, Pyrrole Red, and Perylene Red and apply little by little with a fine brush while checking the appearance. Paint a light base layer.

2 Paint a thicker layer on the second pass. Add red color ink (Talens 422) and blend, while leaving highlights. A non-glossy appearance makes it look more like Japanese-style painting. The bottom lip with the highlight will be a lighter color than the top lip.

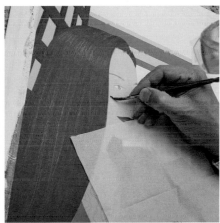

3 Apply blush. Mix rose and pink color inks (Ecoline 422 and 390) with a painting medium and apply it below the cheekbones. Make it lighter than actual makeup would be.

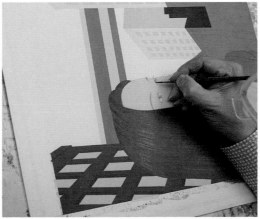

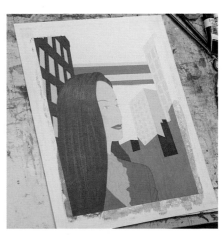

4 Apply eyeshadow. Mix blue and blue-green color inks (Ecoline 580 and 661) with a painting medium and apply lightly to the eyelids. Paint the highlights of the eyes too to show the reflection of the sky.

5 The completed makeup. The lips have a plump appearance.

11. Paint the Sky

1 Cover the piece in a new layer of masking film.

2 Cut very slightly into the edge of the building directly adjacent to the sky and remove the film to expose the sky. Use a pen-style craft knife for small areas and the curved lines of the face. A regular cutter and a ruler can be used for straight lines.

3 Create a light blue-gray color that has the look of a fine day in Japan. Mix Cerulean Blue Chromium, Cobalt Turquoise Light, and Turner Acryl Gouache Titanium White to make a matte blue.

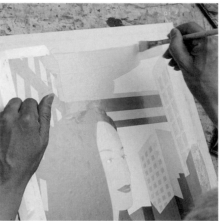

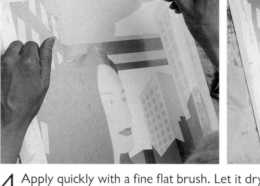

4 Apply quickly with a fine flat brush. Let it dry, without using any tissue, to give it a flat texture.

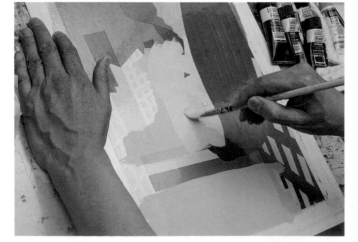

5 Add more white and apply a second time to get a matte finish.

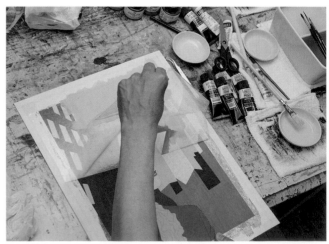

6 Peel off all of the masking film.

12. Adjust the Details

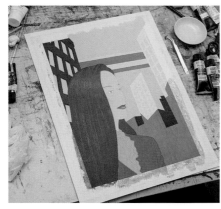

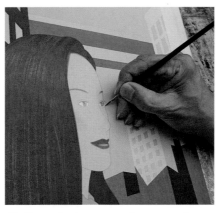

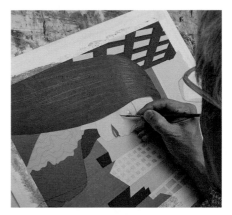

1 Once the color has been added, look at the painting from a distance and check the overall balance.

2 Reapply the covered contour lines. Your ability to keep the lines at a consistent fineness will increase with practice.

3 Add another layer of blush.

TIP

If you are not happy with the entire background, the clothes or the hair, you can make bold changes. Make corrections by scraping away the offending parts or repainting them. When you paint, you can see a lot of points that you missed in the line drawing, like distortions of form or color. Don't be afraid of making mistakes because otherwise you'll be anxious as you work and create a picture that feels cramped. Acrylic paint is easy to use and correct, and it's for that reason that I recommend it.

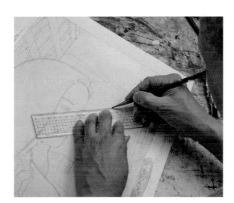

4 Transfer the traced lines of the skyway with a pencil.

5 Trace the window lines with Neutral Gray No. 7 (Liquitex) and the walls with thinned Graphite Gray.

13. The Completed Piece

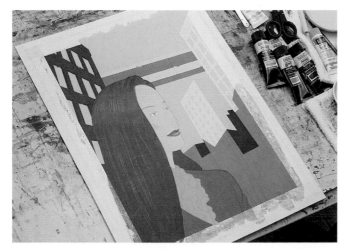

Set the work aside for a day before doing an overall review.

Author's Advice

Referring to Various Works
When you draw, make it a habit to refer to works by various artists. It will break down your stereotypes and allow you to think freely. Reproducing existing paintings is also recommended. You can see how the artist composed the work, and the parts where you try to imitate—but can't—will help you to gradually understand your own painting style.

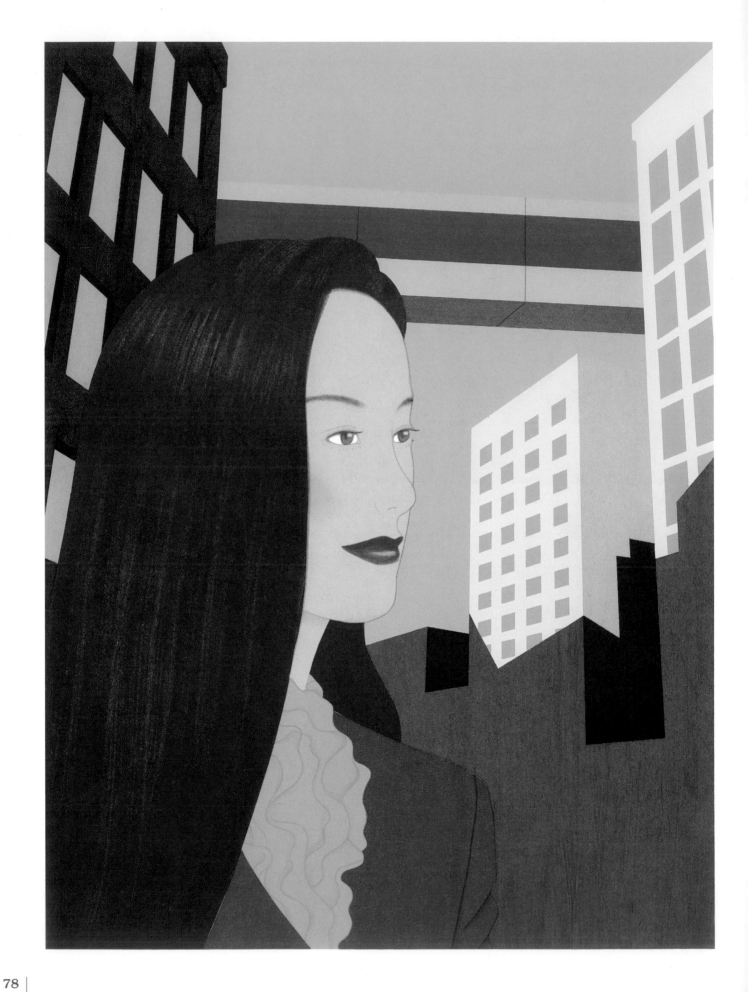

The second Japanese-style illustration is of a woman in kimono. To give it a modern feel,
I am incorporating current makeup and hairstyle trends, and my aim is to create
the matte texture of a Japanese painting by combining use of acryl gouache.
There is no real contrast between the skin color and the background in this work,
so points to note are the adding of contour lines at the final stage to make the figure stand out
and using masking fluid on detailed areas.

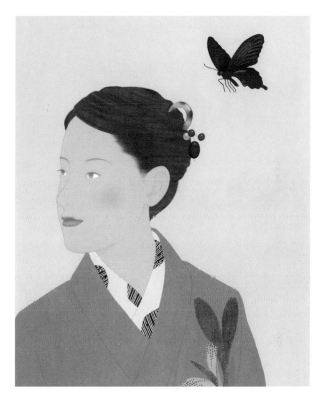

Black Swallowtail

THEME

A modern version of a rather chic kimono.

EXPLANATION

The figure's face has a slight distortion. I have
given her small eyes and a narrow nose, although
I'm not really intentionally making this into my
own form. Ukiyo-e has amazing beauty, but my
paintings are not quite at that level. Expressing
your own interpretation of reality is a difficult
challenge.

Reference photos of
the pose and hairpins.
I adjusted the makeup
and hairstyle so that they
wouldn't be too classic
even for Japanese style.

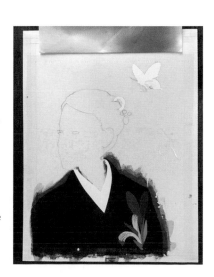

A dark green kimono
before I repainted it.
I changed it to gray
to match the mood
of the face. I also
adjusted the color
of the canna lily,
which symbolizes the
light-heartedness of
young lovers.

1. Paint the Facial Features

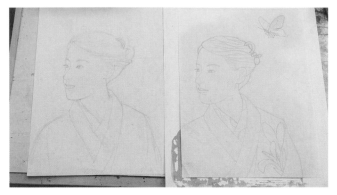

1 The traced-down sketch, created using the model photos and materials such as tortoiseshell combs for reference. On the left is the original sketch.

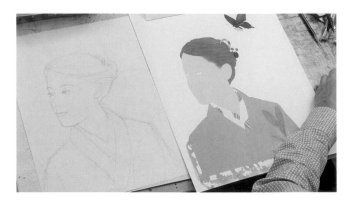

2 I have finished applying color to the face. I've used a pink color for the skin to give a modern look.

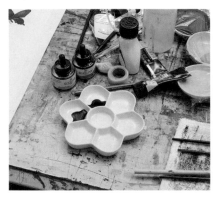

3 Mix two gray color inks (Ecoline 704 and 717) to make the color.

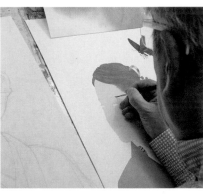

4 Paint in the eyebrows. This is a Japanese-style painting, so I'm using a light color.

5 Paint in the lines of the eyelashes, eyes, nose, mouth and ears. The shape of the ear is complicated, so make some simplifications.

TIP

The brush is a Winsor & Newton Series 7. Kolinsky sable is supple.

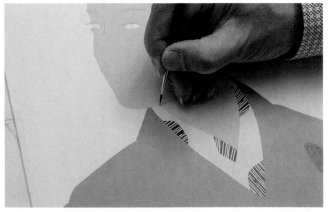

6 Paint in the lines around the neck.

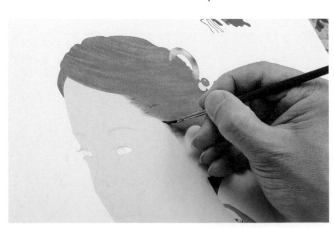

7 Soften the hairline with a fine brush (No. 2).

2. Color the Eyes and Eyelashes

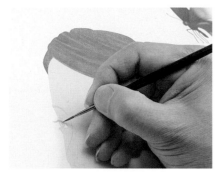

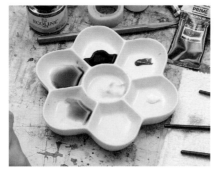

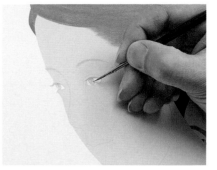

1 Paint the upper part of the iris. For a Japanese-style finish, instead of preserving highlights, paint them gray to give a matte effect.

2 Add Paynes Gray and Turner Acryl Gouache Titanium White to gray color ink.

3 Paint all of the lower part of the iris to give an even matte finish.

TIP

Make the lower part of the irises lighter to create a contrasting transparency.

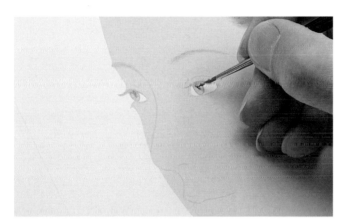

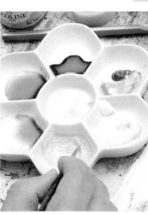

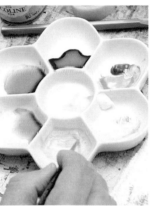

4 Use gray to darken the pupils.

5 Apply color to the eyelashes. Add Turner Acryl Gouache Titanium White and layer this light gray color to make it darker. Japanese people's eyes are not obscured by the bridge of the nose, so pay attention to the shape of the inner corner of the far eye.

3. Paint the Eyebrows

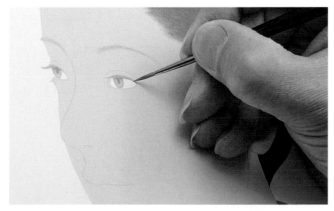

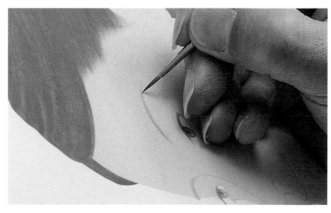

6 Carefully paint in the outer corner of the eye.

Layer the gray, while checking the balance to make sure it doesn't become too dark.

4. Add Blush

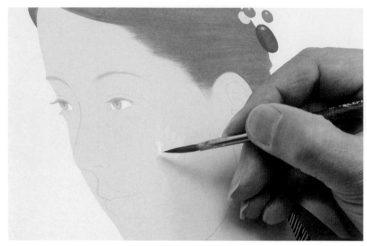

1 Dilute red color ink (Holbein Scarlet) until it is very thin and apply it.

2 Spread it out so there are no streaks. Give it a light finish so it gives the impression of a modern person in kimono.

5. Apply Lipstick

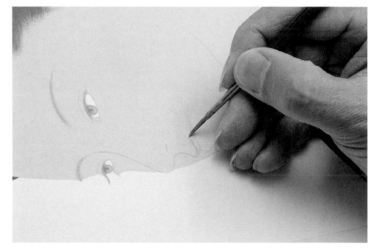

1 Make the lipstick tone by mixing 4 colors with Titanium White: Light Portrait Pink, Pyrrole Orange, Earth Pink and Permanent Rose.

2 Apply color with a fine brush (No. 2).

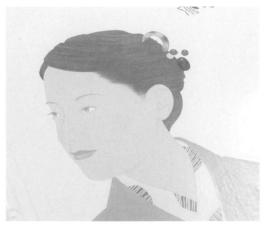

3 Make the top lip lighter for a modern look.

4 Give the lower lip a slightly darker finish, while leaving the highlights.

5 The lips now appear plump.

6. Apply Masking

1 Cover the whole picture with masking film and then use a craft knife to cut out the butterfly (but not the antenna or legs). Cut a hair's width inside the contour lines (the edges of the butterfly will be superimposed when the background is painted).

2 Cut around the figure. Trim the eyelashes carefully too.

3 Cut the connecting part between the baubles on the hair accessory too.

4 Take up an appropriate amount of well-shaken masking fluid with a glass dip pen. The fluid will harden easily, so clean the pen as soon as you've finished using it.

5 Trace the butterfly's antenna and legs, as well as the connecting part of the hair accessory, and then let them dry.

6 The surface can easily become rough when the dry fluid is peeled off, so it's better to use a conservative amount.

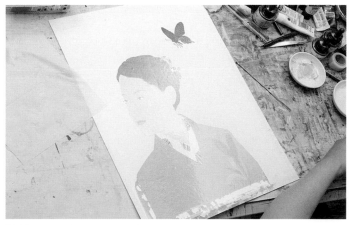

7 The masking is complete.

7. Paint the Background

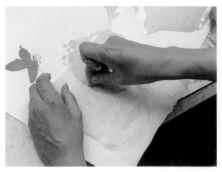 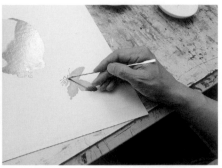

1 Cover the film with tissue and then burnish on the edges and intricate areas with your nail or a suitable tool to seal it.

2 Mix Cerulean Blue Chromium, Cobalt Turquoise Light, Turner Acryl Gouache Titanium White and Liquitex Acrylic Soft Titanium White to make a matte light blue.

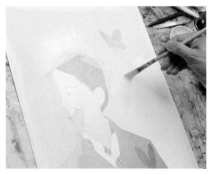

3 Apply the background all at once with a flat brush. Let it dry before proceeding to avoid the risk of prematurely peeling off the masking fluid.

4 Once dry, add a light gray acrylic paint (Liquitex No. 8, No. 7) to create a subdued color and apply a second layer. Having a slightly darker background than the skin will work well.

5 Prepare rubber tape to remove the masking fluid, or use a rubber cement pickup.

 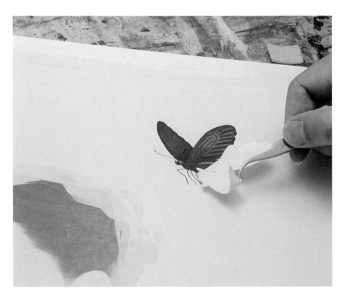

6 Once the paint is dry, rub off the dry masking fluid little by little. The butterfly's legs and other areas are intricate, so take your time.

7 Peel off the butterfly's masking film.

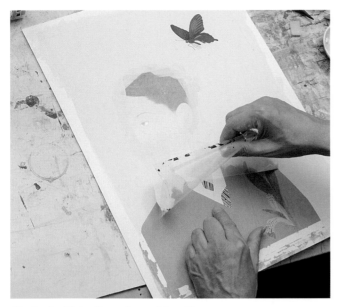

8 Peel off the figure's masking film.

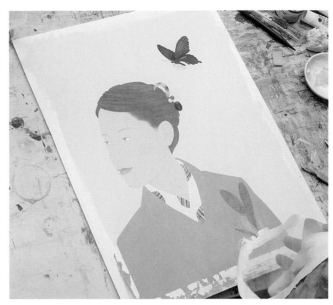

9 The background is a little darker than the figure, creating a nice finish.

8. Adjust the Details

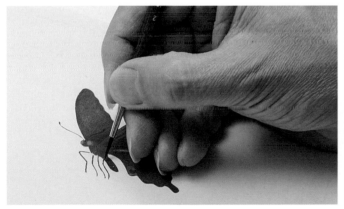

1 Mix Graphite Gray and Mars Black and use that dark gray to touch up the butterfly's antenna and legs.

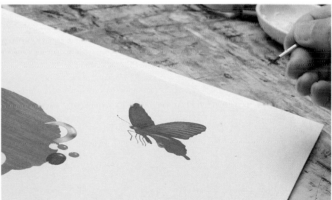

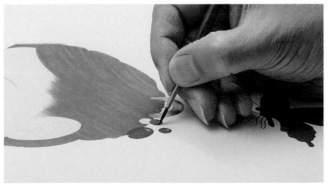

2 Touch up the hair accessory. Use a craft knife to lightly scrape areas where paint has gone astray and apply gray paint.

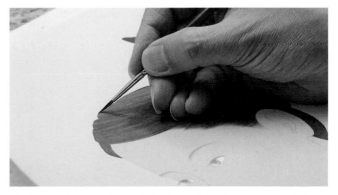

3 Correct the outline of the hair. Add the outlines of the head and hairline.

9. Paint the Facial Contour Lines

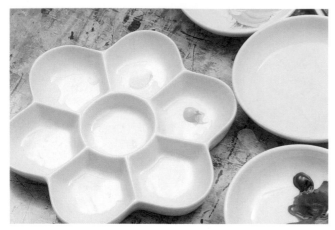

1 Mix Liquitex Neutral Gray No. 7 and Turner Acryl Gouache Titanium White.

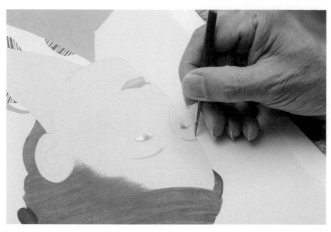

2 Paint the contour lines.

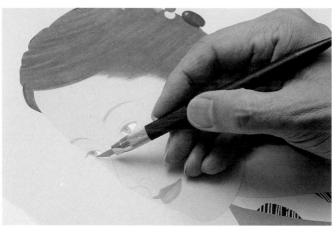

3 While scraping and adjusting, gradually layer the lines a number of times, including the tip of the nose, to make them bolder.

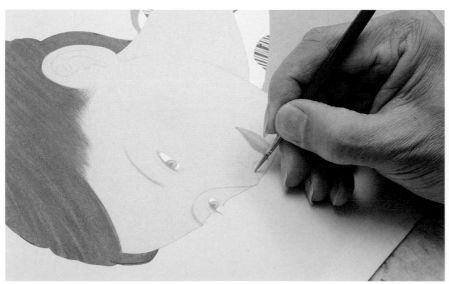

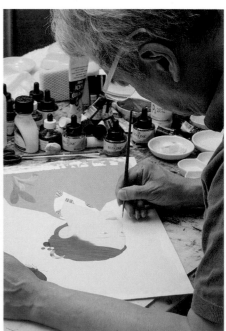

4 The contours have been defined.

10. Correct the Hair Accessory

1 Background paint seeped under the mask in places. To cover it, mix Dioxazine Purple, Permanent Rose and Liquitex Gouache Acrylic Violet to make a red-purple color.

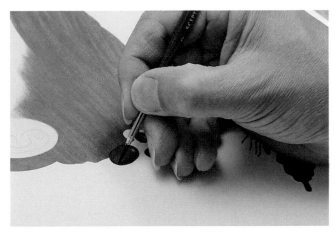

2 Repaint the edge of the sphere to make it round again.

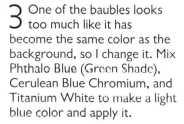

3 One of the baubles looks too much like it has become the same color as the background, so I change it. Mix Phthalo Blue (Green Shade), Cerulean Blue Chromium, and Titanium White to make a light blue color and apply it.

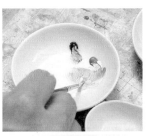

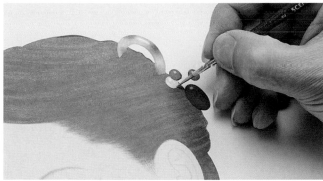

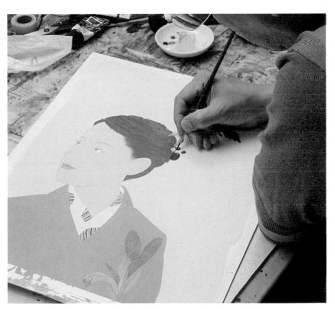

4 Adjust the black baubles with Graphite Gray.

11. Paint in the Hair

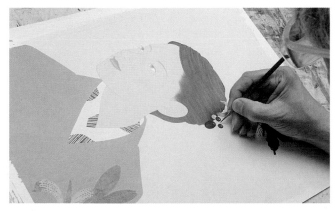

5 Paint the wires connecting the baubles with a gray that is close to white.

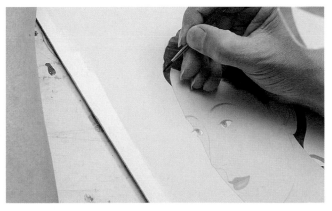

Blur the hairline and indicate in the flow of the hair.

12. Paint the Kimono Seams

1 Dilute gray color ink (Liquitex 717) with water.

2 Indicate the kimono seams.

13. Add More Blush

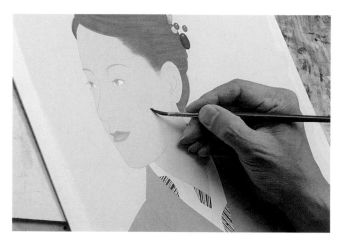

Do this with red color ink (Liquitex 390).

14. The Completed Piece

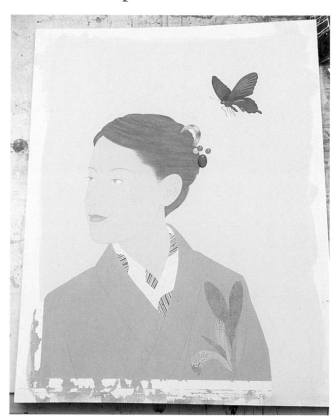

After inspecting your work, remove the surrounding masking tape. It's better to pull it sideways so as not to unintentionally peel away any background paint from the surface.

> TIP
>
> As you saw at the beginning, I started with a dark green kimono and changed it to blue-gray. It didn't match the mood of the face and the contrast with the kimono pattern was too strong, so I went with a more neutral color. Although I painted the flower decoration with bold colors, I softened them by blotting with tissue.

Author's Advice

Learning from the Work of Shinsui Itō
One of my role models for Japanese painting is Shinsui Itō. He was a Japanese painter and printmaker who studied under Kiyokata Kaburaki, and was known for his genre painting that spanned from the late 1920s to modern times. His work as a *bijin-ga* artist was particularly popular. He said that there was a nobility in *bijin-ga*, even when they were supposed to be vulgar. It is interesting to note the way he drew dark eyes with faint highlights, and the way they were narrow in his early period, larger in the mid-period showing influence from Western painting, and then defined by softened lines in his later period, as well as how the contour lines changed for each era.

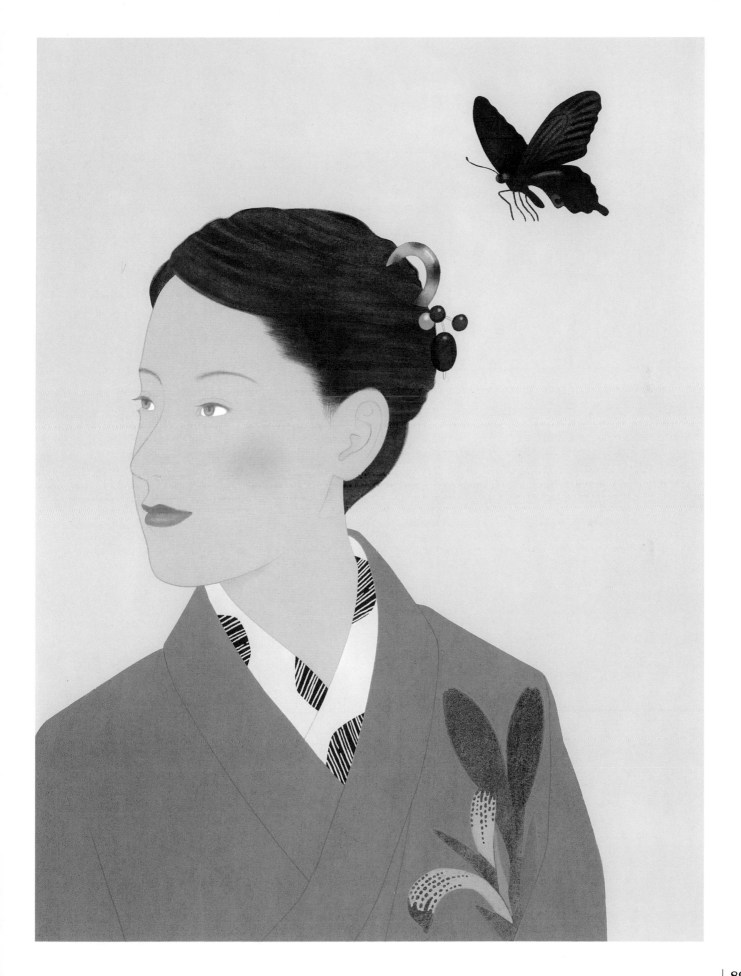

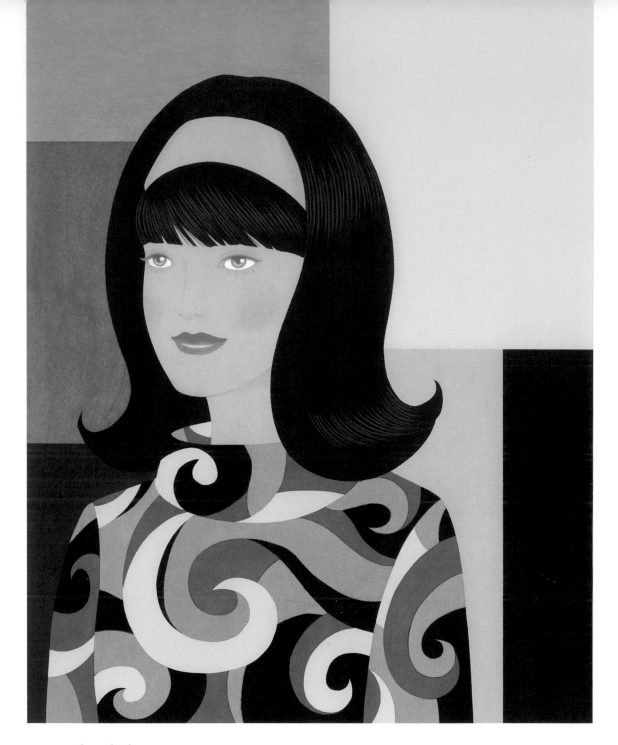

Psychedelic

THEME

An attractive woman wearing psychedelic-style clothing.

EXPLANATION

In my mind, psychedelic colors are: orange (or pink), yellow-green, yellow and purple, but there is room for variation—it's just my impression. In this image, I conceal the eyebrows with the bangs. I tried echoing the waves of the hair with the pattern on the clothes.

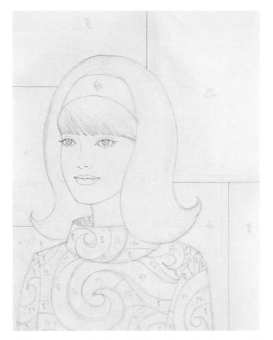

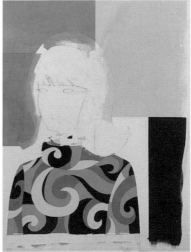

1 I composed a sketch featuring the image of an attractive woman.

2 The psychedelic colors are a key feature. Following the color scheme that I chose in the sketch, I painted the pattern and the background at the same time. The painting order was as follows: yellow and yellow-green → orange → purple → gray → red → chocolate brown.

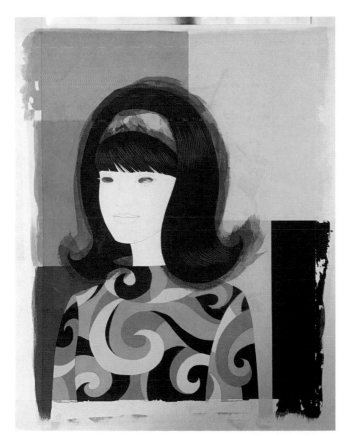

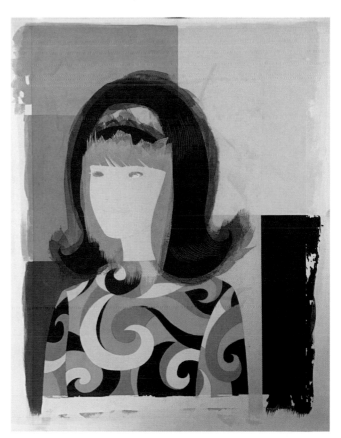

3 The 1960s-style hair features a bouffant and long bangs that cover the eyebrows. I depicted the highlight section of the hair by painting in lighter streaks. I did just the eyelashes in gray to make them look lighter.

4 The piece is nearly complete. I focused on creating balance between all the color areas, with the clothes and hairband having the same colors as the background. The face looks Japanese and the red and deep purple give it a slight Japanese feel too.

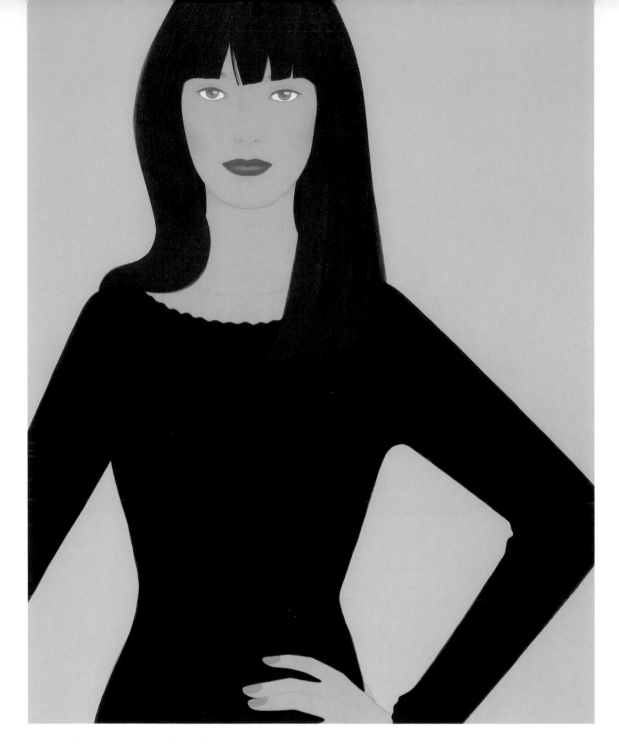

Iconic 1970s' Style

A Japanese woman who resembles Jane Birkin.

I imagined the 1970s icon Jane Birkin, but with a Japanese woman's face. Alex Katz's influence can also be felt. I began by painting the outfit gray, but I felt that somehow didn't match with a Japanese face, so I repainted them in deep magenta. I darkened the lipstick too. Hopefully the subtle texture of the clothes can be made out in these printed images.

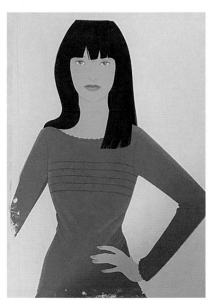

1 I referred to Alex Katz's *The Gray Dress* for the composition and pose. I shifted the position of the figure from the center to create the sense of movement of a woman modeling clothing.

2 The painting order was as follows: dress → hair→ face. I used masking so I could work quickly and boldly.

3 The completed figure. Oftentimes when I try to inject a Japanese look to the face, I wind up with a face without a distinct personality, so I paid careful attention when sketching to make the face look correct.

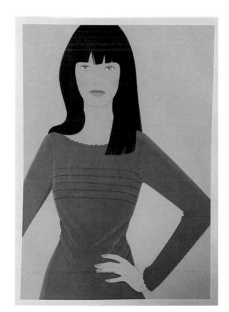

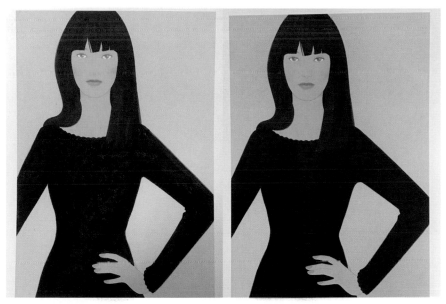

4 I painted the background pale blue.

5 I changed the dress from gray to deep magenta, referring to the artistic effect and color of the kimono in Shimei Terashima's work *Yugure* ("*Dusk*"—1954). Moreover, my expression of the Japanese face and matte hair make it more like Japanese-style painting. I created the texture, blotted it with paper, and then added an extra layer of the same color. I changed the lipstick to a darker color after making the dress maroon (see the facing page).

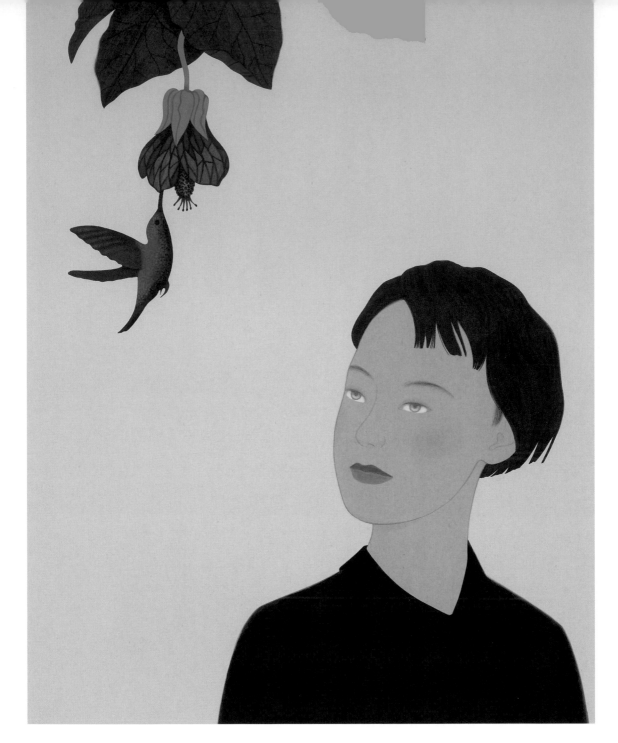

Hummingbird

A girl watching a hummingbird.

I haven't seen a hummingbird in real life, but they are small and come in a variety of colors. They can hover in the air by flapping their wings at high speed. The girl watching the hummingbird has no expression because I think if a hummingbird appeared in front of me, I would appear similarly blank, watching in wonderment. She doesn't seem to be in Japan, however.

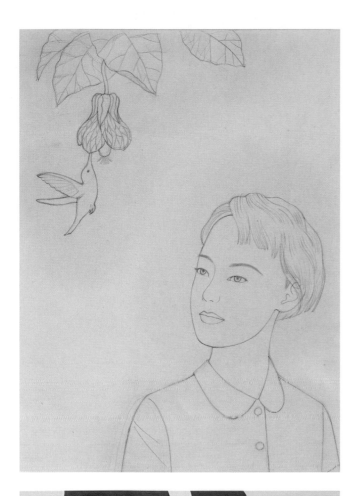

1 The sketch. I drew a placid, attractive woman, while being mindful of the distance between the figure and the bird. I gave her a flat and slightly plain face to create the impression of a Japanese-style painting.

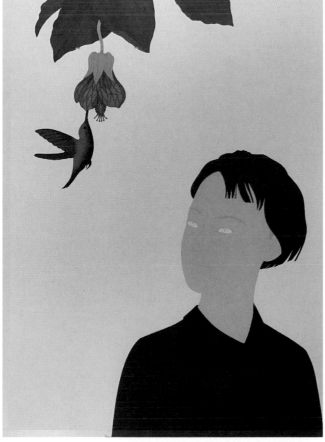

2 I painted in the beautiful shape and gradation of the hummingbird, the texture of the flower and other fine details, and then I painted the key element—the reddish-purple blouse. The eyes can easily change the impression of the picture, so I painted them near the end.

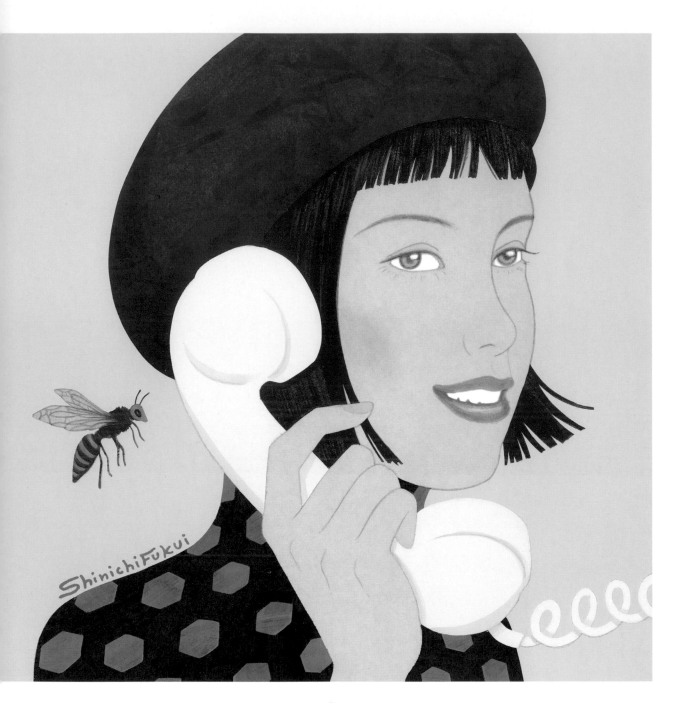

Ms. Hirota Unaware of a Bee

A woman talking happily on the phone, unaware of a bee.

I drew this at the request of Kyoko Hirota (an illustrator and F-SCHOOL student). I took a photo of her talking on the vintage black phone in the school and used that to create a sketch. She also asked me to make the picture a little unusual, so I turned it into a scene where a large bee is advancing on her from behind. I created the sketch while looking at the image on an iPad, and it took about two hours to do during lesson time.

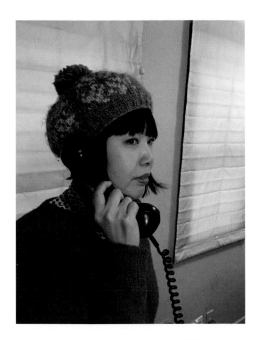

1 The photo of Ms. Hirota that I used for reference. I changed the colors of her top to navy and light blue and painted the phone receiver white, so it turned into a work that gives a completely different impression from that of the reference photo.

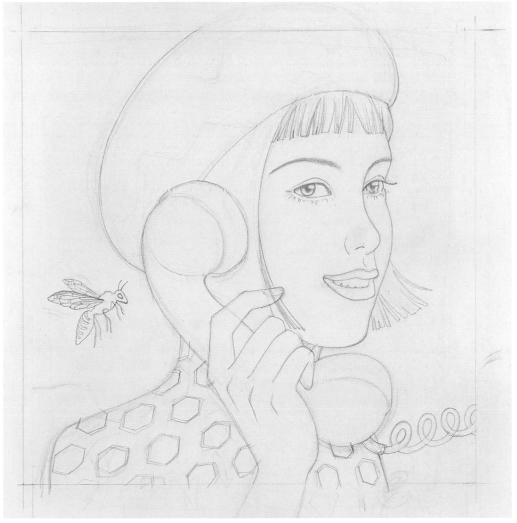

2 I went from drawing an image of an attractive woman to creating a scene that makes you want to shout out, "There's a bee right behind you!" I added a beehive pattern to her top to connect it with the motif of the bee. Key elements of Japanese painting were included with the Japanese model and the planar depiction.

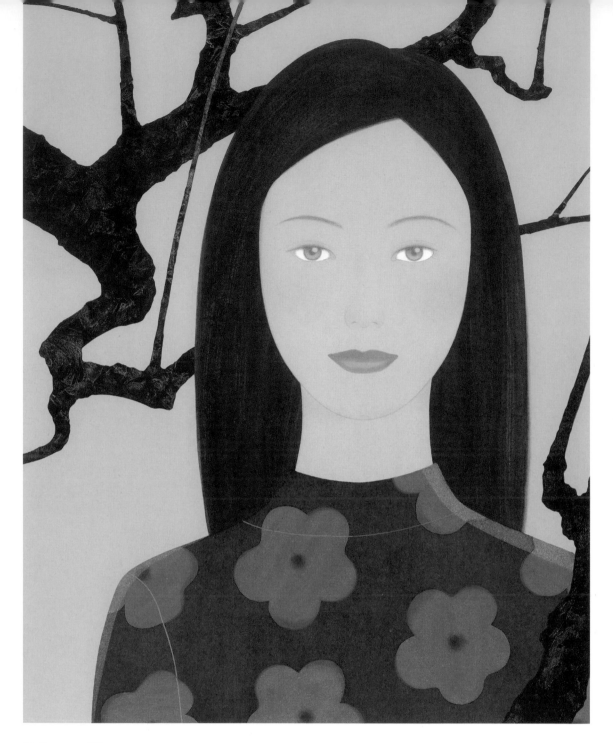

Plum Tree

A juxtaposition of a woman with plum tree branches.

The plum tree branches drawn by Hiroshige are so cool that I included a section of them in this painting. I wanted to create a bright overall look for the work, so I gave the face a light finish and added sunlight coming from behind.

1 Taking inspiration from Utagawa Hiroshige's *Plum Park in Kameido*, I combined a placid woman with plum tree branches sweeping across the background.

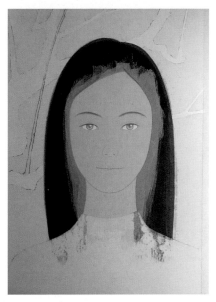

2 I put down the lines of the face with color ink and then overlaid the skin color, having the effect of the contour and face lines being partially concealed, creating a soft finish.

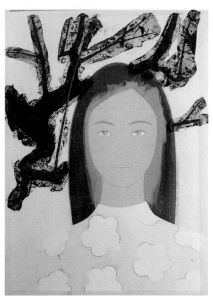

3 I painted the impressive balance of the trunk and branches of the plum tree, paying close attention to the form and texture.

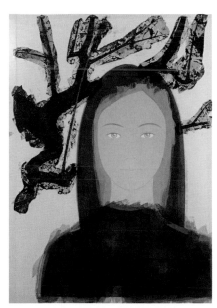

4 The colors were applied in the following order: face → branches → floral pattern → green top → yellow background.

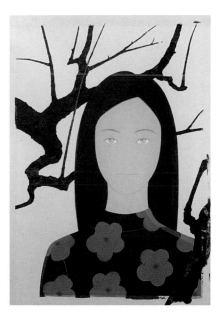

5 If I had drawn the plum flower pattern with too much detail, it would have looked like a kimono pattern, so I kept to only the shape of the flower and made it slightly graphical in style. I also added a branch in front of the figure to create the impression of the figure being surrounded.

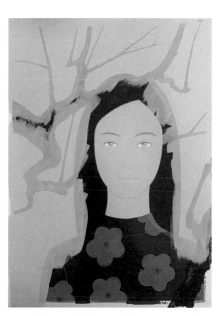

6 Along with the striking pink and dark green, I added a third key color, yellow, to the background. The result was a vivid finish combined with a Japanese impression.

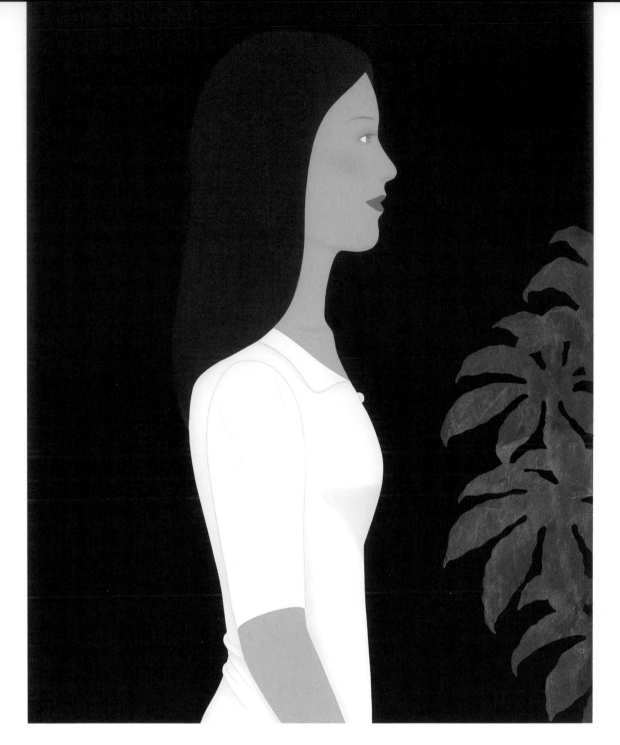

Image of a Dark Room

A figure standing out against a black background.

The first artist I think of when I consider inspiration for paintings of figures standing out against black backgrounds is Caravaggio. Vermeer is another with *Girl with a Pearl Earring*. Those are realistic pieces, but the same effect can be achieved with planar art too. The planar method makes the silhouette in particular clearly visible, so the form needs to be focused and defined.

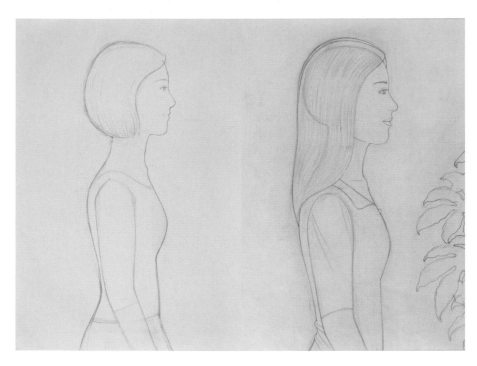

1 The image of a woman with a neat appearance expressed through a side-facing silhouette. I used reference photos of short hair and then adapted the composition by sketching the hair longer from my imagination.

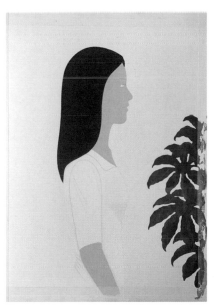

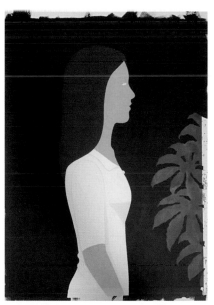

2 I painted in the following order: clothes → hair → plant → background. You can see glimpses of the trial-and-error process where the hair color brush strokes protrude.

3 I added subtle shading to the face and clothes. A three-dimensional impression of light is retained in this flat painting and even at this stage, you can see it's a unique touch.

4 The key colors are essentially black and white, but I made the black of the background slightly grayish to add depth. I referenced Suzuki Harunobu's paintings of figures on black backgrounds to add a Japanese element.

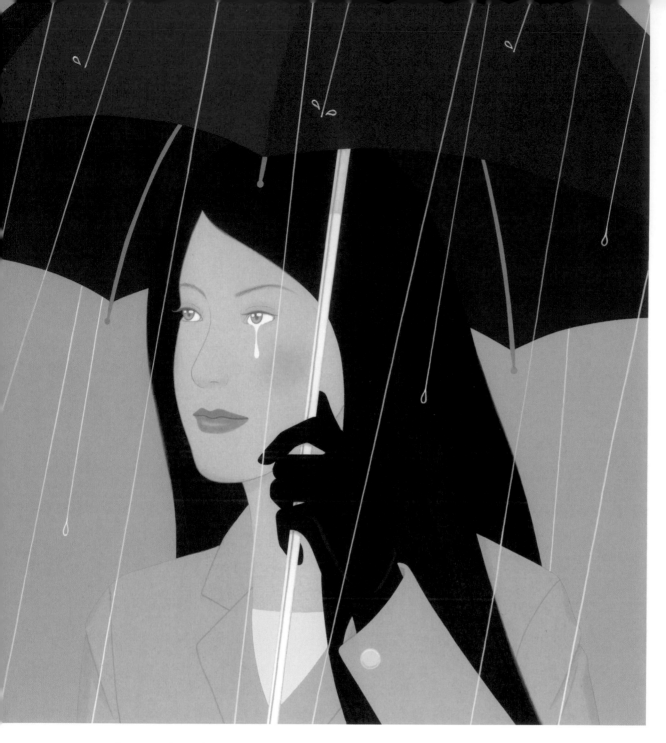

Red Umbrella

A woman holding an umbrella.

Shinsui Itō often drew women holding umbrellas. In ukiyo-e, rain is expressed with lines, whereas Alex Katz uses water droplets, so I decided to use both. Incidentally, the straight lines are grooves. In Katz's painting of a woman with an umbrella, it looks like her eyes are welling up, so I decided that this woman would be crying for an unknown reason. Umbrellas are surprisingly difficult and it seems that the axis and body may not be at quite the right angles in this piece either.

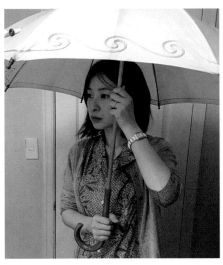

1 I made a recreation using elements from Katz's Blue Umbrella No.2 and early David Hockney for reference. I used a photo I took for reference and incorporated the concept of a woman crying. I also tried to reproduce the way Katz expressed Japanese painting style on surfaces.

2 I transferred the sketch to the board. I very carefully determined how the volume of the inside of the umbrella should appear as this forms the basis of the composition.

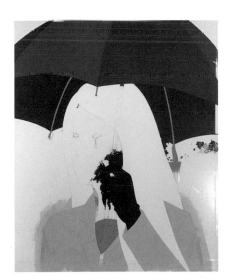 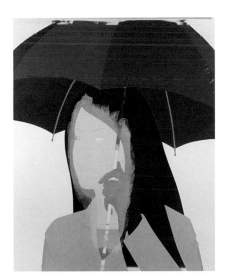

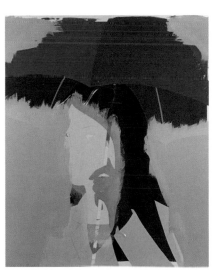

3 The key color is the red of the umbrella, and the different shades indicate the orientations of the different panels. I painted in the following order: umbrella → figure → background → rain.

4 I painted the figure. I started by firmly transferring the traced sketch, although there are many times that I notice distortion or oddities in the shape when I add color. For this reason, I've changed the position of the umbrella and hand significantly from their position in the sketch.

5 To create an original depiction of rain, I synthesized the various ways artist draw rain (see the completed piece on the facing page).

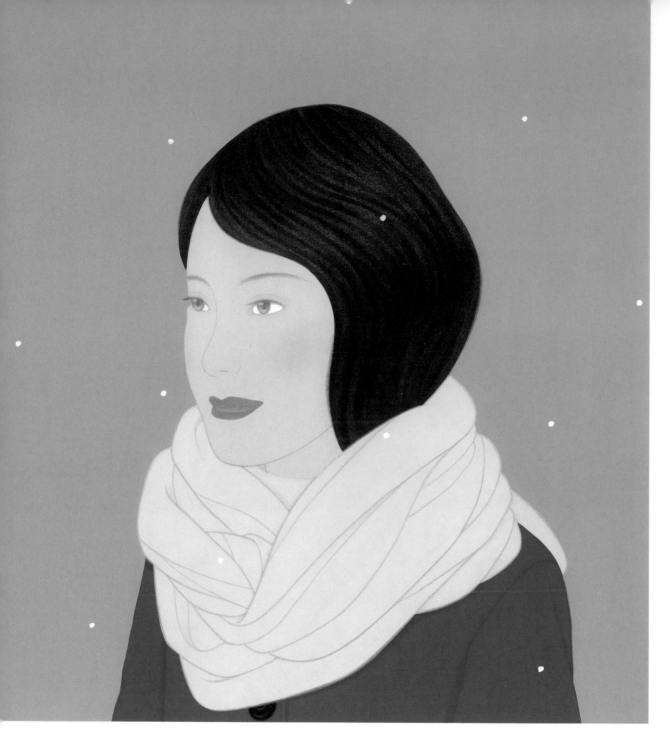

Blue Stole and Orange Coat

THEME

Falling snow and a draped garment.

EXPLANATION

In order to create the sketch for the stole wrapped around the neck, I looked at the way various fabrics draped and then finally drew it myself. It's surprisingly fun and easy to express creases using almost only lines. The girl's face is the same as that for the figure in the blue kimono on page 120. Aside from the stole, the distinguishing feature of the illustration is the presence of gently falling snow.

1 I drew a generally attractive woman based on the same photo that I used to create the piece *Shimada Hairstyle* (page 120). I gave her a winter outfit with a stole as the main feature.

2 I gave the fluffy stole a fuzzy texture and expressed the creases with lines. Keeping in mind the image of a Japanese person with a gentle face, I made this into a Japanese style painting by using Shimei Terashima's method of lightly drawing the face lines, as I've done in other paintings.

3 The key colors are light blue and orange, as in the title, and the background is gray.

4 I painted in the following order: face (ink) and hair → stole → skin and coat → background → reapplying the background → facial features. At first, I painted the background purple as shown in the photo above, but the color seemed too strong, so I switched it to gray.

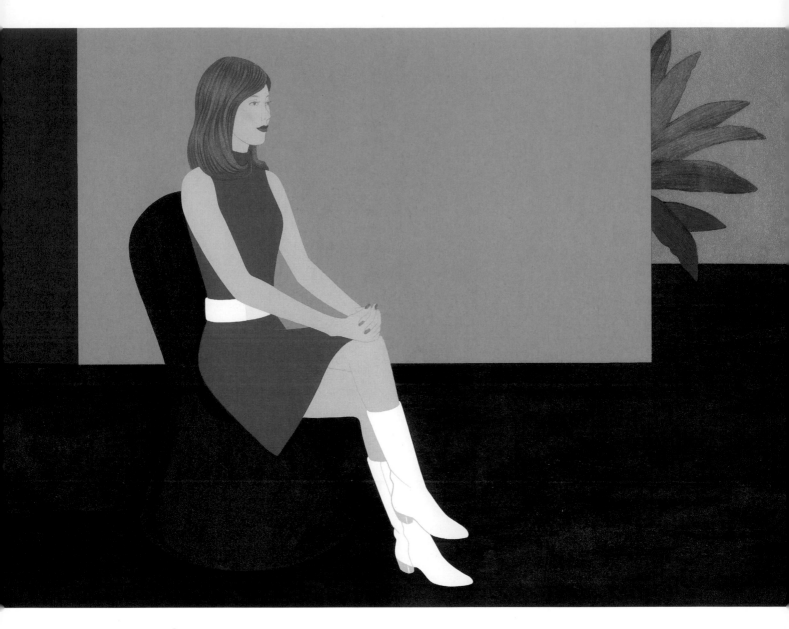

Orange Dress

THEME

'60s fashion and a seated pose with legs crossed.

EXPLANATION

 I wondered as I added the color if the combination of the bright beautiful colors and the very dark green would look a little strange. I started with a black floor, but then I decided on a different approach and made it dark green. It may not come across well in print, but hopefully the green tinge is discernible. The woman's style is an image of '60s fashion. It was challenging to draw and paint the crossed hands and legs, as well as to depict the features of the small face.

1 I made use of the photo I took of the seated pose and drew a person of the 1960s. The order of painting for the background was as follows: figure → chair → plant → floor → wall.

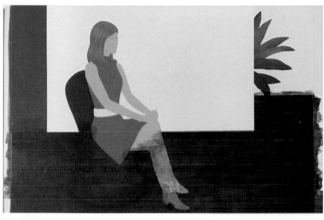

2 The anchoring color is the dark green of the floor. The brightly colored figure and walls stand out in contrast to the deep, somber color of the carpet.

3 I depicted a static scene, remaining cognizant of the balance between the figure and the space.

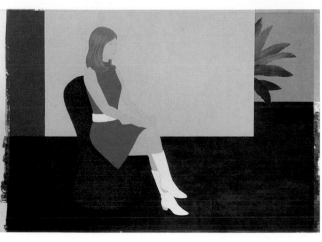

4 The work is nearly complete. I used Shinsui Itō's *Spring Rain* (1955) for reference and expressed the body with lines and surfaces to add elements of Japanese painting.

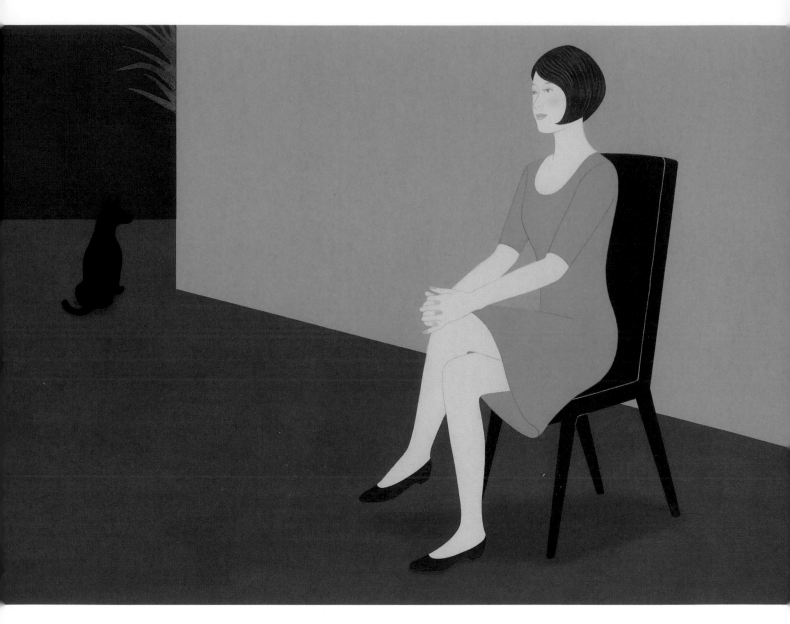

Green Dress

THEME ▶

Woman in a minimalist setting.

EXPLANATION ▶

This work forms a pair with *Orange Dress* (page 106). I referred to photos I had previously taken of a model seated with crossed legs. The form of the hands and feet were difficult and the chair, serving as a motif, was as well. This was because the four chair legs have to make correct contact with the ground, in the same way as the wheels do when you draw a car. Forming the shapes of the shoes was another issue. I combined flashy colors that I wanted to use, but I was careful with the level of brightness between adjacent tones.

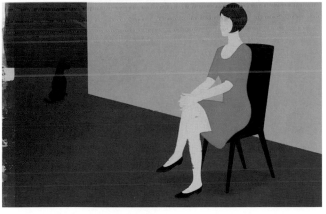

1 I used photos I had taken as reference to form an image of a somewhat casually dressed woman and I combined it with elements such as the silhouette of a dog to create a sketch. The key points for the composition were the pose with crossed legs and the expression of the hands.

2 I painted as follows: figure → chair → dog & plant → floor → wall. The bold color scheme of highly saturated shades, such as the walls, floor and dress, leaves a strong impression.

3 Everything has been painted in. I used Shinsui Itō's *Black Dress* (1956) for reference and, in the same way as with *Orange Dress*, the key point is the expression of the figure with lines and surfaces to make it look like a Japanese-style painting.

4 Even with masking, paint can bleed in along the edges. It happened this time with the red paint, making it look as if the legs were injured, so I painted over the blemishes with skin color.

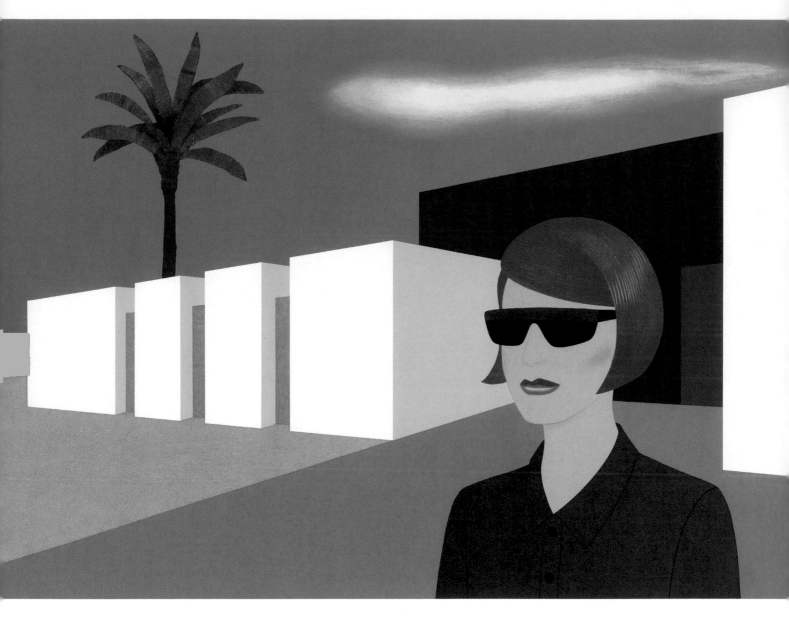

Woman with Sunglasses

THEME ▶

A depiction of a palm tree, an unusual looking building and a cloud.

EXPLANATION ▶

David Hockney's early work frequently featured palm trees. Surprisingly, I can often see them where I live in Aoba Ward in Yokohama too. The cloud in this image is a relatively important element. The building is from my imagination, but it seems like something I've seen somewhere and the figure is a little like an American comic book character. It's a bit of a mysterious piece.

1 I positioned a tall palm tree, a low building, and quite a cool looking woman horizontally in the sketch.

2 I painted in the following order: building → tree → clothes → sky → ground. The key colors are the white of the building and the blue of the woman's clothes.

3 The key point for this work was expressing the characteristics of the sunglasses and cloud in my own way. I was unsure about the cloud's shape, but I finally decided on a presentation that made it look like it was streaked by wind.

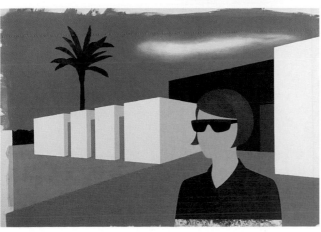

4 The look of a Japanese painting that conveys a sense of the humidity of the air, combined with an American pop art aesthetic, made this a work with a mysterious atmosphere.

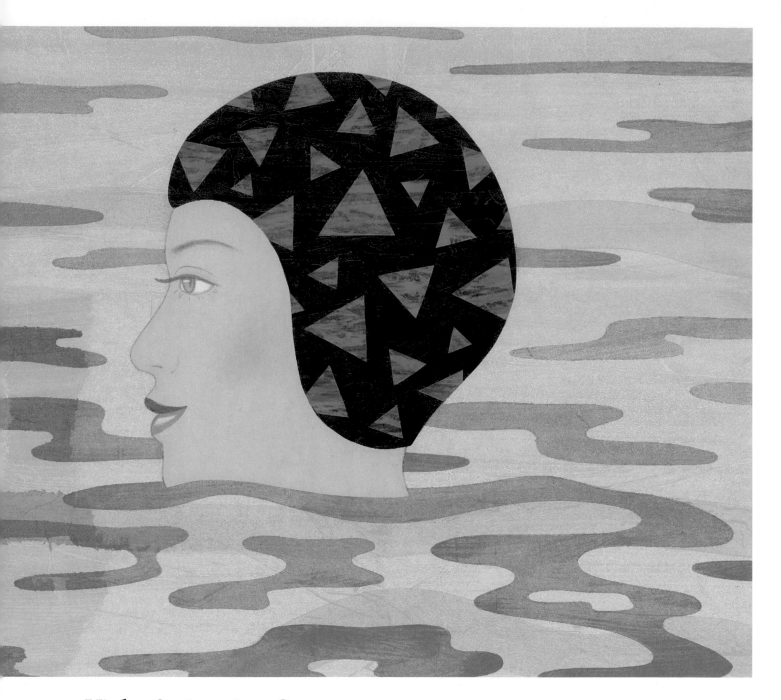

Violet Swimming Cap

THEME

An expression of the surface of water that suits my own style.

EXPLANATION

I was inspired by the depiction of water in David Hockney's pool painting *Portrait of Nick Wilder* and Alex Katz's painting of a man swimming in *Swimmer #3*, as well as pictures of women in swimming gear. I put a swimming cap with a triangle pattern (bearing no special significance) on a woman with a pleasant-looking face. The part on the left that looks like a shadow is where tissue, which I'd used to absorb excess paint, is still attached.

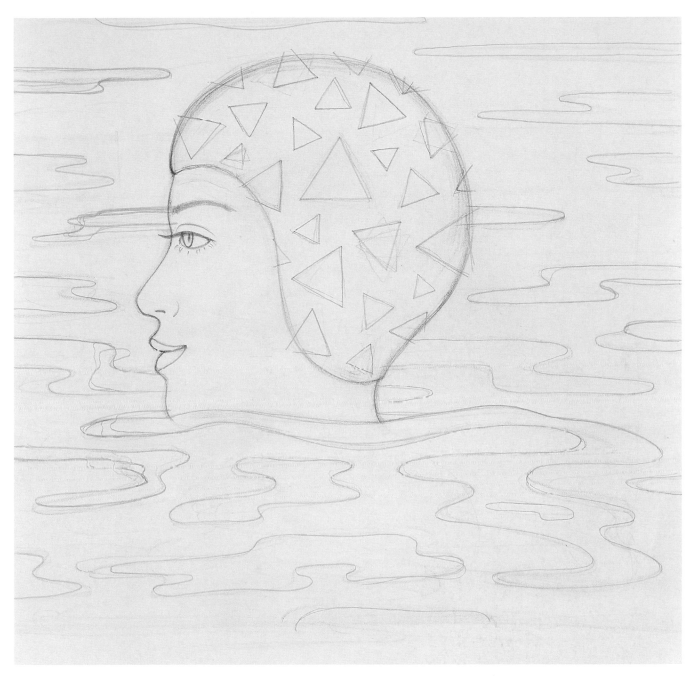

I tried to find common ground between Katz's depiction of water with no reflection and Japanese paintings. The swimming cap is a motif that often appears in Katz's work and the pattern was made by attaching masking film to the violet color surface, and then cutting triangles in it and painting over with a green layer. I kept the tissue that formed the shadow on the left in place as it became an important element by chance. I trimmed the painting and, as a result, it has a finish like a print-style composition.

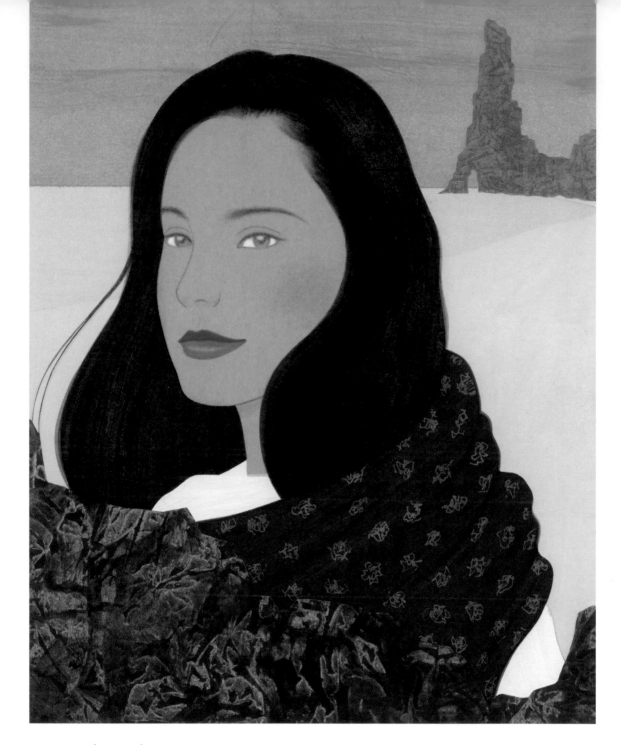

A Rocky Shore

THEME

A rather fantastical scene.

EXPLANATION

My desire to depict rocks may have been influenced by Salvador Dali and Andrew Wyeth. The rock texture came about randomly through the use of blotting tissue, but the form is borrowed from the rocks from *Waterfall and Full Moon* (page 116). I want to paint more rocks in the future. The figure like that of a young woman in a Tarkovsky film, but the face is that of a completely different person. The figure and the foreground rock (as well as the rocks in the background) have a surreal look to them. The bright color combination is inspired by Seymour Chwast's work.

1 I drew a Russian woman that I think I remember seeing in a film. While I was adding the texture to the rock with a tissue, I intentionally changed the impression of the figure in the foreground, the rock and the background color. To create the stole pattern, I painted the entire article light purple, and then set down the pattern with masking fluid. I then painted over the stole with a layer of red before removing the masking fluid to reveal the purple pattern.

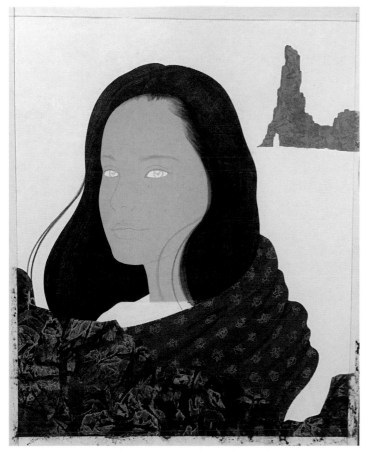

2 When I applied color, the face changed from its appearance in my initial image, so I redrew it as I painted. The order of painting was foreground → background. I reproduced an element of Japanese-style painting with the planar expression of the background (see the completed piece).

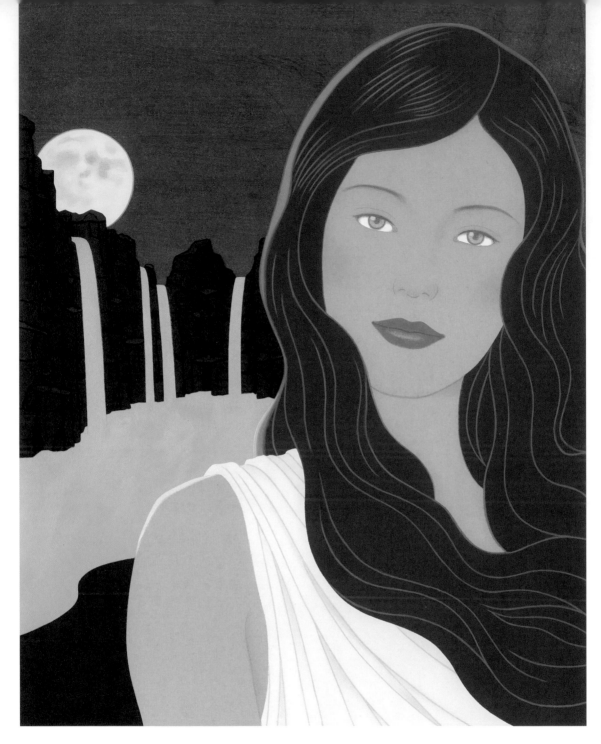

Waterfall and Full Moon

A fantasy-inspired moonlit night and an unknown woman.

EXPLANATION

The woman's clothing is a simple piece of fabric, so it's impossible to determine the period being depicted. It could be more than two thousand years ago or it could be modern times. It's that kind of work. The waterfall, moon and rocks are all motifs that I enjoy drawing. The woman has the subtle look of a goddess from an old Disney animation. Her skin has a slight reddish undertone, but it's bright for a night scene. There is an argument that could be made for making the skin darker or bluer in tone, but the execution would be more challenging.

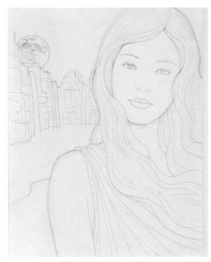

1 I created a sketch using a waterfall and a woman's expressive face as motifs, which came to me when I was brainstorming for ideas to paint.

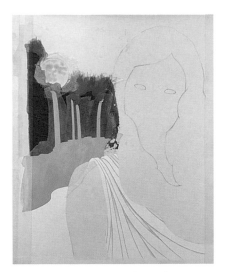

2 I painted the waterfall before the dress. This is a night-time piece so the key colors are a spectrum of blues. I expressed the drape of the dress and the flow of the hair with lines.

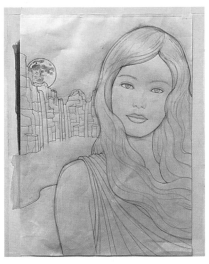

3 I started by imagining the forms of the waterfall, rocks and moon in the background. The texture of the rocks in this painting weren't made with tissue, but rather by rendering the detailed shapes one by one with a brush.

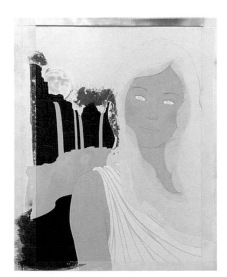

4 I wondered what to do about the skin color, but in ukiyo-e the color doesn't change even at night, so I left it rendered with the usual palette. I strengthened the redness of the skin to hold up to the depth of the blue tones in the background.

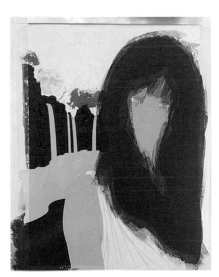

5 Now I've painted the hair.

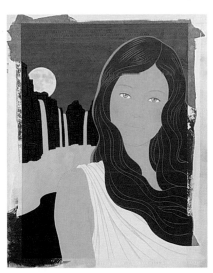

6 The light comes from behind in this piece, so I added reflected moonlight around the edges of the figure. I blurred the edges with a brush, so the sharp definition resulting from using masking film has almost disappeared and it gives an idealized fantasy touch to the image.

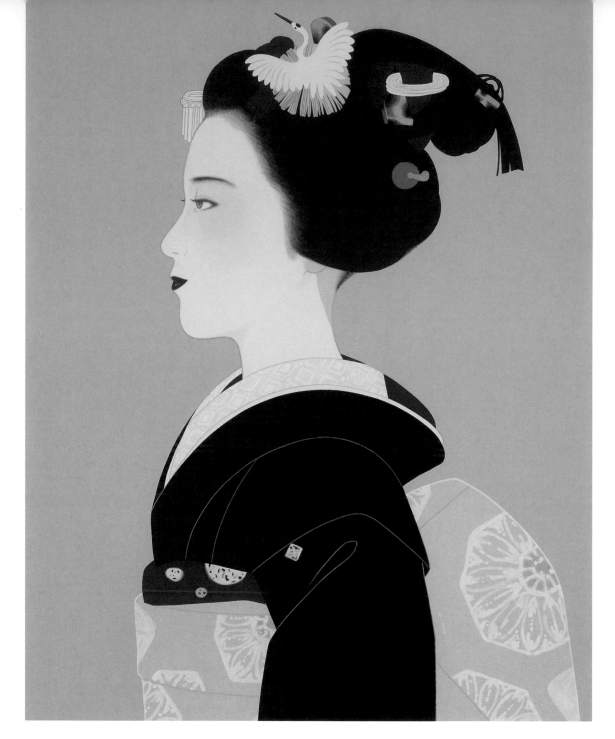

Sakkō Hairstyle

The *sakkō* hairstyle is worn by a *maiko* (apprentice geisha) in the final stage of her apprenticeship.

Shimei Terashima created a number of works featuring *maiko*. As this was a favorite motif of a painter I like, of course I wanted to draw it too! I didn't use any reference for the figure. I can draw the side view of a face without looking at anything, but the unique makeup that a *maiko* wears was difficult because it drastically changed the impression made by the face in the sketch. As expected, the hairstyle was a challenge as well.

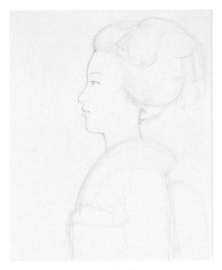

1 I created a sketch of an attractive *maiko* by combining the sideways pose that Shimei Terashima often used in his work with the side profile of a modern Japanese person. I decided the composition, taking into consideration the proportions of the foreground.

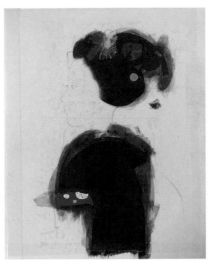

2 I started by painting the black area of the kimono, which is rather large, and the red areas of the kimono lining and the obi scarf.

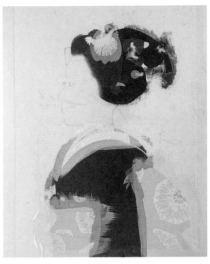

3 For the tortoiseshell of the hair ornament, I simplified the pattern and emphasized the texture of the gold band, carefully painting in all the small details.

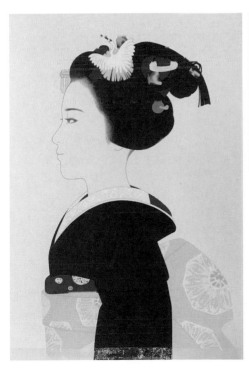

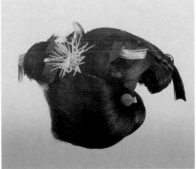

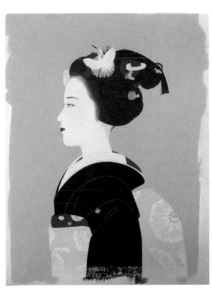

4 The face gives the impression of someone who is an adolescent. Along with blurring the hairline with a flat brush, I referred to Shimei Terashima's frequent practice of leaving out the details of the hair and kimono. The photo above is a reference image I used from an encyclopedia on Japanese hairstyles (*Nihongami Taizen*, published by Seibundo-shinkosha).

5 I chose a background color that coordinated with the colors of the kimono, obi and face. Combining the powerful black and gold kimono with pink has created a cute pop feel.

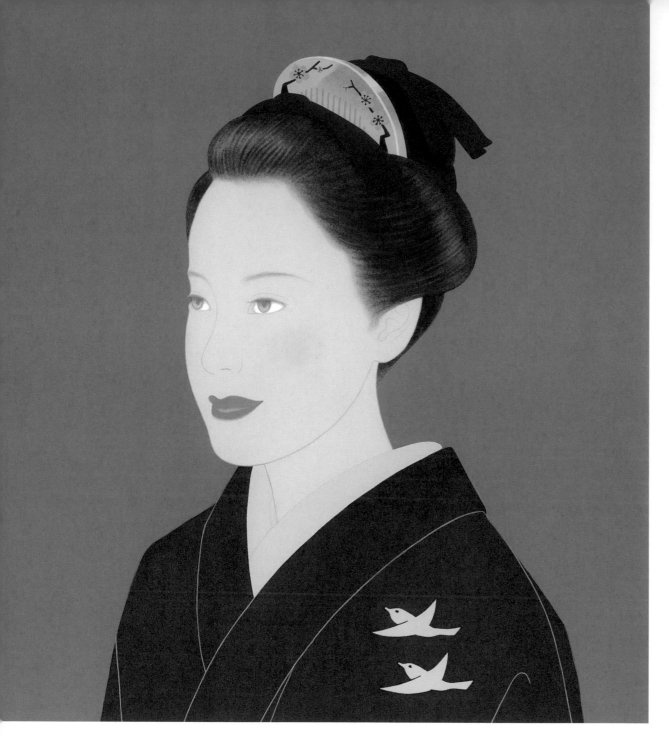

Shimada Hairstyle

A simple and adorable Japanese hairstyle.

EXPLANATION

Beautiful faces change with the times. The women that Shinsui Itō drew were in the style of ukiyo-e, so they all had small mouths. In original ukiyo-e, the eyebrows were raised too, so in comparison, this woman in my piece appears modern. I used the same face as that in the sketch for *Blue Stole and Orange Coat* (page 104). The hair is done in the traditional *shimada* style.

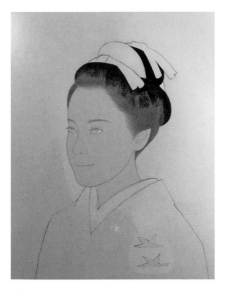

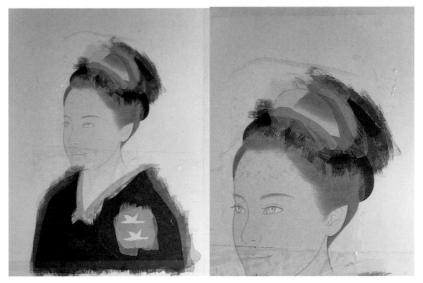

1 I reproduced a *bijin-ga* painting featuring a modern woman. I gave her a large mouth and soft eyes to express a contemporary-looking face.

2 I was very particular about the sweep and shine of the *shimada* hairstyle and also the transparency of the tortoiseshell comb (you can see the back part of the hair through it). I used the encyclopedia of Japanese hairstyles *Nihongami Taizen* for reference while carefully drawing the hairstyle and adding my own arrangements.

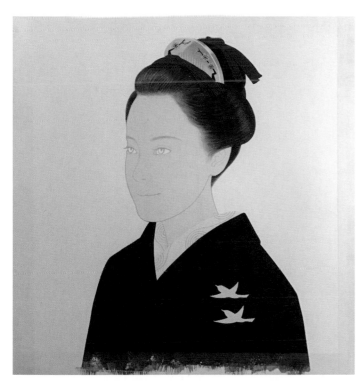

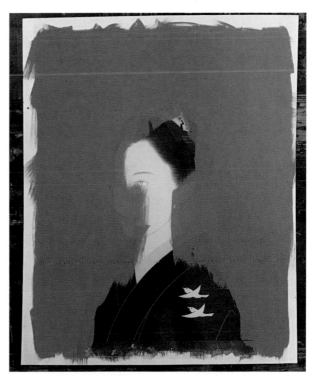

3 I added a bird pattern to the breast of the blue kimono as a focal point.

4 I painted in the following order: face (ink) and hair → skin → kimono → hair ornament → background → face. The blue of the kimono, the gray of the decorative undercollar and the pink of the background form the key colors and give the picture a bright appearance.

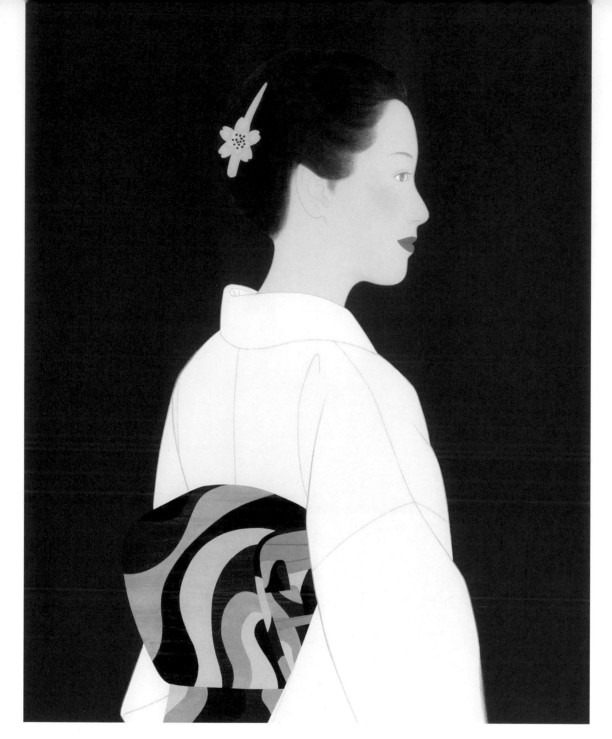

White Kimono

An obi belt pattern.

The inner part at the back of the obi can't be drawn without using reference materials. The modern hairstyle is one that matches well with a kimono. I did deliberate between selecting a grayish background or a strong color like this highly-saturated red one. For work assignments, I usually make this sort of decision based on the intended use.

1 In the same way as in the "How-To" section for the piece *Black Swallowtail* (page 79), I used photos that I had taken of the model to create the sketch. I also referred to the hair clip I photographed to use as reference for modern hairstyles and created an image of a bright, elegant woman.

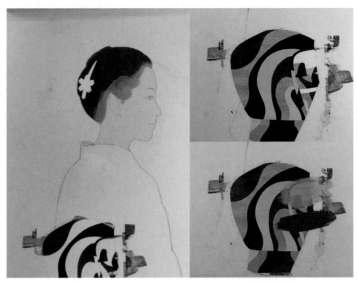

2 A pose that displays the obi is key. The photo I used had a green kimono with a black and gray obi, which I changed to a brighter color combination of red, blue, green and gray.

3 Here, I have finished painting the *obijime* cord. It was very challenging to achieve a good balance with the centrally positioned figure by aligning the neck and shoulders so that nothing looked odd.

4 I painted in the following order: face and hair → skin color → obi and hair accessory → kimono → background.

5 The key colors are red and white. Finally, I painted in the red and gave it texture. The image above shows the blotting paper after the paint has been absorbed.

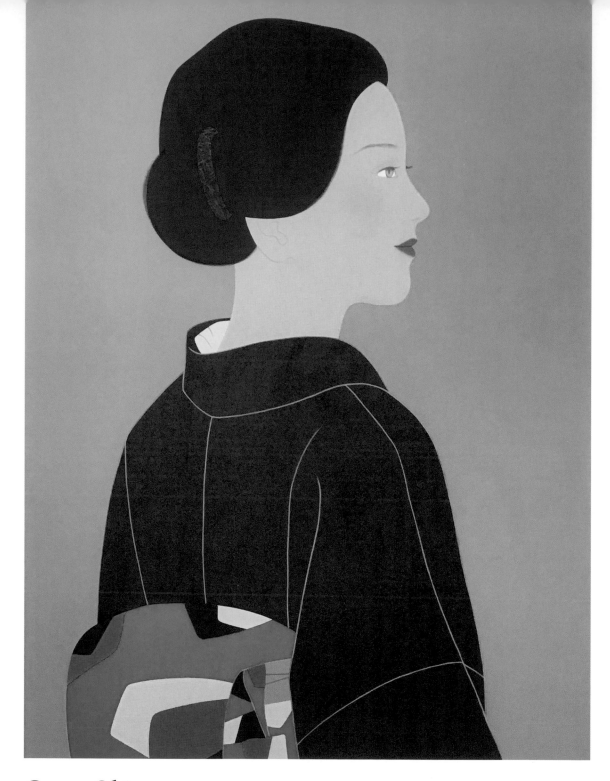

Green Obi

A rather showy kimono.

This piece emphasizes the composition of color surfaces rather than focusing on a realistic depiction. I used flashy colors all over and with sporty tones, it has a more modern look rather than a traditional Japanese one. However, kimono do actually come in all sorts of color schemes, so the sense of realism is not completely lost.

1 I created a pose based on a photo I took, changing the form little by little. I tilted the face slightly upward to give the impression of a figure gazing into the distance. I started by painting the key color of purple.

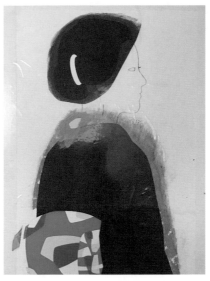

2 The hairstyle is from the Showa Period (1920s onward) and has impressive volume.

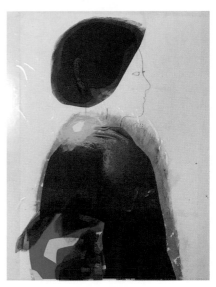

3 I painted in the following order: kimono → obi (green part) → hair → obi (all other parts) and hair clip → background → skin. Here, I've painted the hair clip and obi.

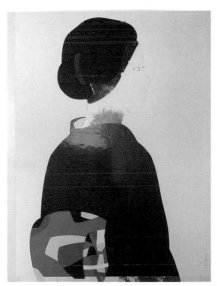

4 Here, the skin and obi cord are left unpainted and I've used masking in preparation to paint the background. The showy green stands out against the complementary color purple.

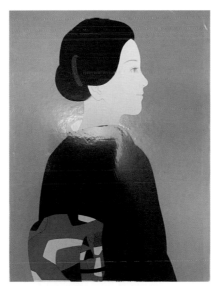

5 Leaving the skin unpainted, I painted in the eyes, nose and other features. I created a beautiful Japanese side profile with very little tonal variation to express Japanese-style painting.

6 After applying the skin color, I traced the outline of the face in light gray to give a soft impression (see the completed piece). The key colors purple, green and blue create a casual feel.

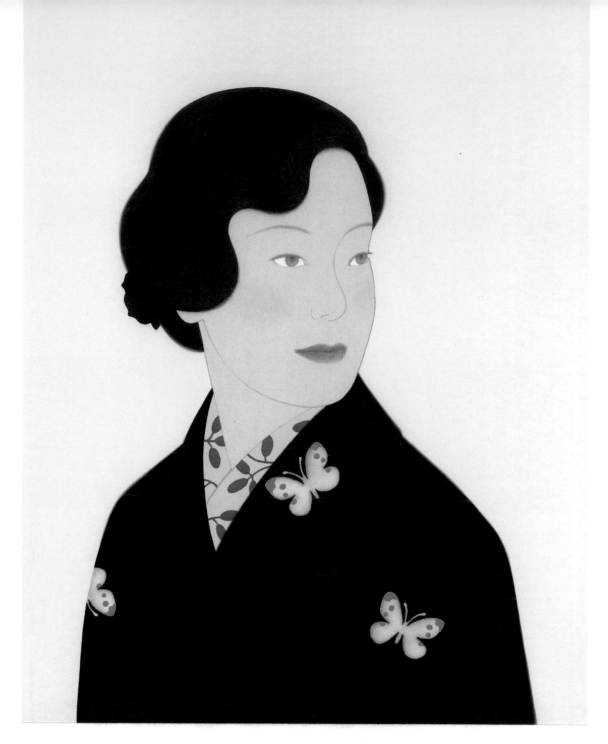

Mimi-kakushi Hairstyle

A Taisho Period (1910s–1920s) hairstyle that covers the ears.

The faces of women drawn by Shimei Terashima have a characteristic Japanese charm to them that is not tied to any single period, so they have enduring appeal, which is elusive. It has the quiet charm of a lovely woman rather than the flash of a stunning beauty. In my estimation, it's no good if the figure is too beautiful or if the piece is too sentimental. I'd like to be able to channel Settai Komura's technique, but I need to practice more to attain that!

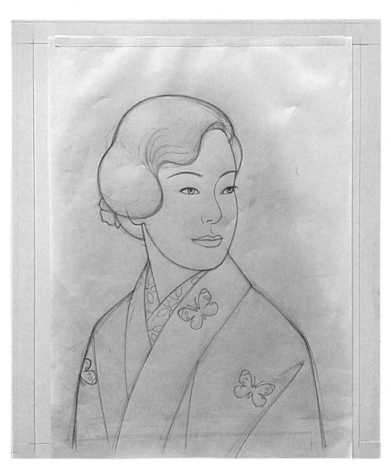

1 I sketched a woman in the style of a beauty posing as if glancing behind. She has a Japanese face, a large wavy hairstyle that covers her ears and she's wearing a butterfly-pattern kimono. The formal impression of a portrait painting can become more casual by positioning the figure slightly to the left in the composition.

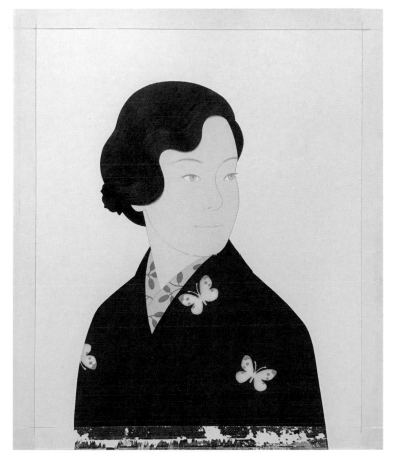

2 The chocolate-colored kimono has a butterfly pattern that effortlessly enhances the charm of this piece, and the slightly rough texture gives it a retro feel. I matched a beautifully colored decorative undercollar with a collar tucked up against the back of the neck for an elegant ensemble. Because this is a kimono painting, I gave the skin undertone a strong yellow cast to give the effect of a Japanese-style painting. I added the impression of springtime with the hair accessory.

A Conversation Between
Shinichi Fukui
and
Takayuki Ino

Illustration and Expressing Japanese Style

A conversation between Shinichi Fukui, who creates illustrations that incorporate Japanese painting styles, and Takayuki Ino, who humorously expresses various Japanese and Western themes.

They were originally teacher and student as Ino was a student in Fukui's illustration class (now F-SCHOOL OF ILLUSTRATION) more than twenty years ago. Although they have different approaches, they are both knowledgeable about Japanese themes and motifs, so their conversation covered a wide range of topics from the subject of Japanese painting to the world of illustration and techniques for expression.

Photography: Toshihiko Sakagami (Tokyo Photo Argus)

An Abbreviation of Illustration?

Takayuki Ino This is about how to draw some kind of Japanese painting, right? [Ha, ha!]

Shinichi Fukui It's a book about how to create Japanese-style paintings with acrylic paint. Or to put it plainly, it's about Japanese-style "illust."

Ino Ah, that's right. [Ha, ha.] I don't mean to make fun of the title *Japanese Style Illust* [the title of the Japanese edition of this book], but Mizumaru Anzai, who you were an assistant for, said we had to call it "illustration."

Fukui He did say that, didn't he? But we all called it "illust." That's how it is. If you ask people of the same generation, they all say it's fine to say that.

Ino So as early as your generation, you were already starting to betray that. Makoto Wada and Mizumaru used the full word, "illustration," so I always thought I should say it that way too, but recently I've been... betraying you all. [Ha, ha!] It's such a long word.

Fukui It's long and it used to be, at first, that I was saying "illumination." I heard the etymology of those words are the same, so I wasn't exactly wrong. During the first generation of illustrators, *sashi-e* was still the only

word being used. Then someone said that intellectuals in the US were saying the word "illustration," but it got misheard and Tadahito Nadamoto said that at first in Japan they were all saying "illumination," but after that they realized their mistake and used the proper word. To begin with, for advertising, people known as commercial artists were doing illustration, design and copywriting all as one job.

Ino Nadamoto almost became an "illumination craftsman." [Ha, ha.] And then in the mid-1960s, pictures with a completely different atmosphere and taste to *sashi-e* appeared. Those new pictures needed a different name.

Fukui What to call pictures used in advertising and posters?

Ino Those were called "illustrations" of course! Then the abbreviation "illust" started being used and suddenly it spread everywhere in Japan.

Fukui At the same time in the editing world, Nobuhiko Kobayashi,[1] who was editor of *Hitchcock Magazine*, began using the word "illustration" in that publication.

The Image of Japanese Painting

Ino To throw in another point, what is the "Japanese-style illustration" referred to in the title? "Japanese style" is really vague, isn't it?

Fukui Yeah, it is vague.

Ino When I worked on a paperback cover for an Ira Ishida[2] novel, there was a depiction inside of a girl wearing a T-shirt. The T-shirt had "Ukiyo-e artist Itō Jakuchū's[3] elephant" written on it and I thought, "Jakuchū's work isn't ukiyo-e," so I told the editor. The book had already gone through one edition change into paperback and then the publisher had changed, so now it was being made into a paperback again. Which meant this novel had been serialized, turned into a book, then a paperback, so this had slipped through the proofreading process three times. When the book came out, I checked and it now said, "Nihonga artist Itō Jakuchū." [Ha, ha.]

Fukui Ah, that's what happened.

Ino Itō Jakuchū isn't *nihonga* either. Wasn't *nihonga* a concept of Japanese painting created in the Meiji Period to compete with Western painting? At that point, ukiyo-e, which we felt was very Japanese, was left out.

Fukui That's right. The definition for Japanese painting is really vague and especially within that, for *bijin-ga*, I don't know where that begins or ends.

Ino Japanese painting now seems to be distorted pictures created using thick and heavy materials and put in gold frames, and the materials are limited to *iwa-enogu*. The original image of Japanese painting was planar with beautifully drawn lines, right?

Fukui I don't know about now, but when I was in junior high, there were a lot of people who used *iwa-enogu* to create abstract paintings or works featuring artistic effects. Those are different from "Japanese painting" per se, but when the general public see them, they have this feeling they might be Japanese paintings.

But illustration is aimed at the general public, so I specifically create works that give the impression of Japanese painting that many people have. However, if you look closely, it's kind of subtle. Simply put, there are no outlines if you make the background black. If you only look at the face, it's not a Japanese painting or anything, and it becomes a work that can't really be understood.

Ino Your idea to use your image of Japanese painting in illustration was innovative.

Fukui It's like with Kan Kazama, if you look at closely at the design, it's not Japanese painting as it's a semi-three-dimensional depiction, not planar. It makes you wonder where the picture came from. I think I may like that kind of feeling. Shinsui Itō as well, he had many works where he included faint shading on the face and that's something very much in common with Alex Katz's work.

Ino There are times when you want the nuance of shadows. You can adjust a picture by adding shadow. Even if the lines don't work well, the surfaces will hold.

Fukui If it was flat and looked like something by Settai Komura, that would be perfect.

Ino Yes, it's difficult to compete with a Settai work that has no shadows and just lines. The scenes require discipline.

Fukui But if you add too many shadows, it begins to look strange and I don't like that. Kan Kazama stops at just the right point. It's like no more shadows can be added than this.

Ino Sohachi Kimura, who I like, depicted shadows quite randomly rather than how they were actually cast, but it's as if they're part of the rhythm of the picture.

Fukui When he depicted rain too, he used white lines, right? He painted with tremendous freedom. His worldview was amazing too.

Ino Would you like to try drawing loose lines like Sōhachi Kimura did?

Fukui Even if I wanted to, I wouldn't be able to. If I tried drawing that way, it would probably become a strange picture. I'm unusually meticulous.

[1] **Nobuhiko Kobayashi** Writer / critic / editor (1932–)
Editor of the mystery periodical *Hitchcock Magazine*, established in 1959, and he denoted the *sashi-e* as "illustrations" in that publication. Incidentally, his younger brother Yasuhiko Kobayashi (illustrator / 1935–) was the art director for the magazine and responsible for the design and *sashi-e* illustrations. Nobuhiko went freelance in 1965 and turned to writing novels and reviews.

[2] **Ira Ishida** Writer (1960–)
Ishida made his debut with *Ikebukuro West Gate Park*, which was turned into a drama and adapted into manga. He won the Naoki Prize for 4TEEN in 2003. Many of his works depict the struggles and emotions of young people.

[3] **Itō Jakuchū** Painter (1716–1800)
Jakuchū was active in Kyoto. While his specialty was birds-and-flowers, his style of painting, which incorporates fantastical images into realistic drawings, is said to be in line with impressionism and surrealism. He is known for having tried techniques and used materials that weren't previously used in Japan. After 1970, his work experienced a resurgence in popularity.

I Started by Drawing *Jidaimono*

Ino I went to your school more than twenty years ago, when it was based in Futako-Tamagawa, but I never chatted with you like this.

Fukui Yeah. At that time, all you did was draw *jidaimono* (samurai period pieces).

Ino I attended Setsu Mode Seminar[4] and all we drew there were tableaus and rough sketches; they didn't teach us anything about illustration. That school produced a lot of illustrators, so I thought if I went there I might become one too.

Fukui It wasn't an illustration school though, was it? The teacher Setsu Nagasawa[5] didn't say anything about it being a place for training illustrators either, right?

Ino But it turned out to be good. For three years, I forgot about illustration and just drew pictures. Setsu Nagasawa was a fashion illustrator and he did *sashi-e* illustrations too, so up to a certain point in time, the drawings he did at the school and his work assignments may have overlapped.

Probably from around the time Kazuo Hozumi[6] was there up to when Toru Minegishi[7] attended.

Fukui I think it was the time when Minegishi and others were there that the most people became illustrators. When I was aiming to become an illustrator, I thought about going to Setsu Mode Seminar because people like Sachiko Nakamura[8] were there and it looked interesting. But I didn't have the money to go.

Ino Setsu was the cheapest school to go to at that time, but you didn't have the means? I don't have an image of you struggling for money. [Ha, ha!]

Fukui It's true though. It took all I had to go to university.

Ino After that, I attended your school because it was the cheapest. [Ha, ha!] If we arrived early, you would look at our work, but I always came later after finishing my part-time job, so I mostly looked at the comments you gave other people. At first, I didn't know what to draw, so initially I don't think I showed you my *jidaimono* work.

Fukui Probably not. I think it was croquis-type sketches.

Ino I remember you saying, "You can draw, but don't you have any other interests apart from drawing? Why don't you try drawing that?" What's the difference between a picture and an illustration? Are they the same? I thought about what I could draw to be an illustration and I started by drawing a person with a *chonmage* samurai topknot hairstyle because that would be an illustration in the *jidaimono* genre. I loved watching samurai period dramas, so I thought I'd trying drawing that.

Fukui Right, at the time there were very few people who could draw *jidaimono* properly, so I thought if you drew that, it would definitely lead to work. But all you seemed to be doing was endlessly drawing them and that's why I asked if there wasn't anything else you drew. Then you started drawing things like images from movies, film directors, and actors, which were interesting. I realized you can draw anything.

Ino The picture of Shintaro Katsu and Akira Kurosawa fighting. [Ha, ha!] When I look at those pictures now I think they're terrible, but you praised them and told me, "there are people with good sense, but very few who are really good," which made me think you're really good at flattering students. [Ha, ha!]

Fukui I flattered them and they assimilated it and became illustrators.

If I said something too strict, they'd lose motivation, right? I think that's a serious responsibility. A lot of people that draw have sensitive feelings.

[4] **Setsu Mode Seminar**
This school, which started as the Setsu Style Painting School, was opened by Setsu Nagasawa in Koenji in 1954 and then moved to Akebonobashi in Shinjuku in 1965. It promoted a free learning style with practical instruction in tableaus and drawing, and it produced a large number of illustrators and fashion designers. It closed in 2017.

[5] **Setsu Nagasawa** Illustrator, painter, and designer (1917–1999)
Nagasawa was a pioneer of Japanese-style painting and head of Setsu Mode Seminar. He was also active as an essayist and a fashion and movie critic.

[6] **Kazuo Hozumi** Illustrator (1930–)
After working at an architectural design office, Hozumi became an illustrator. He was in the first class of students at Setsu Mode Seminar. He's engaged in advertising and men's fashion magazines, and has a wide range of motifs, including cars, fashion, sports, movies and architecture.

[7] **Toru Minegishi** Illustrator (1944–)
Minegishi is known for his very strong retro Showa Period style of drawing and he has produced many book cover designs and illustrations. Since 2005, he has headed the illustration school MJ Illustrations, which has produced a large number of professionals.

[8] **Sachiko Nakamura** Illustrator (1959–)
Nakamura completed the graduate course at Setsu Mode Seminar. She is known for her serious touch in painting and also for her distorted surrealist forms and character illustrations.

[9] **Overlay**
This was an adhesive film sold by Pantone that made it possible to express flat, even color surfaces. It's also known as color tone. It was used to create illustrations and manga art, but with the rise of the digital age, it is no longer produced.

Takayuki Ino
Born in Kochi Prefecture in 1971.
Ino graduated from Toyo University
and from the Setsu Mode Seminar
graduate course. Among his accolades,
he has won the Illustration Prize in
the 44th Kodansha Publishing Culture
Award and the 53rd Takahashi Gozan
Prize. His books include *Vincent van
Gogh, Kokkei Ni Ningen No Utsukushisa
Ha Nai* ("There's no other beauty in
humans than being humorous"), and
Portraits of Painters. He's responsible
for the drawings on the E-TV cartoons
Otana no Ikkyusan and *Mukashibanashi
Hōtei.* He writes a regular exhibition
review column "Chikuchiku Bijutsu-
bu" in the art magazine *Geijutsu
Shincho.*
inocchi.net

Magazine illustration

Animation frame from the NHK program
Historical Anecdote

Kireji to kire—Paperback cover

The Reason for Not Using Japanese Painting Materials

Ino Your father was a painter, right?

Fukui My father was a Western painter, he didn't paint
Japanese ones.

Ino Ah, he did Western works.

Fukui But I had friends who were Japanese painters and
because of that I saw a lot of Japanese paintings. One
winter, I went to a Japanese painter's studio and the smell
of *nikawa* glue (used for *iwa-enogu*) was really strong.
Sticks of *nikawa* are dissolved in a pot of hot water for use
and that pot had been left by the stove and the *nikawa* had
gone off. As soon as I went in, it stank really badly, that's
what I remember most.

Ino So that made you hate Japanese painting?

Fukui No, I didn't start hating it.

Ino But you didn't think to use Japanese painting
materials.

Fukui *Nikawa* smells and *iwa-enogu* is grainy, right? And
you don't mix the colors on a palette, it's like you layer it
up on cloth or paper to draw. It's annoying and it takes a
huge amount of time.

Ino Can't the colors be mixed on a palette?

Fukui They separate because the size and relative
density of the particles are different for each color. If you
try to apply it anyway, it becomes rough and uneven.

Ino What about those block things in a square kind of
palette?

Fukui Ah, a *gansai* palette. That already has *nikawa*
mixed in, so you could say that's easier. But it still takes a
lot of time to paint.

(*While paging through an art collection book of Japanese
painters*) It'd be good to paint like this, but it would take
several months just to create one work. An illustrator's
work is a race against time and I can't say, "that'll take
two months." Plus, I'm pretty impatient. I want to finish it
quickly, so I can't be doing that kind of time-consuming
work. [Ha, ha!]

Ino Did you show your work to Mizumaru, who you
were assistant to?

Fukui I did. He's a pretty laid-back person too—I wonder
if he'll get angry with me for saying that [ha, ha!]—and
when I showed them to him, he just said, "ah, that's good."

Ino What I remember is that up to a point he had been
applying Pantone overlay[9] on coloring, but then he began
using color pencils and he said, "Even such a sloppy way
of applying color can be used for work too."

Fukui He was thinking that creating the painting is so
simple, it's funny that something so easy is work, right?
[Ha, ha!] He told me, "Painting carefully your way is a
loss, my way is much more fun," which is great if you can
do it, but that's not how it goes, is it?

Ino Setsu Nagasawa said when he saw me doing detailed
sketches, "You don't need to do that much."

And that's when I became messy too. [Ha, ha!] I also
liked *heta-uma* ("bad but good"—works that at first
glance looks poorly executed, but is actually skillfully
composed). This is a book on techniques, so I shouldn't
really be saying this, but I wanted to be able to draw
pictures without drawing too elaborately.

Fukui I like complicated things for some reason.

Ino Ah, you're impatient, but you like complications. [Ha, ha!]

Fukui Yeah, I have a complex and mysterious personality. I want to focus on troublesome things and finish quickly. [Ha, ha!] I thought up the masking technique to save time. It's faster to use masking and slap the paint on rather than carefully applying paint with a brush to each part. I thought of that after seeing Mizumaru attaching Pantone to express color surfaces and wondering if that could be done with paint.

Ino Ah, I see. A lot of people were already using Pantone, weren't they?

Fukui Some were airbrushing on top of Pantone too. There's something that cuts out the gloss of Pantone and then you can layer paint on top.

I used Pantone at one point too, but I thought it wasn't that interesting. I definitely prefer painting with a brush.

Ino Were you already painting Japanese style *bijin-ga* at that time?

Fukui I was mainly painting foreigners. I showed my work to Seiichi Hayashi and he said, "It's pretty good, but why foreigners? You're Japanese, so do the normal thing and draw Japanese," and I said, "Ah, right." [Ha, ha!]

Ino Hayashi's *Koume-chan* may be representative of Showa Period *bijin-ga*. Your paintings as well, when I was on an escalator in a department store in Tsu City, Mie Prefecture, where I'm from, I saw a poster and thought, "That painting of a woman is really beautiful." I was still in high school at the time.

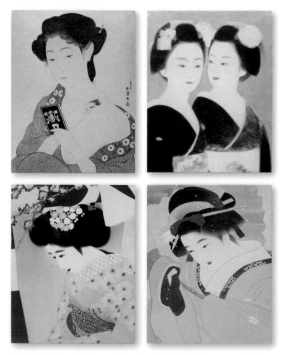

Gendai Nihon Bijin-ga Zenshu (Modern Japanese *bijin-ga* art collection book published by Shueisha in 1979)

An Attraction for Shimei Terashima

Fukui Shimei Terashima is my favorite painter at the moment, but he has quite a rough way of drawing.

Ino I wasn't even aware of Shimei Terashima until you recommended him and then I started looking at him.

Fukui It's surprising how little he is known. Everyone knows artists like Shinsui Itō and his teacher Kiyokata Kaburaki, but not Shimei Terashima and Nakamura Daizaburō.

The style is rough, but it's as if this way of drawing is easy to see, or rather I can keep looking at it forever.

Ino When you think of *bijin-ga*, you get an impression of something vulgar, but Shimei Terashima is refined. He's not sentimental and not obsequious. The faces are amazing. The faces that Nakamura Daizaburō drew have a kind of pattern to them, but Shimei Terashima's faces have real personality. When did you learn about Shimei Terashima?

Fukui A long time ago. In junior high or high school, I had an art collection book at home, different to this one, and I saw his work in that. But I wasn't that interested at the time. I was only aware he was someone who created this kind of picture. I think I was looking because I was interested in Shinsui Itō then. When you're young, you're more interested in how they are drawing, right? So I was more attracted to Shinsui Itō's way of detailed, neat drawing. I thought his way of drawing umbrellas was brilliant. But I wasn't quite as impressed with his faces.

Ino They look a bit like dolls. Do you have all the volumes in this *Gendai Bijin-ga Zenshu* series about modern *bijin-ga*?

Fukui No, not all of them. They were pretty expensive when they came out, so I only bought the ones for artists I was interested in. When I was a student, most of my part-time salary was spent on art collection books, so that's why I couldn't go to Setsu Mode Seminar. [Ha, ha!]

Ino Talking about *bijin-ga*, what about Sentarō Iwata, who once dominated the scene?

Fukui He's not bad, but I'm not really influenced by him. I feel he includes too much sentiment. Settai Komura and Shimei Terashima only drew people's situations and didn't need to express any inner thoughts as they were conveyed naturally. That's a cool thing to do.

Ino I don't like Sentarō Iwata either. When you look at *sashi-e* collections and see Settai Komura and other *sashi-e* illustrators' work that they did in newspaper serializations of novels, they're amazing quality, but then you see all the illustrations that were used in the articles and some of them weren't that good, which is a bit of a relief. [Ha, ha!]

Fukui I think it's hard to maintain the same tension in every single illustration.

Ino Looking at this, Settai Komura drew in various ways too.

Fukui He has a strong tendency for doing monochrome line drawings, but he did a range of things. Performing arts too. Osamu Harada wrote a book about Settai and had a lot of materials on him, so I asked him to show me an old bound book.

Ino He did the written characters for the title too, right? It's pretty difficult to include lettering in a painting.

Fukui Because you have to show your own aesthetic in the characters as well.

Ino A lot of Japanese painters in the past also created *sashi-e*, so their depictions of scenes were good too.

Fukui Such as Shinsui Itō's pictures that were like Toulouse-Lautrec's. Depicting this amount of people is really difficult.

Depicting full figures is hard too. There are surprisingly few full-figure representations in Japanese painting.

Ino The printmaker Shikō Munakata[10] was also a great *sashi-e* illustrator, wasn't he? The image has been carved with such movement that it feels like your eyes are glued to the woodblock, but he also expresses Jun'ichirō Tanizaki's eroticism and darkness very well, so it acts as an illustration.

Fukui He had unexpectedly brilliant adaptability. That he can adapt this style so much like this is amazing. There might be this thinking that, "this person can only do this kind of picture," but if a professional gets a work request, they can work with it one way or another. For people wanting to become illustrators, I think it's better that they don't really think about adaptability to begin with. First of all, draw what you find interesting and become known for that. Then, if you just think about what to draw when the work assignments come in, it'll work out.

They Don't Teach You What To Draw

Ino Neither of us did art in college, but people who love art and want to go have to do plaster cast drawings first as part of the exam to be able to enter. It's as if the basis of painting is to draw realistically. That feels like the field is being narrowed, right?

Fukui Oh yeah, the plaster cast drawings. There were lots of plaster casts in my father's studio, so a lot of students wanting to get into university would come and draw them. But even though my father was teaching the students that, he always said, "You shouldn't get too good at this. Just do it now and when you get in, you don't have to do it anymore."

When I was around junior high school age, there was one student who was really bad and he drew Agrippa[11] like a black stone Jizo statue. I liked him though because he had the most unique character.

Ino Ha, ha, ha!

Fukui But skilled students' drawings were like photos and I thought, "Wow, you can draw like that?" So I tried too, and while I didn't get that good at it, I found if you do it for several months you can get pretty skilled at it. It's that kind of thing.

Ino Once you're in college, you hardly ever do them, right? It just continues being done as part of the entrance exam system.

Fukui Some students get frustrated and waste years on it, it's strange, isn't it?

Ino It's seriously strange. Because artists like Itō Jakuchū and Katsushika Hokusai didn't do plaster cast drawings either. African art influenced Picasso,[12] and there weren't even art schools then. And what about Kiyoshi Yamashita?[13] So I feel even the basics are different, depending on the person.

Fukui Yeah, they're all different. It's fine to do art at college, but if you just do what the professors teach you, you can't make a career out of it. You have to start rebuilding from there otherwise you can't create your own style. So in the end it's the same whether you go to art school or not.

[10] **Shikō Munakata** Printmaker and painter (1903–1975)
After seeing Van Gogh's paintings as a child, he aspired to be a painter and, impressed by Chosei Kawakami's work, he also started creating woodblock prints. He referred to himself as a *hanga* (printmaker) and his work received high international praise. In addition to prints, he also produced oil paintings, calligraphy and *yamato-e* paintings.

[11] **Agrippa**
Marcus Vipsanius Agrippa was a Roman soldier and lieutenant to the first Roman Emperor Augustus. His plaster cast is regarded to be easy to draw, so it's good for beginners.

[12] **Pablo Picasso** Painter and sculptor (1881–1973)
Born in Spain, he was the greatest artist of the twentieth century. His style changed with every era, but he is most well known for his cubist period. In later years, he focused on surrealism and continued to create prints and ceramic works.

[13] **Kiyoshi Yamashita** Painter (1922–1971)
He suffered neurological damage when very young, but his talent for creating pictures from torn pieces of paper bloomed at the institution he entered. When he was 18, he set off wandering round Japan and produced paintings of all the places he visited, gaining him popularity and he became known as "The Naked General" and "The Japanese Van Gogh." He died at the age of 49 due to a cerebral hemorrhage.

Ino They can teach you how to draw, but not *what* to draw, right?

Fukui Eventually you have to think about the basics for yourself.

Ino Yeah, that's where your foundation is. Do you talk about that kind of thing with your students at your school?

Fukui I get the impression, "you want to draw this kind of picture, right?," but it usually turns out to be wrong. I'll tell a student, "you should do it more like this," but that person doesn't want to, so I just tell them to do it by themselves. [Ha, ha!]

Ino It's not possible to know about other people, right? [Ha, ha!] It takes time to figure out exactly what you want to do and the themes you want to pursue, but it's not like you can stop drawing until then.

Fukui Everyone gets frustrated trying to reach that point, that's why I give them praise.

Reproduction Works When You Don't Know What to Draw

Ino When you don't know what to draw, I think it's a good idea to reproduce other art.

Fukui Reproduction is good. It's good to imitate.

Ino When you draw something, you learn that you should do it like this or that these are the kind of difficulties you'll have to contend with.

Fukui Yeah, and that's how you learn you can't do it one way, but if you do it this other way, you start to see what you can do. That's the way to get to originality.

Ino The picture you think is good might look simple because the subject is organized well, but when you try drawing it, you realize that you're paying close attention to the details.

Fukui Then you understand how great the original artist is. You draw a lot of different styles, even Van Gogh, don't you? But Van Gogh[14] is not a great choice to copy, right?

Ino Ah, I did think that at first. However, the oil paintings and other works he created when he was young are very skillfully made.

Regarding his work, he had great skill—even as far back as his first two or three pieces. I think at that point, however, Van Gogh began looking for a different direction to develop his style. But he could easily draw the construction of that complicated bridge in *The Langlois Bridge at Arles*.

Fukui Ah, that's perhaps so. That's a tranquil picture, isn't it? I wondered how such an intense person could create such a calm scene.

Ino Moreover, he started painting when he was 27 and died at 37, so he was only active for ten years!

Fukui Yeah, amazing people live such short lives. Some people just charge ahead in a short amount of time and end on a high point. Like Jean-Michel Basquiat. When I was striving to become an illustrator, Basquiat and neo-expressionism were extremely popular, and there were a lot of works displayed at the Graphic Exhibition that were imitating neo-expressionism.

Ino That was around the time Takayuki Terakado,[15] a student at Setsu Mode Seminar, won the Grand Prize at the Nippon Graphic Exhibition, wasn't it? Because the paintings at the school were originally neo-expressionist.

Fukui Didn't you go in that direction?

Ino I did try painting them, huge pictures, with a brush splatting paint everywhere. Entire B art panels, but I didn't think it'd be worth showing them to you, so I didn't bring them to class.

Fukui Really? I wanted to see them though. [Ha, ha!] I didn't like neo-expressionism itself, but Basquiat and Schnabel were interesting and I looked at them.

Ino That style of painting is fun, right?

Fukui Yeah, it's not the same as small sketches. I actually like both. I like painting people's faces in minute detail, but I apply paint broadly to the backgrounds with a brush and each is fun in its own way. Creating details with a brush is fun too.

[14] **Vincent van Gogh** Painter (1853–1890)
Van Gogh was known for his unique undulating brush strokes and bold colors, and is said to have been a pioneer of expressionism. He's viewed as a representative post-expressionist painter.

[15] **Takayuki Terakado** Painter and illustrator (1961–)
Terakado graduated from the Aesthetics department in the Graduate School of Letters at Osaka University and from Setsu Mode Seminar. In 1985 he won the 6th Nippon Graphic Exhibition Grand Prize. His series of works depicting angels is very popular. He is also engaged in book cover design and performing arts. He is a professor at Kobe Design University.

[16] **Soga Shōhaku** Painter (1730–1781)
Shōhaku's work featured detailed depictions and bold treatment of space, using themes of Chinese folklore and with an eccentric style of painting, in which he distorted facial expressions to make the figures look ugly, that gained him popularity and led to him being called a "heretic artist."

[17] **Kawanabe Kyōsai** Ukiyo-e artist and painter (1831–1889)
Kyōsai studied under Utagawa Kuniyoshi, learning various techniques from the Kanō, Tosa and Rimpa schools, and he is popular for his caricatures. He had an outstanding painting ability and worked using all kinds of techniques and themes, including ink painting, bird-and-flower painting, Buddhist painting, and even evil mountain and river spirits.

To Include Kimono Patterns or Omit Them?

Ino It's the same as with ukiyo-e, but kimono patterns are a highlight of Japanese art, aren't they? I get fed up and just make abstract marks and lines. How far do you go drawing in the pattern?

Fukui I used to draw it in carefully. While I was doing that though, I was paying attention to just that and not looking at any other part. And before I knew it, I couldn't tell if it suited the figure I was drawing it for. [Ha, ha!]

Ino Ah, I can understand that. Do you do the sketches just to a certain extent?

Fukui I do the sketches properly. At that point, I feel like I've finished and, of course I apply color, but the figure and the kimono have become separate items and I start wondering inwardly how they got split. You could say that's typical of Japanese painting though.

Ino It has to do with the painting materials too, you're painting them separately so the picture gets separated up too. I think that's interesting to say that's a trait of Japanese painting.

There is a lot of momentum and power in the works of Soga Shōhaku[16] and Kawanabe Kyōsai,[17] but they also draw the patterns of the kimono precisely. There are the bold images and then in contrast they're also drawing very patiently.

Fukui That's true. Shimei Terashima didn't draw any pattern at all. I don't know if he was impatient or not, but in his early period, he did draw them and then he kind of stopped.

Ino Instead, you can see the perfect representation of the kimono's shape and color in the scene.

Fukui The depiction of the face is soft and blurred. So if you draw the kimono in detail, the figure doesn't stand out. That's something similar to Alex Katz. I tried drawing a *maiko* in the general style of Shimei, but the pattern was a pain, so I hardly drew anything and just added some texture[18] instead.

Ino Like Matisse,[19] right?

Fukui I like that. It's not so Japanese. The blurring is subdued too, unlike Nakamura Daizaburō's extensive blurring.

Ino It's tedious to depict patterns, but it's kind of a highlight, or rather it's satisfying to do.

Fukui Recently I've been doing more drawings with psychedelic patterns and fun elements.

Drawing Multiple Pieces at the Same Time

Ino The faces are planar, but the hair is three-dimensional.

Fukui Yeah, most Japanese paintings are like that. I think maybe I draw hair differently every time, depending on the picture.

Ino The color of the eyes are a little lighter.

Fukui I think that may be Shimei Terashima's influence. Some of Alex Katz's paintings are like that too. Shimei Terashima doesn't just make the eyes lighter, the lines are faint too. So the whole face appears softer.

Ino Were all your pieces newly created this time?

Fukui I created around 20 pieces and I did them in just over three months, depicting a range of subjects.

Ino Approximately how long does it take you to create one?

Fukui The small ones are quickly done—two or three days at most. The *maiko* painting was big, so that took a bit longer—four to five days.

Ino I've never taken four to five days for a single piece in my entire life! [Ha, ha!] I want to be able to finish one piece within the period that my concentration lasts. Even if it's slow going, I'll split it over two days at the most.

Fukui I create a number of pieces simultaneously. This time I did fifteen pieces together at the same time. I've gotten used to working that way. When I'm busy with work assignments, I'll run four or five in parallel, but Meg Hosoki,[20] she had a seriously huge amount of work at one

[18] **Texture**
This is a word to describe the artistic effect used to express unevenness and the consistency on the surface of a painting. It can be created using pen marks when drawing or with the thickness of the paint, as well as produced when making the underpainting.

[19] **Henri Matisse** Artist (1869–1954)
Matisse's work, influenced by Post-Impressionists like Van Gogh and Gauguin, used striking colors and bold brush strokes and he was said to be representative of Fauvism. He gradually changed to a more gentle style of painting and in later years shifted to producing collages.

[20] **Meg Hosoki** Illustrator and picture book author (1961–)
Hosoki engaged mainly in illustration for advertising and women's magazines, and for many years she was responsible for the cover of *OZ Magazine*. In recent years, she has also been creating picture books.

point, but she said she couldn't do them all at the same time. She couldn't move on to the next piece until she'd finished the one she was working on. For me, whether it's ten or twenty pieces, I think it's better to keep the brain active by working on them in parallel. People have completely different ways of doing things, don't they?

Ino Does the choice of using a hairdryer or not have something to do with the color?

Fukui I don't really think so, but as a principle I hardly ever use one, because the board then tends to warp. But illustrators have deadlines, so we can't really be taking it easy.

How to Make a Mistake Not Look Like One

Ino Are you completely analog and depict rain by hand?

Fukui Yeah. Rain is often used as a motif, isn't it?

Ino Rain gets drawn last, so it's scary that it could all get messed up right at the end.

Fukui Yeah, if you get that far and then you make a mistake creating the rain grooves at the end, that's it. I can't stand that kind of anxiety. [Ha, ha!] But, and I think this is the same for you, after working for so many years, you don't make a mistake, right?

Ino Recently, I've been doing about half of my work on my computer. I always draw lines by hand, but a lot of the time I add the color using Photoshop.[21]

Fukui Ah, then you can't mess up. When you've been an illustrator for a long time, it's not so much that you stop making mistakes, but more that you don't allow them to remain mistakes.

Ino Ah, I can understand that. Is it because I've gotten better or is it because I've gotten better at hiding mistakes, which of the two?

Fukui Both. I've heard that violinists and pianists in classical music make mistakes in concerts, but they have a technique to make it seem like it wasn't, so it's similar to that. You're making a mistake, but you don't let it be seen as a mistake.

Ino In Nagasawa Rosetsu's[22] *Monkeys by a Waterfall* folding screen, there are rocks that look like spilled ink and then monkeys have been drawn there, but that could have been a mistake to start with. That's fine when painting your own work, but for illustration work assignments, you hand in the rough sketch and then usually you have to hold to that very closely.

Fukui I draw detailed sketches and submit them, but I know quite a few who draw them loosely, with room for improvisation.

They do that because if you draw a sketch without any leeway and then later realize it's not going to work that way, it becomes a big problem. Like this one, this is a bit of a mistake. Tissue got stuck to part of the background and I couldn't remove it, so I left it. It happened because when I was painting the background, I added a bit too much painting medium and it became too sticky. When I came to wipe off the excess paint with the tissue, it ripped and got stuck. In the past, I would have tried forcibly removing it, but now I say, "Oh well."

The Materials Change, The Paintings Change

Ino Do you draw these on illustration boards?

Fukui Yeah, the finest type of Crescent board.

Ino And how do you use the acrylic paint?

Fukui Acrylic paint has a sticky feeling when using it, doesn't it? The usual method is to dilute it to a paint / water ratio of 3:2, but I increase the ratio of water, so it feels like I'm using watercolor paint.

Ino Do you have any preference for brushes?

Fukui For fine brushes, the Winsor and Newton Series 7. They're for watercolor, but they use kolinsky sable, from the tail hair of a British sable, which has a delicate suppleness to it. I like those the best.

Ino Are those the ones that cost around $88 (10,000 yen) each?

Fukui Not that much. About $17.50 (2,000 yen) to $26.50 (3,000 yen).

Ino I heard that Goro Sasaki[23] uses ones that cost close to $90 each. It's a thick brush, but if you use the tip, you can paint fine lines.

Fukui Ah, the thick brushes like the No. 7 cost that much, but the fine ones don't. With a No. 3, you can draw quite a fine line. What brushes do you use?

Ino I use Namura brushes that I buy at Sekaido, they're around $8.75 (1,000 yen) to $17.50 (2,000 yen), I think.

Fukui Ah, Namura brushes are good too. There's a Chikyudo store in Yokohama College of Art and Design near my house and I buy my brushes from there.

I also use Sceptre Gold II brushes, which are a mix of kolinsky sable and nylon. Those are pretty good too and I

[21] **Photoshop**
Photo editing software developed by Adobe. It was originally software for retouching photographs, but it is also used a lot to create illustrations. It has become a standard tool in the design and printing industry, and is indispensable for managing and delivering digital artwork.

[22] **Nagasawa Rosetsu** Painter (1754–1799)
He is said to have been a pupil of Maruyama Ōkyo (1733–1795), but his style was bold and uninhibited compared to his teacher, and he was known alongside Soga Shōhaku and Itō Jakuchū as a painter with fantastic ideas.

think Suzy Amakane[24] was using them. The flat brushes at Seishindo are good, but they're not sold at Seikaido. You can order them from Uematsu and Chikyudo.

For paint, recently all I've been using is Liquitex Prime and it's brilliant for color development. Since I switched over to Prime, my paintings have become more vivid or more that the hues have gotten brighter.

Ino I've been using acrylic paint and watercolor paint for ages, but recently I used oil paint and that was amazing. It spreads easily and it creates beautiful gradation. With acrylic and watercolor, the colors change after they've dried, but oil paint colors stay the same, so that was good.

Fukui The colors don't change with Prime. The painting medium normally used is a whitish acrylic resin, so the color changes, depending on whether it's wet or dry. Prime uses a transparent medium, meaning it doesn't change color after it's dried. The medium in Liquitex has also become transparent to a certain extent, so the color doesn't change that much.

Ino Recently, there are huge transparent tubes of cheap acrylic paint being sold. The color development of those is bad, isn't it?

Fukui That's because those colors are made by mixing a number of different pigments. The cheap types have

[23] **Goro Sasaki** Illustrator (1956–)
After graduating from Aichi Prefectural University of the Arts and from Art Center College of Design, he started as an illustrator. He creates watercolor paintings based on realism and is active both in Japan and internationally.

[24] **Suzy Amakane** Illustrator (1956–)
He is known for his pop comic-style illustrations using painting techniques. He produces works in analog and digital, as well as creates modern art pieces incorporating Lichtenstein and other pop art methods.

various pigments already pre-mixed and when you mix them more, the pigment gets even more muddied, so it has poor color development. Prime only uses single pigments, so even if you mix colors, they stay quite vivid. With conventional Liquitex, the red is slightly subdued, but it's not like that at all with Prime. After starting using Prime, I hardly ever use other paints, only as a supplement. And then there's something called raw color, isn't there? That's made by artificially mixing several pigments together to make strange colors. I very rarely use that kind of thing.

Ino Do you use plastic wrap to cover the palette you've mixed and made colors on?

Fukui Yeah, there's a bottle sold for that purpose too, but I can't be bothered. It's quicker just to cover it with wrap and it doesn't have to last long, just a few days until you've finished painting.

Ino (*Looking at the painting materials*) I use a kneaded eraser too.

Fukui That kneaded eraser is from Bumpodo. All the others produce crumbs. I'm pretty particular about that.

Ino Oh, really?

Fukui This is masking film. Most people who do airbrushing use this, but Shusei Nagaoka[25] used masking tape. He cut it up into tiny pieces and applied it. I didn't say anything to him, but I wondered why he was doing such a frustrating thing. [Ha, ha!] Oh well, everyone has their own completely different way of doing things.

When you paint with oil paint, do you use a canvas?

Ino I've only done one oil painting for work so far, but that was canvas. I have noticed though at art museums that painters have used oil paint on small pieces of paper. Which means it's fine to use paper too, right?

Fukui That's right, you can paint straight onto Arches[26] and other papers without doing underpainting.

Ino I'm thinking about using oil paints like transparent watercolor.

Fukui The color development is great and it spreads well too. Because you're mixing and painting on the canvas. The brush moves completely differently to how it does with acrylic paint.

Ino When I painted with oil paint, it felt somehow like the picture improved.

Do Good Reference Materials Make For Great Pictures?

Fukui What kind of paintings have you been looking at up to now?

Ino I don't have any specific preference for a genre.

I look at manga and contemporary art too. It's not as if I like all Japanese art though. The same with classic medieval European paintings, they are drawn realistically, but I'm not so interested in that, even though I do have some favorites.

Fukui Who do you like in Western painting?

Ino I like van Eyck[27] and El Greco.[28]

Fukui Ah, van Eyck and El Greco, I like that area too. I see.

Ino When I was a high school student, I thought Caravaggio[29] was amazing. I wondered what I could do to draw that realistically, I thought it was some kind of inspired work, but actually since the Renaissance there had been a projector-like device called a *camera obscura*,[30] a tool that could be used to copy the form of objects, and that had instantly increased the level of realism in pictures. David Hockney explains that in his book *Secret Knowledge*. It's a professional secret of painters, but they act as if they're not using it. [Ha, ha!] Nowadays, people drawing realistic pictures are definitely using photos, but there are some that claim they aren't.

Fukui That's right. The artists doing photorealism use projectors to paint. Pater Sato said he started using one because an art director told him to do that.

[25] Shusei Nagaoka Illustrator and artist (1936–2015)
Nagaoka was well known for his works using a cosmic image and he was engaged in various kinds of work, like album cover art, on an international scale. From 1970 to 2004, he was based in the United States.

[26] Arches
This is high quality watercolor paper that began being produced at the Arches paper mill in Lorraine, France in 1452. It's made of 100% cotton pulp, produced using a semi-mechanical process similar to that of handmade paper, and it has excellent durability and water absorbency. It comes in three different textures of extra fine, fine and rough, along with a range of weights.

[27] Jan van Eyck Painter (1395–1441)
Van Eyck was a representative Dutch painter. He was appointed a court painter, but is also said to have taken work from townspeople too. He's known as a painter who improved on oil paint materials that had been used up until that point and he established oil painting techniques.

[28] El Greco Painter (1541–1614)
El Greco was one of Spain's greatest painters and his work was representative of the mannerism style. He worked in Venice and Rome before traveling to Spain to work in Toledo. He is known primarily for the *The Disrobing of Christ*, located in the Cathedral of Toleo.

Ino When I started drawing *jidaimono*, it was really difficult to collect reference materials. Whether you're drawing loosely like Sōhachi Kimura or with a precise touch, if you don't know the objects properly, you lose confidence and can't draw. Now you can get any kind of materials online, so I think that's why more people are drawing *jidaimono*.

Fukui That could be so. It's like with the *maiko* hairstyle, if you don't have any reference, you can't draw it. Now you can find that type of material online, so these are times to be thankful for.

Ino I feel like the quality of pictures by the digital generation with all this access to information has increased by around 150%, what do you think?

Fukui Yeah, but it's questionable. I referred to an encyclopedia on Japanese hairstyles for the *maiko*'s hairstyle, and I could see photos of just the hair, but that kind of detailed material is difficult to find online. So you can see materials online, but I feel most are at a level where it just lets you understand to a certain extent.

Ino When I draw Japanese hairstyles, I cheat a lot. I know that they change between the early, middle and late Edo Period and again into the Meiji Period, that's it. But as I'm drawing and thinking what to leave out, my picture comes together.

Fukui That's usually the case. This building in the background doesn't need to be so detailed.

Ino Oh, that's a nostalgic-looking building. You used masking on the windows to paint it, right?

Fukui It's easier that way. It's hard painting squares with a brush. I think it's interesting how the windows are slightly uneven too. It'd be even easier drawing it on a computer, but it would be too neat and that digital look makes it seem like everyone else's work, doesn't it? I think it's better if the personality of the artist comes out not just in the figures, but in the background and other elements too. If you use a computer, everything becomes the same, and that can be a pitfall, I think.

Ino Ah, I see.

Back View (Source and year unknown)

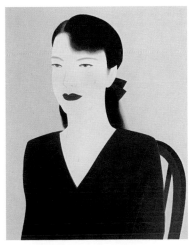

Black Clothes Editorial (1988)

[29] **Michelangelo Merisi da Caravaggio** Painter (1571–1610)
A representative painter of Italian Baroque. He became the darling of the art world for his realistic expression and depiction of dynamic light and darkness, but he died at the young age of 38. He was short-tempered and confrontational, ultimately committing a murder, and while he was traveling to Rome to receive a pardon for that crime, he allegedly died of a fever.

[30] *Camera Obscura*
A device which obtains a projected image using the principle of the pinhole camera by casting an image of an outside view through a small hole onto the wall opposite that hole (the image is inverted). It began being used in the fifteenth century and had a significant effect on the development of realistic expression.

The Difficulty in Incorporating Japanese Taste

Ino It's difficult to create a flow in the illustration scene right now. There are no movements like there were before. There was a kind of revival in the illustration world in the 1980s, but is this generation looking to the '80s for what is missing now?

Fukui It might be the same with music. In our time, first there was photorealism, then *heta-uma*, that kind of flow.

Ino At that time, if we were to name people who were creating Japanese-style paintings like you began doing then, it would probably be only Yasuhiro Yomogida?[31]

Fukui Yomogida and Kan Kazama. I submitted neo-expressionist-style paintings to the Graphic Exhibition and was selected as a semi-finalist, but they didn't feel like my paintings at all. Then I saw Kazama's paintings and thought Japanese-style painting is really interesting.

Ino How about Shinya Fukatsu?[32]

Fukui Fukatsu is of the same generation as I am. Fukatsu often won The Choice[33] award and prizes at the Graphic Exhibition.

He paints with a very careful touch, but then after that he scratches or scrapes at the surfaces and the realization that he was damaging them on purpose was interesting. I looked at them and thought, wow, he's doing something strange.

Ino There are people in every generation that incorporate Japanese style into their work, but it's really difficult to do it in an interesting way.

I think there have been people in every generation who have done things like Akira Yamaguchi,[34] but they didn't work out. Akira Yamaguchi did really well. I wonder why.

Fukui It could be there are those times too. In short, I think there's a difference between those who stop at copying something and those who have something close to this in their nature and can absorb it and then also express it well.

Ino Were there not many people who incorporated Japanese style into their work at the Graphic Exhibition?

Fukui Not many at all. Seiichi Hayashi told me to depict Japanese people and I wasn't sure what to think. The Graphic Exhibition wasn't such a big deal, but when I submitted work for The Choice and Nadamoto chose it, I thought, "Look, I can get into The Choice!"

Ino That's a pretty good connection, being chosen by Nadamoto. Tadahito Nadamoto is one generation previous to Wada, et al., so he's been more influenced by European art than American.

Fukui Yeah, the colors were slightly stylish, more cool than the vivid colors of American art.

[31] **Yasuhiro Yomogida** Illustrator (1941–)
Yomogida worked with Dentsu before going freelance. He has been engaged in many historical novel illustrations and book cover designs using illustration expressions with a Japanese touch. He is a member of Waraji no Kai, a *jidaimono* illustrator group.

[32] **Shinya Fukatsu** Illustrator (1957–)
Fukatsu won the Nippon Graphic Exhibition Special Prize in 1984 and Annual Creator's Award at the same exhibition in 1987. He creates works with a Japanese taste that is similar to ukiyo-e, Japanese paintings, and animal and plant illustrations. He designed the 1998 Nagano Paralympics official poster.

[33] **The Choice**
This is a magazine illustration competition that has been held every issue since 1981 in the magazine *Illustration*, and which has produced a large number of professional illustrators. There is a special system where one judge choses a winner each time and Shinichi Fukui won it eight times, a record that went unbroken for a long time.

[34] **Akira Yamaguchi** Artist (1969–)
Yamaguchi draws a whimsical world that intertwines the past and present in the style of *yamato-e* and ukiyo-e paintings, and he has received high praise both in Japan and overseas. He presents works at exhibitions and is also involved with book cover design and book illustrations, as well as *yonkoma* comic strip manga.

Becoming Able to Draw Anything in Your Own Way

Ino There comes a time when you can create your own form and style, right?

When you draw what you want, expressing it in some kind of form, people who see that will praise it and you'll be selected in competitions, but if you draw in a different way to that, you'll find you can't do it well and it doesn't come together. I thought that I didn't understand anything about painting. The fact is whatever way you depict, I think it's best to convey what you want to convey.

Fukui Norihisa Tōjinbara[35] said in the past that people who change their painting style depending on the motif are inflexible in their thinking.

Ino Oh, inflexible.

Fukui Meaning it's better to think to draw everything in your own style. I think so too. You can do anything with an image. If you think about depicting water or fire or rocks in your own style, you can.

Ino But Tojinbara has a wide range of expressions, including line drawings and painting. Toru Minegishi only has one way of drawing, but he can draw in any situation, and he can draw caricatures, cars, buildings and various motifs. That can be the case too.

Fukui Yeah, I should be able to draw a variety of motifs in my own style, but I may get to thinking that I can't. A student at my school called me because she had an illustration work assignment and asked me, "what do I do, I can't draw a car?" and I thought maybe she was feeling that way because of her lack of interest in cars, but then she asked, "what's a sedan?" I told her a sedan was just a normal car, so if she tried drawing that, she'd be able to do it.

Ino That's a job where you absolutely have to draw a car, isn't it?

Fukui Yeah, but she hadn't drawn one up until then.

Ino It's really difficult to draw when you don't know the subject well. You get worried that you're making unintentional mistakes.

Fukui Yeah, that happens, if someone who doesn't know draws it, then it gets pointed out, "there's no car like this." I think at that time I said to her it was fine just to start by drawing four wheels so they're on the ground.

Ino Men's suits, for example, change depending on the era, right?

That's one of the technical abilities an illustrator has to be able to distinguish. Just with one suit form, it creates a whole atmosphere. But with only four wheels touching the ground, it ends up....

Fukui It might not be able to run or the figure is too big to drive the car—it could end up in a number of problematic ways.

Ino Those would also make interesting pictures though.

Fukui It depends on the type of painting and creative style. A creative style where you don't care about that is easier, but with my creative style, I would definitely be bothered about it.

But as you're working, you want to be able to draw those parts properly, don't you? Aquirax Uno said too that he preferred creating artwork that he got asked to do through work, rather than drawing what he liked. I think illustrators are like that, so although I created the pieces in this book how I liked, I think there's a way for illustrators to enjoy drawing requested motifs and themes in their own creative style.

[35] **Norihisa Tōjinbara** Illustrator and art director / 1950–
He is engaged in book and book cover design, magazine illustrations, and art direction. He is well known for his picture of the back view of a sorrowful man. He opened HB Gallery, an art gallery that specializes in illustrations, in 1985.

Afterword

I started creating the new works for this book at the start of June and by mid-September, in the space of three and a half months, I'd completed twenty pieces. This isn't a very fast pace for an illustrator, but along with creating these, I wanted to try new ideas and techniques that I hadn't done before, so it took more time than usual. Even at the sketching stage, it took time to create the shapes of the faces and bodies and form the compositions. For the faces in particular, I'm always striving to improve, so I would put a sketch in progress aside and then come back to it to refine it. I find that if you rough in the shape to a certain extent and then leave it for two or three days, you can view it a little more objectively and then correct the shape. After painting too, I left the pieces for a time and then made adjustments. So, to save time overall, I worked on ten to fifteen pieces at the same time.

The size of the original painting depended on the image, but the ones I created this time were A3 (11.69 in × 16.54 in / 297 mm × 420 mm) to B3 (14.33 in × 20.24 in / 364 mm × 514 mm) on average, which are larger than the ones I usually draw for work assignments. It makes it easier to work on details that way. In addition, when I was planning my sketches, I looked carefully at how various artists work through the process. When I saw the photos showing Shimei Terashima continuously reworking his drawings at the sketch stage, I realized that, even with his great talent, he was going through a process of trial and error—and that gave me courage.

I would like to convey my sincere gratitude to the seven illustrators who contributed their work to this book and to Takayuki Ino for the conversation.

Thank you very much!

—Shinichi Fukui

About the Author

Shinichi Fukui is an illustrator who was born in 1958 in Shiga Prefecture, Japan. He attended Aoyama Gakuin University before embarking on a career as an illustrator, creating illustrations for corporate advertising for companies like Shiseido and for magazines. He received The Choice Annual Award and Award of Excellence in 1988. Since 1989 he has been teaching illustration at culture schools and in 2006 he opened the F-SCHOOL OF ILLUSTRATION. The unique teaching methods at the school in conjunction with the diverse curriculum designed to develop the strengths of the students has produced a large number of professional illustrators. His books include *Fukui Suku-ru no Shinhasso Tanoshiku Kakeru Irasuto no Kotsu 27 (27 Tips for Drawing Fun Illustrations: New Ideas from Fukui School—Genkosha)* and *Jinbutsu wo Egaku Portrait Drawing* (Bijutsu Shuppan-sha). fukui-school.com

F-SCHOOL OF ILLUSTRATION

F-SCHOOL OF ILLUSTRATION, headed by Shinichi Fukui, the author of this book, is an illustration school for all levels of students from beginners to professional illustrators.

Classes are three hours of practical skills, based on a unique curriculum. New topics are always being introduced, so even if you attend continuously, the same contents will not be repeated.

There is no need to bring your own art materials as these are provided by the school.

At F-SCHOOL, students can essentially work the way they like, while receiving individualized instruction and advice. This method of artistic development has produced a large number of professional illustrators.

Lessons: One Lesson—3 hours / 3 times a month. One term—4 months (12 lessons). One class has 5–6 students and classes are available morning, afternoon and evening, varying depending on the day.

fukui-school.com
045-961-0471
fschool@mac.com

"Books to Span the East and West"

Tuttle Publishing was founded in 1832 in the small New England town of Rutland, Vermont [USA]. Our core values remain as strong today as they were then—to publish best-in-class books which bring people together one page at a time. In 1948, we established a publishing office in Japan—and Tuttle is now a leader in publishing English-language books about the arts, languages and cultures of Asia. The world has become a much smaller place today and Asia's economic and cultural influence has grown. Yet the need for meaningful dialogue and information about this diverse region has never been greater. Over the past seven decades, Tuttle has published thousands of books on subjects ranging from martial arts and paper crafts to language learning and literature—and our talented authors, illustrators, designers and photographers have won many prestigious awards. We welcome you to explore the wealth of information available on Asia at **www.tuttlepublishing.com**

Published by Tuttle Publishing, an imprint of Periplus Editions (HK) Ltd.

www.tuttlepublishing.com

NIHONGA-FU ILLUST TECHNIQUE
© 2019 SHINICHI FUKUI
© 2019 GENKOSHA CO., LTD
English translation rights arranged with GENKOSHA CO., LTD. through Japan UNI Agency, Inc., Tokyo

English Translation ©2022 Periplus Editions (HK) Ltd.
Translated from Japanese by Wendy Uchimura

ISBN 978-4-8053-1673-3

Staff (Original Japanese edition)
Design & Art Direction Naoko Otaki (blanc graph)
Interview/Editing Sanae Kimura
Photography Toshihiko Sakagami (Tokyo Photo Argus)
Interview Support F-SCHOOL OF ILLUSTRATION
Painting Material Support bonnyColArt Co., Ltd.
Issuer Hiroshi Kitahara
Editor Toshimitsu Katsuyama
Editor-in-charge Yasunari Motoyoshi

26 25 24 23 22 10 9 8 7 6 5 4 3 2 1
Printed in China 2201EP

Distributed by
North America, Latin America & Europe
Tuttle Publishing
364 Innovation Drive
North Clarendon, VT 05759-9436 U.S.A.
Tel: (802) 773-8930
Fax: (802) 773-6993
info@tuttlepublishing.com
www.tuttlepublishing.com

Japan
Tuttle Publishing
Yaekari Building 3rd Floor
5-4-12 Osaki
Shinagawa-ku
Tokyo 141-0032
Tel: (81) 3 5437-0171
Fax: (81) 3 5437-0755
sales@tuttle.co.jp
www.tuttle.co.jp

Asia Pacific
Berkeley Books Pte. Ltd.
3 Kallang Sector #04-01
Singapore 349278
Tel: (65) 6741 2178
Fax: (65) 6741 2179
inquiries@periplus.com.sg
www.tuttlepublishing.com